THE 50 GREATEST PHOTO OPPORTUNITIES IN WASHINGTON, DC

Monica Stevenson

Course Technology PTR

A part of Cengage Learning

COURSE TECHNOLOGY
CENGAGE Learning™

Australia, Brazil, Japan, Korea, Mexico, Singapore, Spain, United Kingdom, United States

COURSE TECHNOLOGY
CENGAGE Learning™

The 50 Greatest Photo Opportunities in Washington, DC
Monica Stevenson

Publisher and General Manager, Course Technology PTR:
Stacy L. Hiquet

Associate Director of Marketing:
Sarah Panella

Manager of Editorial Services:
Heather Talbot

Marketing Manager:
Jordan Casey

Executive Editor:
Kevin Harreld

Project Editor/Copy Editor:
Cathleen D. Small

Technical Reviewer:
Ron Rockwell

Interior Layout Tech:
Bill Hartman

Cover Designer:
Mike Tanamachi

Indexer:
Sharon Shock

Proofreader:
Laura R. Gabler

For product information and technology assistance, contact us at **Cengage Learning Customer & Sales Support, 1-800-354-9706.**

For permission to use material from this text or product, submit all requests online at **cengage.com/permissions**. Further permissions questions can be e-mailed to **permissionrequest@cengage.com**.

Library of Congress Control Number: 2009933324

ISBN-13: 978-1-59863-994-0

ISBN-10: 1-59863-994-3

Course Technology, a part of Cengage Learning
20 Channel Center Street
Boston, MA 02210
USA

Cengage Learning is a leading provider of customized learning solutions with office locations around the globe, including Singapore, the United Kingdom, Australia, Mexico, Brazil, and Japan. Locate your local office at:
international.cengage.com/region

Cengage Learning products are represented in Canada by Nelson Education, Ltd.

For your lifelong learning solutions, visit **courseptr.com**.

Visit our corporate Web site at **cengage.com**.

Printed in the United States of America
1 2 3 4 5 6 7 11 10 09

This book is dedicated with love and gratitude to Roger Dehnel. Without his bike-pedaling and pen-wielding skills, it would never have come to be.

Acknowledgments

The book you are reading is the result of the collaborative efforts, talents, and contributions of many people. I am extremely indebted to the generosity and hospitality of Courtney Lodico and Laura Saba, proprietors of The Woodley Park and Embassy Circle Guest Houses. Their warmly embracing demeanors, excellent photo-op suggestions, and bountiful dinners inspired and energized me. I also could not have produced the photography in this book without the liberal support of Chris Butcher, Anthony Herfort, and all the folks at Penn Camera in Washington, DC. I thank Nancy Regg of Rolling Thunder®, Inc., Tom Bell of the DC Guesthouse, Jenny Reisner of the Stabler-Leadbeater Apothecary Museum, and Celia Lourens of the National Aquarium. I am grateful to Michael Stevenson and Roger Dehnel for their insightful suggestions in the picture-editing process.

I am especially appreciative to Amadou Diallo for introducing me to Kevin Harreld at Course Technology PTR. I am grateful to Cathleen Small, my editor, for her buoyant sense of humor, sharp eye, encouraging manner, and politic deadline reminders. Thanks also to Ron Rockwell, technical editor; Bill Hartman for his layout skills; and Mike Tanamachi for cover design.

About the Author

For the past 20 years, **Monica Stevenson**'s work has enlivened the New York commercial photography world. Monica lays claim to a first-rate portfolio of still-life (but action-packed) photography produced at her thriving studio in Manhattan. She specializes in jewelry, cosmetics, liquids, and high-end luxury goods. As a hobby, Monica practices the equestrian arts, but the camera is never far away, and her body of work includes her black-and-white equine photography that has been internationally exhibited and collected both privately and by galleries. Monica's commercial and fine arts photography can be viewed at www.monicastevenson.com. In addition, Monica has produced two photographically illustrated children's books. She teaches digital photography and lectures as a guest speaker at art schools throughout the country. Monica lives in Millburn, New Jersey.

About the Series Editor

Amadou Diallo is a New York City–based photographer, author, and educator whose passion for travel photography has taken him around the world. His words and images have been featured in national magazines and have graced some of the most popular photography-related sites on the Web. His fine art photography has been exhibited in galleries nationwide and is in a growing number of private collections. He is on the faculty at New York's renowned International Center of Photography. For information about his photography and workshops, please visit www.diallophotography.com. Amadou lives in Fort Greene, Brooklyn.

Contents

Introduction

This book is one in a series of travel guides written for photographers. If your photographic ambitions begin and end with a cell phone camera, this book may offer little beyond pleasing images. But if photography plays a large role in your travel plans, this book is equal parts photo essay and how-to guide for capturing some amazing shots on your trip. Have you ever seen a published photograph and wondered just how it was created? Well, this is your chance to go behind the scenes as I walk you through all the steps necessary to re-create what's in the book. You'll come away with professional-quality images that will have friends and family marveling at your vacation photos.

Great Travel Photos

Taking a vacation snapshot is easy; just press the shutter button. Creating memorable photographs of your travels is another thing entirely. Thumb through any magazine of travel photos, and you'll find that the best contain three basic elements—a compelling subject, an interesting vantage point, and appealing light.

Pros may make it look easy, but the truth is that long before the camera comes out of the bag, a good deal of research and planning are required to combine these three factors in a single image. While on assignment, a travel photographer may spend days choosing subjects, exploring different vantage points, and waiting for the right weather before getting the shot that's finally published. For amateur shutterbugs in an unfamiliar city with only a limited amount of time to photograph, such in-depth preparation is rarely possible. The result? Disappointing photos.

This book helps you make the most of your photography in Washington, DC by presenting 50 of the best photo opportunities the District has to offer. I'll show you exactly where to find the most interesting and least obstructed views, give you the best times of day to shoot, and guide you through the steps I used to photograph the images in these pages. Think of this book as your personal assistant. The research, location scouting, and planning have already been done, allowing you to dedicate your time to capturing stunning photographs of this amazing city.

Washington, DC

The capital city of the United States, Washington, DC is a reflection of the diversity of the United States. Its city life is as urban as any other metropolis, while its position at the heart of the nation reflects the scale and grandeur of the country as a whole. DC, however, is not a flashy city, but one of magnificent, understated elegance. The city was constructed under the initial guidance of French architect Pierre Charles L'Enfant beginning in 1791, and as a result of his classic hand, the layout of Washington, DC presents the sensitive photographer with formal, painterly compositions at almost every turn.

Washington, DC contains an extraordinary concentration of significant architecture and monuments and is a metropolis that is maintained to the highest standards, presenting the opportunity for elegant and rich photography. But it is also a city pulsing with creativity and vibrant energy—every weekend there occurs a plethora of international, cultural, and sporting events. The photo opportunities presented in this book represent a mixture of the traditional views of DC (often taken from a superior vantage point) and views of the atypical, uncovered through research, observation, or serendipity (or a combination of all three!). Personally, I am drawn to make visually arresting photographs that can be supported most often by an interesting storyline, and I hope you will see that my selection of photo opportunities reflects this.

DC is, as a rule, a straightforward city for photography. The people of Washington, DC are a welcoming and convivial bunch and will often proudly suggest ideas for your next photograph. Handy websites for searching for events, festivals, and accommodations include www.culturaltourism.org and www.washington.org. The Metrobus and the Metrorail (www.wmata.com) provide excellent access to neighborhoods throughout

the city, but given DC's relatively manageable area of 10 square miles, cycling (www.bikethesites.com) and walking are fantastic alternatives for the more energetic.

However, a word of caution with respect to photographic access—this is the nation's capital, and security restrictions, especially since 9/11, have been tightened. On federal sites, photographic access and/or use of tripods can be limited, and efforts to achieve the best shot may bring you to the attention of the security officers. If this is the case, polite withdrawal is the best response. On the other hand, certain sites, such as any national park property, are quite restrictive of only professional photography. (For permits, see www.nps.gov.) As a general rule, a small camera, light gear, and an amateur's enthusiastic demeanor will get you through. I have found that the more professional you appear, the more restricted your access may become.

How This Book Is Organized

Each chapter in this book covers a particular theme, with photo opportunities arranged in alphabetical order. At the start of each photo opportunity, you will see weather icons followed by the best times of day to shoot. Taken together, this information helps you plan your daily itinerary based on optimal photographic conditions.

These icons indicate, from left to right, sunny, partly cloudy, overcast, and rainy conditions.

Accompanying text gives a brief overview of the history and significance of what's being photographed. Next, two shots for each photo opportunity are paired with detailed information showing you step by step how to get an identical shot. A photo caption provides lens and exposure information, as well as the time of day and the month the image was photographed. You'll also find travel directions and admission information.

Will My Photos Look Like Yours?

With this book you'll learn where to go, what to shoot, and how to photograph it for professional-looking results. But snapping the shutter is, in many ways, only the start to making a great picture. The skills involved in transferring high-quality images to your computer; making adjustments for contrast, color, and saturation; and then printing them are thoroughly covered in numerous books on digital photography. The focus of this book is on everything that happens up until the shutter button is pressed.

The appeal of a book like this is that you learn in great detail how to compose shots identical to those of a professional photographer. But please don't stop there. Everyone has his or her own way of seeing, and you may find that a different angle, time of day, or weather condition makes a more compelling statement about your personal experience in Washington, DC.

I've identified 50 interesting subjects to photograph, and I'll show you how I went about doing it. Whether you choose to duplicate every shot in the book or use these images to spark your own creative take on the city, my goal is for you to enjoy photographing this town as much as I did.

Photo Gear

The desire to capture professional-quality images doesn't mean you have to own the most expensive equipment. But you will need the flexibility that a single lens reflex (SLR) camera/lens system offers to duplicate the images between these covers. In many instances, a tripod will be required for a sharp image. I promise to keep the tech jargon to a minimum, but you should be familiar with terms such as aperture, shutter speed, depth of field, and focal length to get the most out of the sections describing how I set up each shot. These images were shot with a digital camera, but the concepts and techniques apply equally to film shooters.

Camera Bag

I try to keep to a minimum the gear that I carry with me when I travel. The weight of camera, lenses, flash, and tripod adds up very quickly, and it does not take much to make your pack feel like a sandbag only a few hours into your day. On the other hand, you don't want to slim down excessively—it is disheartening to be faced with a potentially beautiful photograph, only to be without your tripod or the appropriate lens. For this book, I photographed solely with 35mm digital

My camera bag is a Lowepro SlingShot 300 AW.

My equipment includes a Canon EOS 1 Ds and a Gitzo G1297 tripod. Mounted on the tripod is a Really Right Stuff ball head.

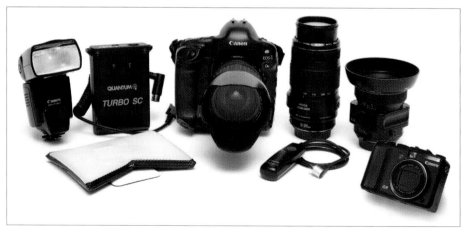

Images in this book were shot with, from left to right, the Canon 580 EX1 electronic flash with the Quantum Turbo SC battery and LumiQuest diffuser, 28-135mm f/3.5-5.6 IS (mounted on camera), EF 70-300mm f/4-5.6 IS, an electronic cable release, 24mm f/2.8 PC, and the Canon G9.

equipment, as it is relatively lightweight, affordable, and comes with a vast choice of accompanying lenses and accessories. In the images on the previous page, you can see my current choice of camera gear. In addition to the Canon EOS 1Ds, I also carried, as a backup apparatus, my little Canon PowerShot G9. This camera may be small, but it packs a punch and makes lovely files.

Digital Cameras and Focal Length

Unlike in the film days, when all SLR cameras used the same size of film, today's digital models vary in the size of the sensor that records the image. With an identical lens, two different cameras can provide different angles of view based solely on the physical dimensions of their sensors. On a full-frame sensor—one that measures 24×36mm—a 50mm lens is considered a standard view. But put that same lens on a camera with a smaller sensor, and a significant portion of the image is cropped off. To achieve a comparable view, you need to use a wider focal length. Table I.1 shows approximate focal length equivalents between a full-frame sensor and two reduced-size sensors. For simplicity's sake, all lens focal lengths listed in this book will correspond to their full-frame equivalents. If the dimensions of your camera's sensor are smaller than the 24×36mm film standard, you'll need to use a wider lens to achieve the same field of view.

TABLE I.1 APPROXIMATE FOCAL LENGTH EQUIVALENTS

To match the coverage of a full frame sensor at...	A 1.5x crop sensor needs a lens at...	A 2x crop sensor needs a lens at...
20mm	12mm	10mm
50mm	35mm	25mm
85mm	55mm	42mm
100mm	70mm	50mm
200mm	135mm	100mm

Equipment Rental

A great convenience of shooting in Washington, DC is the availability of camera equipment for rent. If there's a particular shot detailed in this book that requires equipment you don't own, the place to go is Penn Camera, conveniently located on E Street in the downtown area. The folks behind the counter are super-friendly and very knowledgeable, and they repeatedly went the extra mile to help me. They stock cameras, lenses, tripods, and more, and you can rent by the day or the week. This store caters to working pros, so the equipment is kept in perfect working order.

Okay, enough about gear. Let's get to the photos.

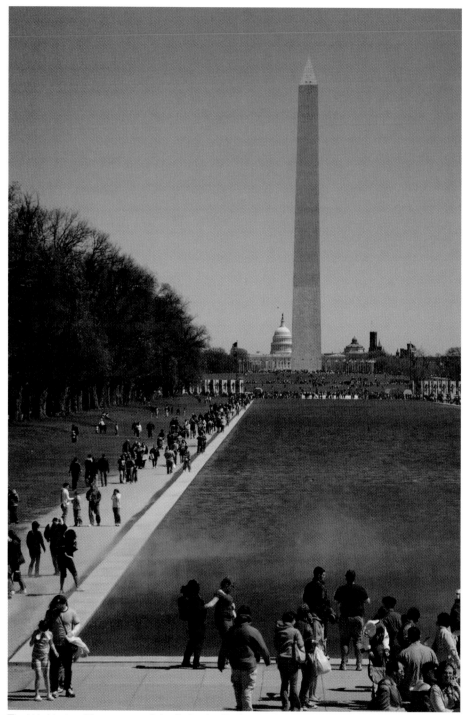
The Washington Monument and the Reflecting Pool.

CHAPTER 1
Architecture and Monuments

The myriad buildings that constitute the governmental heart of the United States are arranged primarily and artistically around the National Mall, the architectural focus of Washington, DC. These buildings take inspiration from both modern and classical schools, and the spacious layout of the city center allows for ample opportunity to capture their finest aspects. Throughout the remainder of the city you will find a plethora of fine architecture reflecting such a diversity of influences that your memory card will be bursting at the seams!

DC also presents a feast of commemoration in the form of dramatic and eye-catching sculpture and statuary. Bronze is the frequent medium of choice, and photographic opportunities abound throughout the city. The good and great of the political, military, and scientific worlds vie for attention with remembrances of seminal events in our nation's history. You will not run short of subjects in this field.

Shooting Like a Pro

Unlike most urban centers, Washington, DC is, for the most part, spacious and harmoniously arranged, so finding a vantage point with an appealing view toward your edifice or memorial of choice is not too difficult a task. The major, and I mean *major*, obstacle to acquiring a professional-looking photograph of DC's monuments is the constant crowds. Each year, some 700,000 tourists descend upon the Lincoln Memorial alone, with most of this veneration occurring during normal business hours, when you, too, are most likely to be shooting! Professional photographers overcome this by working at odd hours and being creative in their approach. With a modicum of forethought and ingenuity, you, too, can come home from your trip with lovely photographs and accompanying tales of achievement that you will be proud to display.

The Gear

A medium focal length lens is appropriate for the majority of architectural shooting situations you will encounter in DC, since there is often no dearth of space between you and your subject. You can capture well-composed shots of most sculptures and memorials with a 35mm to 70mm lens. There are exceptions, of course. I find that a wide PC (*perspective control*) lens is almost invaluable when photographing broad and tall structures, such as the National Cathedral, where I used a 24mm PC lens. This lens behaves somewhat like a view camera, with manually controlled vertical and horizontal shifts that prevent the converging lines that result from pointing your camera up at a tall building. The PC lens does require a bit of practice to use, but it is a fantastic tool that will allow you to keep the sides of buildings and other vertical axes parallel in your photograph.

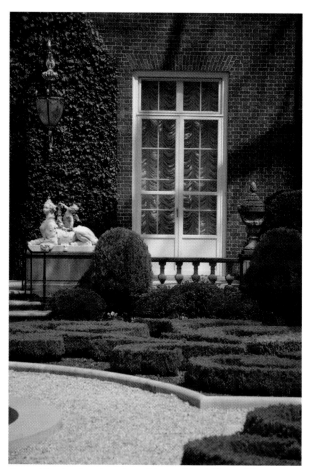

An architectural and garden tableau of the Hillwood Estate.

There are situations, on the other hand, that will require a longer focal length lens to achieve the look that you are searching for. For some shots of the Capitol building, I used a 135mm focal length, and at the Lincoln Memorial I was able to pull the 300mm lens out of my bag. Whenever possible, use your tripod and bubble level to ensure that both horizontal and vertical axes are straight.

The Plan

Shooting the famous monuments in the early morning hours or after the sun has set will greatly increase your chances of having a crowd-free sight line. Often, the light at dawn can be pale pink and glorious and will wrap the city's white marble monuments in a delicate glow. A deep blue evening sky and the night's cloak of darkness do much to either disguise the crowds that may be present at your chosen shooting location or possibly discourage them from visiting at all. During the summer months and many spring weeks, the popular tourist attractions are literally swarming with families and school-age children— you will have to plan your shoot list accordingly or work the throngs into your photo to lend a sense of scale and in turn add a touch of life and humanity. I also find that including plant life—a tracery of unadorned

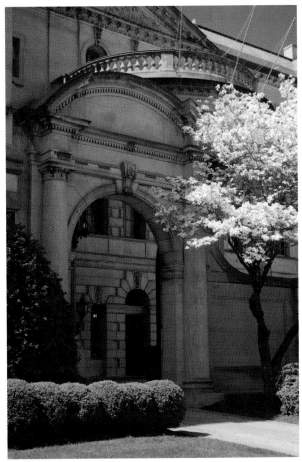

The entry arch of the Cincinnati Club on Embassy Row.

branches in the winter and spring or a lush, leafy framework in summer—adds a real sense of place to a photograph and can soften the sometimes harsh lines of stony structures.

When to shoot: morning, evening

Arlington National Cemetery

The National Cemetery, located in Arlington, Virginia, is the last resting place for members of the armed services fallen in each of the nation's wars and, among others, explorers, historical figures, and justices of the Supreme Court. Arlington also is the final home for two of our nation's presidents. One cannot help but feel moved by a visit to the cemetery. The vast yet orderly sea of small, plain gravestones is a vivid testament to the dedication to a cause of those who rest within.

The site was designated as an official military cemetery in 1864. More than 300,000 people are buried here, with an average of 28 additional funerals each weekday.

The Memorial Amphitheater near the center of the cemetery is the home of the Tomb of the Unknowns, where unknown American service members from World War I, World War II, the Korean War, and the Vietnam War are interred. This site has also hosted the state funerals of many famous Americans, such as General of the Armies John J. "Black Jack" Pershing, as well as annual Memorial Day and Veterans Day ceremonies. The amphitheater is constructed of white Danby marble from Vermont and presents many striking views.

The Shot

Wherever you point your camera in the National Cemetery, you likely will have before you an arrangement of hundreds of gravestones, the linear placement of which makes for solid and organized compositions. You must take care, however, to place the foreground stone in a balanced juxtaposition against those behind and also to position yourself so that you can accentuate the long, straight avenues of grass between the markers. This sense of infinite acreage lends great emotion to the photograph.

I searched for a gravestone with a beautiful diagonal shadow falling on it from the branch of a tree above. This shadow and the dappled light falling through the leaves above are evidence of my use of *chiaroscuro*. This technique is particularly helpful here to maintain some nice tone in the foreground stones, which would otherwise be a stark, alarming, and toneless white. This view of the gravestones was taken in Section 38, at the corner of Schley Road.

CHIAROSCURO

The technique of using light and shade in pictorial representation, or the arrangement of light and dark elements in a pictorial work of art. It is, essentially, the distribution of light and shade in a picture. I am an enormous fan of chiaroscuro and feel that shadows and their interplay with light can add a tremendous amount of interest to a photograph. Spring in DC, with thousands of trees yet to leaf out, is a perfect time to play with branches and the shadows they create over your subject.

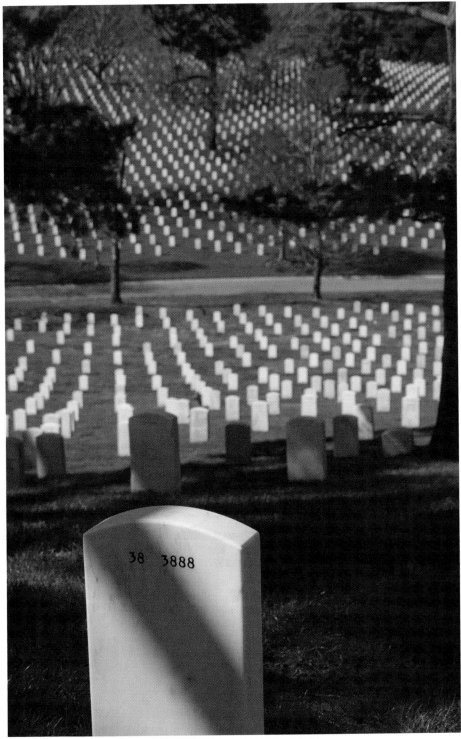

Focal length 70mm; ISO 100; aperture f/10; shutter 1/400; April 3:47 p.m.

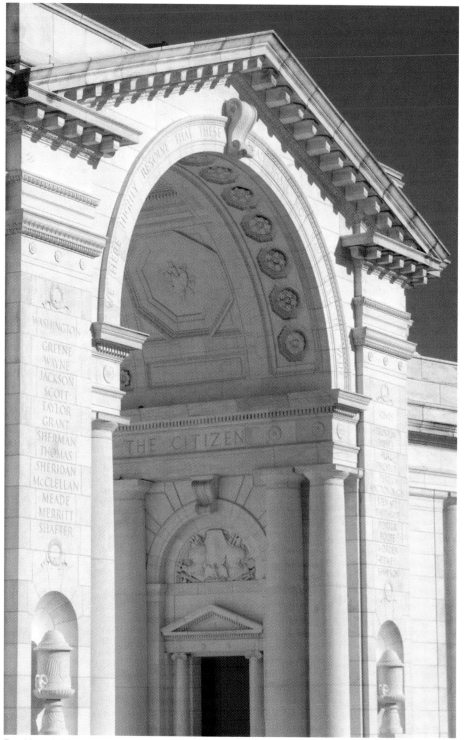

Focal length 22mm; ISO 100; aperture f/5.0; shutter speed 1/1250; April 5:14 p.m.

The Shot

To render legibly the texture on the white marble of the Memorial Amphitheatre, the light in which you are shooting must rake across the face of the carvings. As the late afternoon sun beams from the west at a low angle, every minute detail of the bas-relief lettering, dentil moulding, carved rosettes, and even the shallow fluting of the urns is brought into stark contrast. The material of the amphitheatre itself acts as a gigantic and all-encompassing reflector card, bouncing light in all directions and reaching almost every nook and cranny of the structure with perfectly balanced fill light. This makes for a very wide and beautiful tonal range that the camera is able to capture—from a near bright white on the lightest faces of the bricks to a deep black inside the doorway, where light cannot bend the corner to illuminate. The deep blue of the afternoon sky to the east makes a vivid contrast against the pale stone—a study in blue and white!

John F. Kennedy's grave.

Getting There

Arlington National Cemetery is located a short distance into Arlington on the southwest bank of the Potomac River. It is reached via the Arlington Memorial Bridge, which itself is to the southwest of the Lincoln Memorial and the Mall.

The Cemetery is open to the public at 8:00 a.m., 365 days a year. From April 1 to September 30, the cemetery closes at 7:00 p.m.; during the other six months, it closes at 5:00 p.m.

A side entrance to the Memorial Amphitheatre.

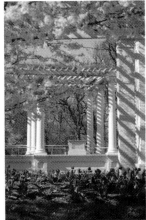

The gazebo at the hilltop of the cemetery.

Ample paid parking is available to visitors and is accessible from Memorial Drive. During all open hours, the Arlington National Cemetery Metro stop is regularly served by high-speed subway trains.

 When to shoot: morning, afternoon, evening

The Capitol Building

Topped by the Statue of Freedom, the U.S. Capitol building is the iconic architectural representation of the U.S. government. The imposing building houses Congress, the legislative branch of government, in both its Senate and House forms and sits majestically at one end of the Mall, facing away toward the Washington Monument and the Lincoln Memorial. The Capitol building, with its famous cast-iron dome and marble façade, probably tops the White House as the most defining of DC sights.

Construction of the Capitol was begun in 1793, and Congress took up residence in the (unfinished) building in 1800. The Supreme Court was located there in 1810. Despite being burned by the British in 1814, the main structure was completed in 1829. Another fire in 1851 (not the British this time) consumed the Library of Congress. Further extensions and enlargements continued throughout the nineteenth century, and modernization continues to date. Both the Supreme Court and the Library of Congress have, over the years, moved to their own buildings, leaving Congress to its own merry devices.

The Shot

There are 360 degrees of vantage points from which to view the Capitol dome, yet certainly the most interesting shots happen when you place something else in the frame to add complexity, depth, and a sense of location to your image. This shot was taken from Independence Avenue, in front of the Rayburn House Office Building, which is directly south of the Capitol building. The day was a classically picture-perfect one, with the sky a deep blue and the air dry enough to keep the light crisp and clear. In May, the leaves on the trees are still new, and their emerald color, combined with the cerulean blue of the sky, the clean white of the dome, and the dark teal of the statue, contribute to the fresh and sparkling appearance of this image. I was happy to have a cloudless sky, because additional areas of white in the frame would have pulled attention away from the focus on the dome. As you compose your picture, remember to be conscious of where you place your main subject—you want the foliage to complement the subject, not overwhelm it. Try to avoid too much overlap or an excessively complicated pattern.

FOCUS POINT: FOREGROUND OR BACKGROUND

Having committed to making a photograph of a subject with added foreground and/or background elements, you now have the choice of where to place your focus. In the case of these shots of the Capitol dome and tulips, you can see the difference when you choose to focus on the flowers or to focus on the building. These two objects are so far apart in distance that no matter what the camera's aperture or what focal length lens you are using, it would be virtually impossible to render both the flowers and the dome in tack-sharp focus.

Here is where a creative choice comes into play. You can focus on the flowers and make a picture of tulips with the Capitol in the background, or you can focus on the dome and make a picture of the Capitol with tulips in the foreground. Each

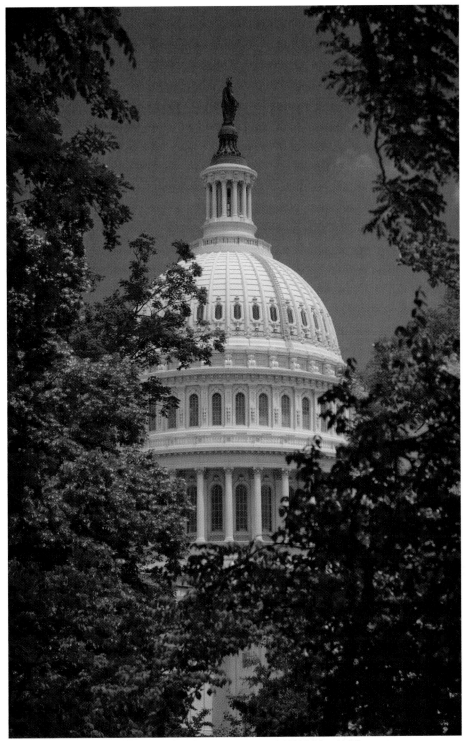

Focal length 135mm; ISO 100; aperture f/5.6; shutter speed 1/640; May 11:50 a.m.

photograph has a very different look and message, and it is a personal aesthetic decision as to how you prefer to shoot the scene.

Do remember that if you choose to make the foreground in sharp focus, you should be sure to scan the frame left to right, and in the case of flowers or plants, make sure that there are no dead, brown, or broken leaves or flowers that would detract from what could be a perfect image. The same can be said for the focused background version, but when your subject is large and front and center, imperfections only become more obvious.

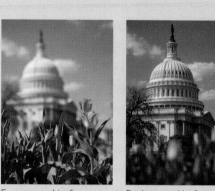

Foreground in focus. Background in focus.

The Shot

To capture this scene of the Capitol building from a northwest vantage point, stand on 3rd Street NW, just a few steps south of Pennsylvania Avenue. In April, most of the trees in DC are not yet in full leaf, and the branches of this enormous and aged oak tree make a dramatic filigree through which to view the imposing dome. Aside from its majestic bearing, the overriding characteristic of the Capitol building is that its angles and sculpted details accept scrutiny under almost every lighting situation. What better model can one ask for?

On the day I shot this image, the rain had abated for only moments, and the sky was thick with clouds when I clicked the shutter, yet the white painted metal (yes, metal—*not* white marble or some other unusual stone) shows beautiful detail and tone. The soft light lends a painterly quality to the scene, as do the muted greens, browns, and pinks of the foreground flora. The two pedestrians at the bottom of the frame display accurately the scale and grandeur of the scene.

Getting There

The Capitol building is located at the east end of the Mall, at the intersection of North/South Capitol and East Capitol Streets. The Capitol constitutes the center point of DC's street numbering/lettering system, sitting at the adjacent corners of the NE, NW, SW, and SE quadrants of the city.

The Capitol is closest to the Capitol South Metro station, and walking in a northwest direction for less than half a mile will bring you to either the east or west frontage of the building.

If you are interested in touring the inside of the building, the Capitol Visitor Center is open to visitors from 8:30 a.m. to 4:30 p.m. Monday through Saturday, except for Thanksgiving Day, Christmas Day, New Year's Day, and Inauguration Day. Tours of the U.S. Capitol are conducted from 8:50 a.m. to 3:20 p.m. Monday through Saturday.

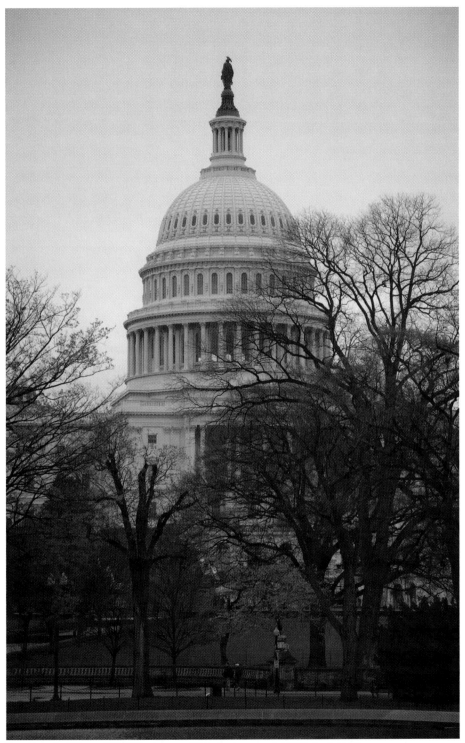

Focal length 125mm; ISO 100; aperture f/5.6; shutter speed 1/200; April 11:05 a.m.

 When to shoot: morning, afternoon

Albert Einstein Sculpture

Einstein was a scientist of supreme imagination and tenacity who reshaped the way in which we think about the structure of our universe. He is honored through this engaging statue showing him in relaxed pose, scribbling with pencil in his ever-present notebook, the map of the heavens spread at his feet. Unveiled in 1979, the statue presents an over-life-size tribute, lovingly burnished where the thousands of school-age visitors have clambered onto the great man's lap. Located in the southwest corner of the grounds of the National Academy of Sciences, Einstein can be found in patient contemplation amongst elms and hollies.

The Shot

I chose to do a close-up of Robert Berks' marvelous Einstein 3D portrait, as this intimate view conveyed clearly the kind and droopy eyes; large, intelligent forehead; and tousled hairdo of this great scientist.

Bright sun would be too high contrast for this sculpture—the shadows would be deep and black instead of soft and full of information and texture, as they are here. The wrap-around quality of the diffused light also renders the highlights on the bronze in a broad and sculptural manner, which is much more appealing than the harsh, specular highlights

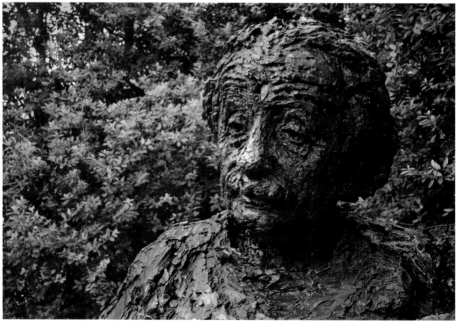

Focal length 70mm; ISO 100; aperture f/5; shutter speed 1/20; May 1:53 p.m.

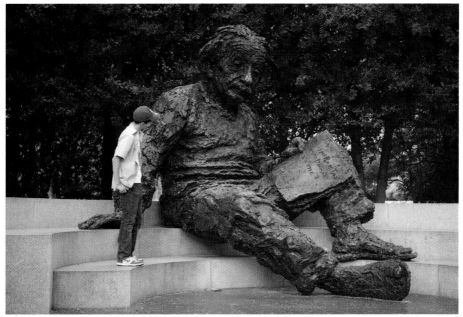

A fan of Einstein, studying his theorem.

that one would see under the light of a full sun. The variegated background of the leafy, green rhododendrons mirrors perfectly the rough and irregular surface of Einstein's head and shoulders.

I would usually search for a contrasting background when shooting a portrait, as this helps to focus your eye on the subject, but in this case, the complementary background is a stroke of luck. I love the way that Einstein blends into the background because the textures are so similar, but at the same time he is delineated by the difference in materials—hard metal versus the organic feel of the leaves. A bit of social creativity was required to capture the full shot of Albert sans crowd: "Okay. Everyone who is *not* a genius theoretical physicist, out of the shot!!" The tourists complied with my surprise request, and I was able to catch Einstein alone in his reverie with the universe.

A superb video is available on the sculptor's website—robertberksstudios.com—that tells from soup to nuts the story of the constructions. It is a must-see.

Getting There

The National Academy is located off Constitution Avenue between 21st and 22nd Streets. The closest Metro stop is Foggy Bottom, from which a walk of five blocks south and two east will bring you to the Academy. Einstein's statue is positioned between the main building and Constitution Avenue, which itself flanks the Mall.

When to shoot: morning, afternoon

The Navy-Merchant Marine Memorial

The Navy-Merchant Marine Memorial is one of the most striking and imaginative of DC monuments and commemorates sacrifice by sailors of the U.S. Navy and Merchant Marine during World War I. Known colloquially as Waves and Gulls, the piece, constructed in this case from aluminum, presents many angles and views for striking photography.

The Shot

This monument is compositionally quite complex, and the ideal thing to do when you arrive is to spend a few minutes studying and searching for your favorite point of view. I chose a low angle to give the impression that the birds were soaring above me and to make the waves awe-inspiring as they seem to roil and heave toward the camera. I filled the frame edge to edge with the birds' wings, which gives the photograph tension and creates strong and appealing negative spaces. My composition is triangular and balanced, and the viewer's eye travels from the uppermost gull serving as the apex down and around to the waves in the foreground, where they swirl and crash against the edges of the frame.

A detail of the leading gull.

The water in this sculpture is rendered in a very illustrative style with decorative, almost beadlike sea foam, whereas the gulls are so lifelike you can almost hear their salty squeals. There are a multitude of whimsical, Art Nouveau details in every corner of the piece—spirals, shells, feathers, and scales abound. As with most metal sculptures, a cloudy or overcast sky is the perfect lighting situation in which to shoot this striking monument. Don't forfeit a trip, however, if it is a sunny day—the matte aluminum surface is more forgiving in harsh light than one of polished bronze.

NEGATIVE SPACE

In flat art, such as photography, painting, or drawing, negative space is the area or background around an object (the subject—in other words, the positive space) and the spaces between its parts. Think, for instance, of the hole in a doughnut or the space between a bucket and its upright handle. Negative space is something to be aware of and can be a crucial element in your photographic compositions. It becomes most visible when it forms an interesting shape and/or one that is conceptually appropriate to your subject matter. Many artists believe that good design hinges on the balance between and equality of negative and positive space in your compositions.

Getting There

The memorial is located in Lady Bird Johnson Park on Columbia Island and is best approached by the walking/bike path that follows the southwest bank of the Potomac River from the Arlington Memorial Bridge toward the Pentagon. The Metro stop at the Arlington Cemetery is about a 10-minute walk to the memorial.

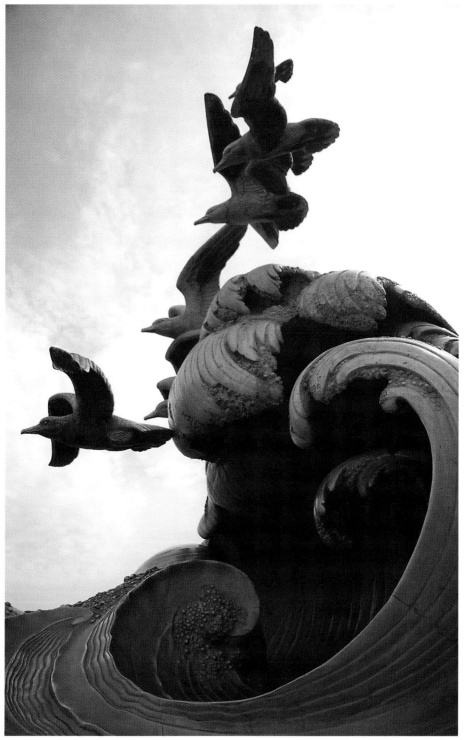

Focal length 28mm; ISO 100; aperture f/4; shutter speed 1/1000; May 9:14 a.m.

 When to shoot: morning, afternoon

Downtown

One might be fooled into believing that the only noteworthy buildings in the center of DC are the White House and the Capitol. Far from it! Throughout the area surrounding these famous sights, you can find a wealth of architecture from neoclassical government buildings, to dramatic monuments, to refined and stately family residences.

The majority of architectural interest in DC lies within the northwest quadrant of the city. It pays to become familiar with the layout of this area to maximize your photo opportunities. Streets running east to west are lettered consecutively, while streets running north to south are numbered. Streets running diagonally are named after states. The design was first outlined by L'Enfant in 1791, but the city really took its current shape following the work of the McMillan Commission in 1901, which led to the city's current European-style grandeur. This plan led to the clearing of previous slum dwellings and gave rise specifically to the Mall and its monuments and to Union Station.

The Shot

The Blair Lee House was built in 1824 for Dr. Joseph Lovell, first Surgeon General of the United States and original organizer of the Army Corps of Engineers. This National Historic Landmark has served since 1942 as the official guest house of the President of the United States. It is an excellent example of Washington residential architecture.

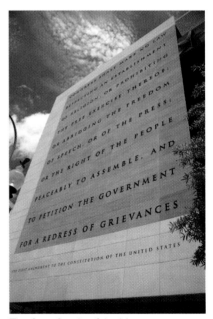

The front façade of the Newseum.

Nestled into the northwest corner of the frenetic square surrounding the White House, the façade of the Blair Lee House is pictured here in a calm and peaceful still life. The Federal style architecture of the building lends itself to a geometric, almost Mondrian-like composition, the effect of which is deepened by the patchwork sidewalk at the bottom of the frame.

I shot from directly opposite the house, elevated by a stone curb to ensure that my camera lens would truly be centered on my subject and that my vertical lines would be straight. Accurate right angles are a vital aspect in the structure of this image, as is the soft light from an overcast sky. Harsh shadows would disturb the flat, cubist effect I have captured here. I took several frames, moving the camera slightly up, down, and laterally, until I settled on a pleasing composition of lines and rectangles. You can see how the Washingtonian's penchant for well-manicured shrubs can add to the beauty of a photograph! You must wait patiently, also, so that the pedestrians in this busy area are out of the frame.

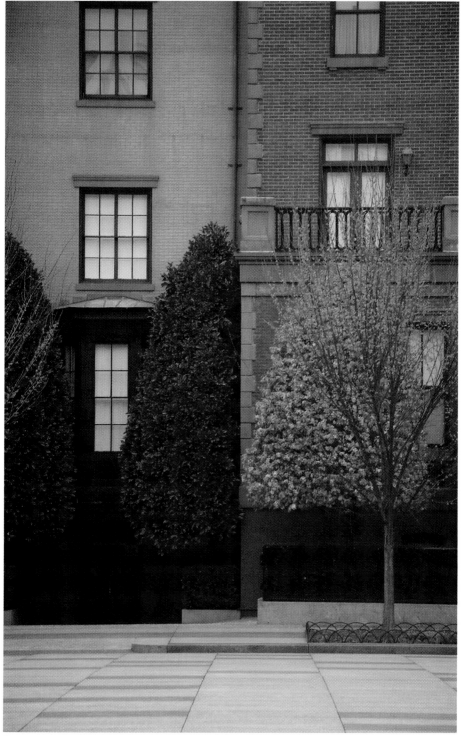

Focal length 110mm; ISO 100; aperture f/5.6; shutter speed 1/80; April 2:44 p.m.

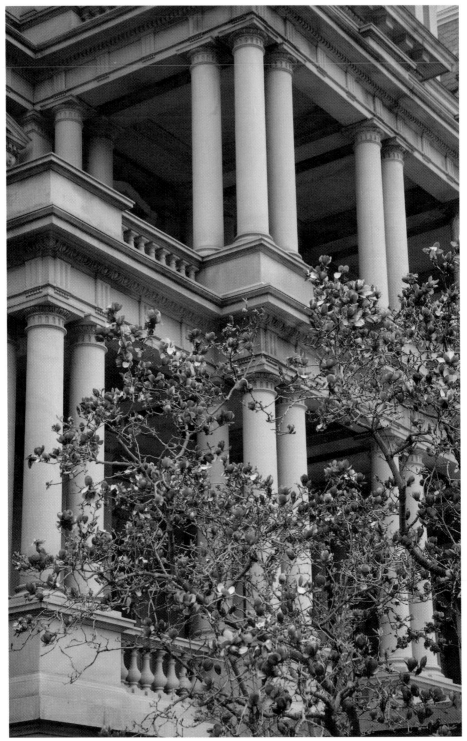

Focal length 80mm; ISO 100; aperture f/5.6; shutter speed 1/50; April 2:50 p.m.

The Shot

On the west side of the White House lies the Executive Building. These offices are the workplace for the majority of White House staff. This French Second Empire–style structure was once referred to as "America's greatest monstrosity" by Harry S. Truman, and the building presents much flamboyant yet admirable detail for the keen eye.

This shot is an architectural study in gray, rose, and white and once more shows my fondness for juxtaposing organic elements with rigid structural ones. The day again was overcast, which creates a full, luscious tonal range in the image. If this shot had been taken under full sun, the shadow areas would be deep black, and the gentle tonal transitions in the gray stone would be lost.

A winter tree on the side of the National Gallery.

The tracery of branches and magnolia blossoms separates beautifully in this situation from the soft gray under layer, whereas if the light had been harsh, the overlay effect of the tree would have been too complex and jarring to the eye. Stand on the corner of E Street NW and 17th Street and point your camera up to capture the corner of the building behind this enormous magnolia. Of course, depending on the time of year that you are there, you will have blossoms, leaves, or bare branches before you. Foot traffic poses no problem here, since you are cropping well above the level of the sidewalk.

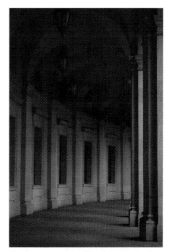

Archways at the Environmental Protection Agency building.

Getting There

All five Metro lines run through the White House/ Capitol area and can be used to access any part of the surroundings of the Mall. The Mall itself is 1.5 miles in length and can be explored on foot, but in summer be conscious of the heat and humidity when planning your itinerary.

The Farragut North and Farragut West stations lie about 500 yards to the north and northwest, respectively, of the Executive Building. Walk south on 17th Street to find the Executive Building opposite F Street.

The Blair Lee House is located on Pennsylvania Avenue, just to the north of the Executive Building. It is not open to the public.

 When to shoot: morning, afternoon

Embassy Row

Prepare your equipment and yourself for a trip to the architectural zoo! Imagine a closely packed and orderly array of exhibits arranged for simple access for the visitor. Also imagine that each exhibit reflects both the culture and prosperity of its country of origin and a process of evolution from earlier displays. This is Embassy Row, and entrance to this architectural menagerie is free! More than 60 of the foreign embassies located in Washington, DC are situated on and around Massachusetts Avenue NW. Walk the two-mile stretch of Embassy Row and bring home a record of how each nation uniquely presents itself in our capital.

The tone for this section of DC was set in the late nineteenth and early twentieth centuries by the construction of many fine homes by the social and political elites. Known as Millionaires' Row, the street held on to that status until the Great Depression. Starting in 1929, with the newly constructed British Embassy (built to reflect an English country home, which now serves as the British Ambassador's residence), the Row progressively developed its current character through a process of modification, addition, and new building. Architectural styles and accompanying monuments can be found that intriguingly reflect the nationality of each embassy.

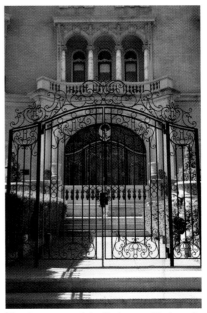
The front gate of the Embassy of Indonesia.

The Shot

Set before you on Embassy Row is a panoply of architectural styles, and your first decision when shooting is what sort of photograph you would like to bring home. Modern and spare? Baroque and curvy? To satisfy the first choice, I meandered up the hill to #3301 Massachusetts Avenue for the Finnish Embassy. This building is a splendid representation of Finnish values—from use of natural light, evidenced by the generous use of glass blocks, to the Finns' yen for a direct connection with nature. (The façade has a healthy covering of vines and ivy, and only five trees were cut down to build the structure.)

Stand on the sidewalk across the wide expanse of the avenue and situate your camera so that it is directly in front of the Embassy. With a medium telephoto, you can fill the frame with the building and crop out the parking area in the front. This focal length will also allow you to maintain the straight lines and right angles that are crucial to the impact of this photo. The façade is quite flat, so you do not need great depth of field. Try to shoot on a partly cloudy or sunny day. If the sky is overcast, the light will be too soft, and you will not have enough contrast to bring out the beautiful details in the material of this structure.

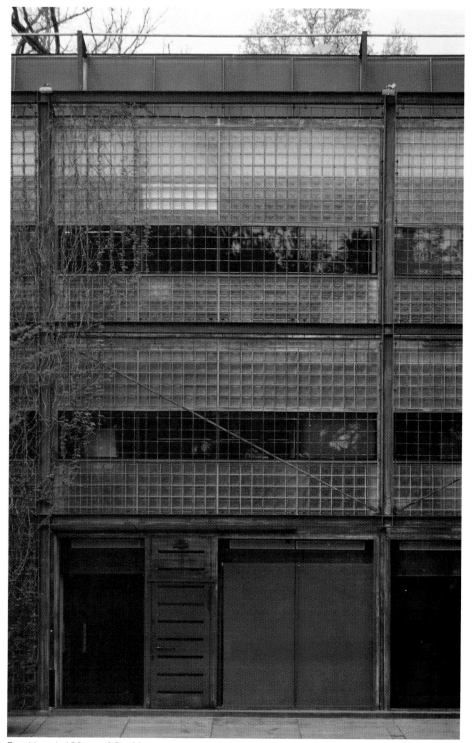

Focal length 130mm; ISO 100; aperture f/7.1; shutter speed 1/60; April 2:39 p.m.

The Shot

For a more romantic visual experience, walk a few blocks down the hill of Massachusetts Avenue to #2440, the Mexican Embassy. This building is designed in a classic Hacienda style, and as you walk by, you can almost hear the mariachis as you are transported south of the border just for a few moments. Try to photograph here on a fully sunny day, since this sharp and direct light creates beautiful negative spaces under the arches and between the columns of the peach-toned adobe walls. The contrasty light only serves to further the illusion of Mexico in DC.

I stood in the driveway just outside of the embassy and moved left and right until the upper curves of the stairwell arches and its windows were framed perfectly by the large opening of the main entrance. I kept the Mexican emblem above the arch in its entirety and purposefully arranged the quarter circle of shadow at the bottom-left edge of the frame.

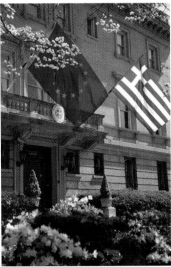

The success of this type of photograph relies heavily on your sense of composition, so be very careful and deliberate as you are placing the shapes within your frame. If you feel hesitant or unsure of how exactly to compose the shot, take several pictures, moving left and right and up and down to place the shapes in several different arrangements. Later, when editing at your computer, you can find the composition that most appeals to you.

The façade of the Embassy of Greece.

A statue of St. Jerome the Priest in front of the Croatian Embassy.

Getting There

Embassy Row is readily reached via the Metro, taking the Red Line in the direction of Shady Grove and alighting at Dupont Circle. Most of the embassies lie to the northwest, although several also are located to the southeast. If you're driving, look for parking along the side streets off Massachusetts Avenue.

The Mexican Embassy is located at 2440 Massachusetts Ave. NW, 500 yards northwest along Massachusetts Avenue from Dupont Circle. (If you reach Sheridan Circle you have gone too far.)

The Finnish Embassy is located at 3301 Massachusetts Ave. NW, 1 1/4 miles northwest from Dupont Circle along Massachusetts Avenue, just before you reach 34th Street. This latter distance can be covered using one of the Metropolitan Area Transit buses (N2 or N4) for a nominal charge, but if you are up for the walk, you will be able to study a fascinating array of embassy architecture for the complete length of your exertion.

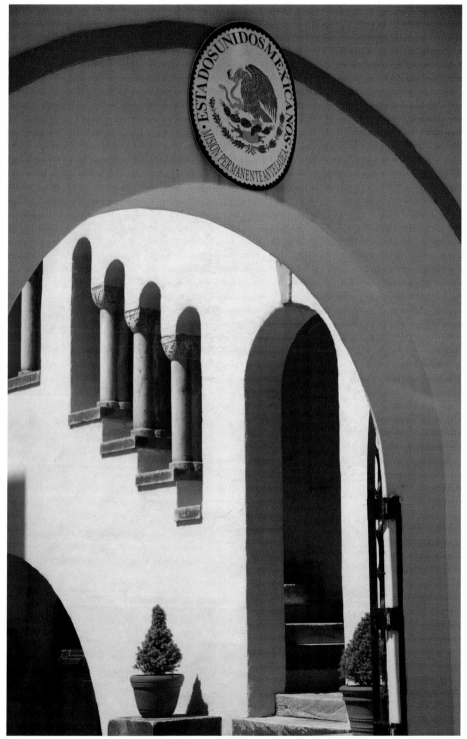

Focal length 75mm; ISO 100; aperture f/5.6; shutter speed 1/800; April 10:43 a.m.

Georgian Colonial Architecture

The Georgian architectural style dominated British and American construction during the 18th century. Named after the Kings George who ruled Britain and the colonies during that time, the design prevailed throughout Britain and the developing province. The style is recognizable for its simple one- or two-story symmetrical box design. A panel front door is centered and flanked by multi-pane windows, usually five across. A decorative cornice is usually included to lighten the initial severity of the design.

Alexandria is located five miles to the south of DC on the west bank of the Potomac. The town was instituted in 1748, and these historical roots define the architectural style that characterizes its streets. In 1791, George Washington included Alexandria in the area to be known as the District of Columbia, and although the town represents a DC outpost, it is a thriving and fascinating part of the community.

The Old Town section, in the eastern and southeastern areas of Alexandria, is the oldest part of the city and is designated a historic district. Old Town is chiefly known for its townhouses, art galleries, antique shops, and restaurants. The rejuvenated waterfront harkens back to the town's early days as a thriving colonial port. Visit Old Town Alexandria and seek out its classic Georgian Colonial architecture.

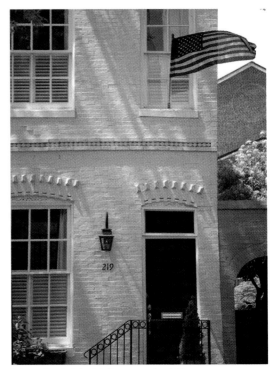
Interesting brick details on a colonial home.

The Shot

This home, the Carlyle, holds the honor of being the only stone, 18th-century Palladian-style house in Alexandria, Virginia. Its plain and geometric façade make a simple and direct photographic statement if framed well. I stood on the sidewalk just to the right of the gate and the arch of the brick wall. Rather than take only a flat, frontal shot of the home, I opted to include the soft curve of the brick wall at the bottom of my frame. This adds a bit of texture and depth, and I like the contrast of the smooth curve of the wall to the right angles of the building. The spare and monotone quality of the house is furthered by the fact that it is slightly backlit, keeping any raking shadows off the façade. Be sure to have your lens as straight and centered to the house as possible. I actually stood on my camera case to elevate me slightly and keep the lines of the house from converging.

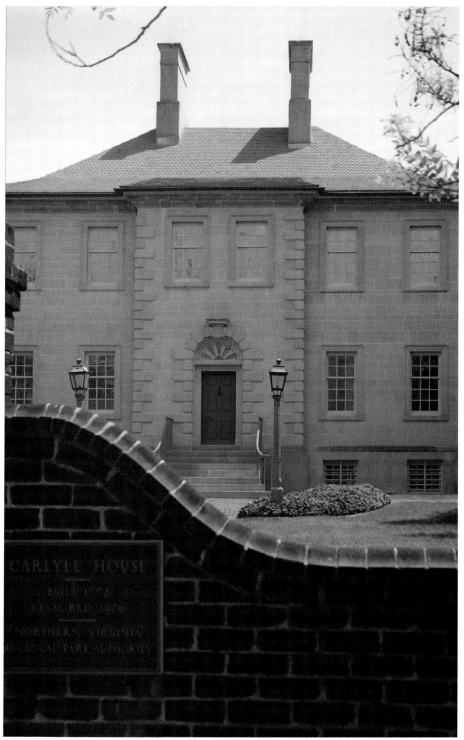

Focal length 47mm; ISO 100; aperture f/5.6; shutter speed 1/200; April 11:35 a.m.

The Shot

This shot demonstrates not only a sample of classic colonial architecture, but also one of the very convenient lighting situations to be experienced in Old Town Alexandria. The majority of the residential streets are lined and sheltered by old and majestic trees, which makes for attractive shots even at the height of the day. The leaves and branches of the trees act as a living cuculoris and cast interesting and playful shadows on your subject matter. An added bonus to shooting around noon is that most pedestrians will be lunching, and your path of view will be clear. I prefer to avoid including people in this type of scene, because it is only without the modern touches of clothing and autos that you can truly convey a sense of historical authenticity. So, unlike most places and days, shoot away at noon and treat yourself to a well-deserved late lunch at any one of Old Town Alexandria's great pubs.

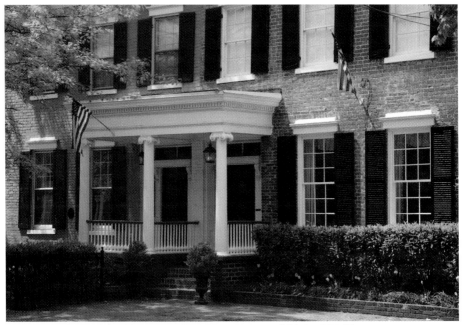

Focal length 75mm; ISO 100; aperture f/5.6; shutter speed 1/100; April 11:47 a.m.

 Cuculoris is a term that comes from cinematography and describes a panel with irregular holes cut into it to cast a pattern of shadows onto your subject. It is also called a *cookie* and can be handmade or something that you find in nature.

Getting There

Take the Blue or Yellow Line Metro to the King Street stop and either walk about 10 blocks to the east or take a DASH (Alexandria city) bus for a dollar to the historic area. To drive to Old Town, take the George Washington Memorial Parkway along the west bank of the Potomac to East King Street. There are parking meters on the street and plenty of parking garages in the area.

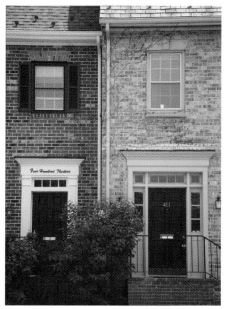

A portrait of contiguous brick colonial homes.

A period detail shared by two homes.

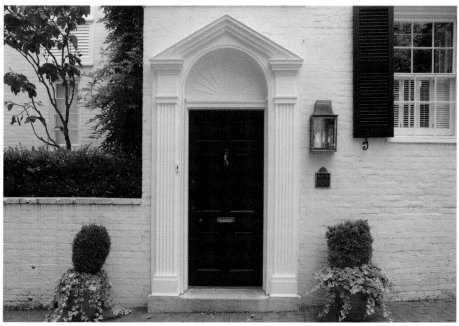

A Georgian door-surround in…Georgetown!

When to shoot: morning, afternoon, evening, night

Lincoln Memorial

IN THIS TEMPLE
AS IN THE HEARTS OF THE PEOPLE
FOR WHOM HE SAVED THE UNION
THE MEMORY OF ABRAHAM LINCOLN
IS ENSHRINED FOREVER

Etched high on the wall, these simple but compelling words ring out from this spectacular memorial to Abraham Lincoln. As President during one of the seminal events in the history of the United States, Lincoln is justly memorialized in this imposing white marble and limestone edifice, which stands proudly at one end of the Mall.

Construction was begun in 1914 and completed in 1922. The stately design is based on that of a classical Greek Doric temple. The imposing steps and columns first take the eye, but you are then drawn to the inner chamber, where Lincoln's statue sits pensively looking out across the Reflecting Pool toward the Washington Monument. On the walls around the statue are chiseled the words of the Gettysburg Address and of Lincoln's second inaugural address. As a truly fitting commemoration, it is no wonder that the Memorial receives millions of visitors every year.

The Shot

The Lincoln Memorial may have millions of visitors each year, but on any given evening, you will probably only encounter thousands of them. A cloak of darkness works wonders in toning down brightly colored tees and baseball caps into one, dark, amorphous mass. I actually prefer this photo to a less peopled one. The dimmed throng with their colored camera flashes tells a story of how popular a place this really is.

For shots like this, when time of day is a crucial factor (I researched ahead the exact time for sunset), I like to arrive at least 30 minutes early to ensure that I will have time to handle any technical problems that may arise. I placed my camera and tripod at the farthest point in the plaza facing the Memorial and made sure that I was centered and squared in front of the Memorial. I use a ball head on my tripod, which makes tiny adjustments along any axis very simple to perform. After a couple of test shots, I was able to see on my viewing screen that the Memorial was straight in the frame.

The exposure compensation on my camera was set to −1.67, which gave me the overall dark image I was looking for and made certain that the brightly lit statue of Lincoln would not be overexposed. The shutter speed of almost a second allowed me to capture a few of the hundreds of flashes from the tourists' cameras, and, to my happy surprise, I was also able to catch the colored light trails from one of the many jets that evening on its way to Reagan National Airport. I snapped quite a few exposures, but my favorites happened after the sun had set, when the luminance of the deep blue sky matched that of the spotlight on the pediment.

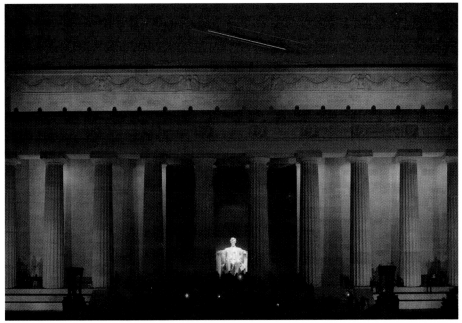

Focal length 70mm; ISO 100; aperture f/5.6; shutter speed 0.8 seconds; April 7:19 p.m.

 Nighttime and long exposures are greatly aided by the use of a cable release. It's a tiny and weightless addition to your camera bag, yet it can be indispensable.

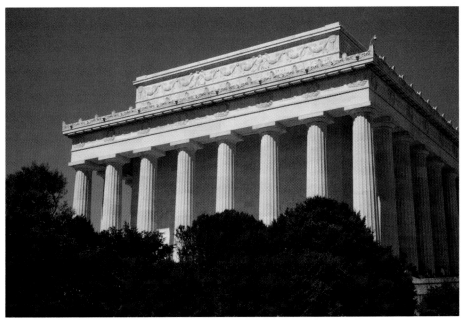

The exterior viewed from the south.

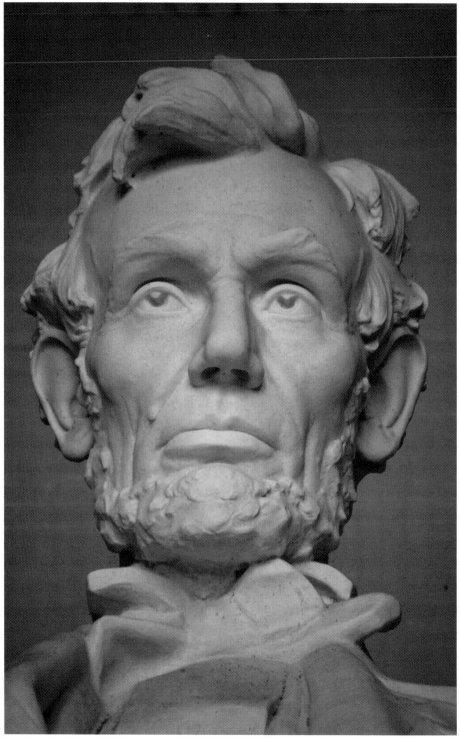

Focal length 300mm; ISO 100; aperture f/5.6; shutter speed 1/80; May 1:09 p.m.

The Shot

One of the most alluring aspects of this Memorial is the stark contrast between the palatial and mathematical outer perimeter of the structure and the meditative, almost religious quality to the interior. Even when bustling with crowds, the area immediately surrounding Lincoln's statue is hushed, and the reverence is palpable. Security is *very* strict and the no-tripod rule is strongly in effect, so I had to be mindful, even with my 300mm IS (image stabilization) lens to avoid camera shake. I kept my elbows close to my sides, held my breath when pressing the shutter, and took several frames of each view that I photographed. This ritual in itself makes shooting Lincoln's hands and visage a devotional experience! The light in the interior is soft and enveloping and spreads beautifully over the creamy stone. I also love the quick falloff and how Lincoln's head is rimmed in shadow.

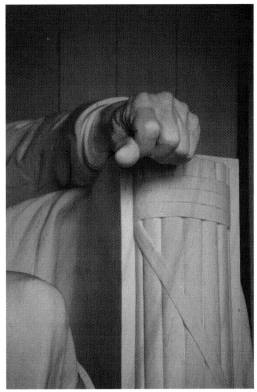

A meditative study of Lincoln's left hand.

Previously confined to only the professional market, IS, or *image stabilization*, is a technology that is now finding its way to the consumer. Image-stabilized cameras and lenses use very small gyroscopes to stabilize the equipment during exposure, resulting in sharper photographs with less motion blur from camera movement. This technology proves especially useful when shooting handheld with a long telephoto lens.

Getting There

The Lincoln Memorial is sited at the western end of the Mall. The closest Metro station is Foggy Bottom on the Orange and Blue Lines. Turn south out of the station and enjoy the half-mile walk down 23rd Street through the campus of George Washington University and past the State Department. After crossing Constitution Avenue, you will take to the paths that meander through the Mall. Find your way to the front of the Memorial, which faces toward the Washington Monument and the Capitol to the east. The Lincoln Memorial is close to the Korean and Vietnam War Memorials, which you should also visit.

When to shoot: morning, afternoon, evening

Washington National Cathedral

In this outer northwest section of Washington, DC lies the National Cathedral. The church is dedicated for national purposes and welcomes people of all faiths and perspectives. Though specifically Episcopal in denomination, the Cathedral has a broad mission acting as a national focal point, both religious and civic in nature. The calendar includes a full palette of services throughout the week and also organ recitals, art and architecture tours, lectures, and other educational opportunities. In addition, the Cathedral hosts events of major national significance, including Presidential Inaugural prayer services and funeral and memorial services for former Presidents.

Construction of the Cathedral was begun in 1907 and with the final completion in 1990 of the West Towers, it achieved the unusual distinction of being the most extended construction project in the history of Washington, DC. The American Gothic architectural style towers ornately above the surrounding suburban environment. More than 100 gargoyles, 200 stained glass windows, and nearly 300 angels adorn the structure, which presents multiple magnificent aspects.

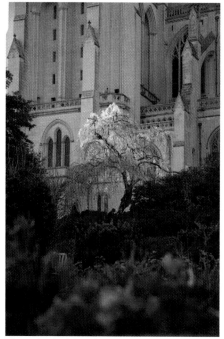

The cathedral shot from the herb garden.

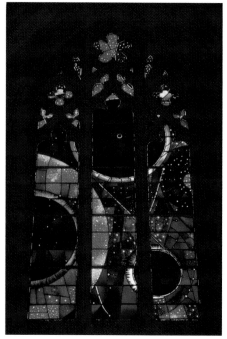

One of the many striking stained glass windows.

The Shot

Shooting a frontal portrait of the National Cathedral is a perfect opportunity to pull your wide-angle PC (perspective control) tilt-and-shift lens out of your gear bag. At the time of this writing, Canon has just come out with a 17mm PC beauty, but for this shot, the 24mm PC was sufficiently wide. There is quite a spacious park in front of the church, and by standing on the pathway that is at the farthest edge of the park, I was able to capture, even in landscape format, the top of the turrets and some passersby in front to show scale. I prefer a horizontal shot over a vertical one for this view, since the inclusion of air and scenery on either side does much to show the enormity of the cathedral. The jumble of leafless tree branches adds a haunting air, and the deep blue eastern sky of sundown is an appropriate and rich background.

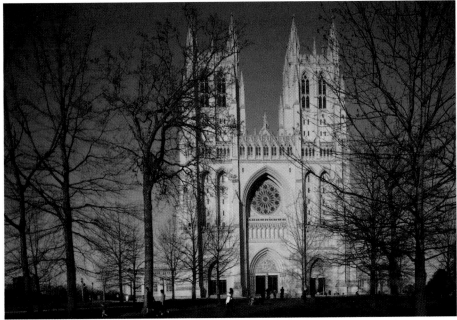

Focal length 24mm; ISO 100; aperture f/5.0; shutter speed 1/1250; April 6:02 p.m.

The Shot

This shot is a superb example of how at the same location on the same day and only an hour apart, one can create a photo that is of an utterly different mood and theme. This is the view of the Cathedral as you crest the hill of Woodley Road, walking west. It was a beautiful, clear spring day, and the sun was low in the sky late in the afternoon, which gave depth and zing to every surface. As I came upon this view, with its tapestry of various textures and colors, I knelt low to frame the picture with branches from above and daffodils below. The wooden bench lends the scene a meditative quality and a vestige of human activity. Possibly someone was recently sitting on the bench reading and was whisked away up the stairs by churchly responsibilities. You can almost hear the staccato footsteps on the stone or the gentle rifling of pages by a breeze.

Getting There

The National Cathedral is located in northwest DC, some four miles from the Capitol. It can be reached from Massachusetts Avenue—turn north onto Wisconsin Avenue where it crosses Massachusetts Avenue, and the Cathedral will be on your right after 200 yards. A visit to the cathedral can be combined with your visit to Embassy Row, the northern end of which is found back on Massachusetts Avenue.

Driving to the Cathedral is feasible—there are many side streets on which to park, but you will find much of the space taken by zoned residential parking. Use the Cathedral's underground parking garage, which is accessed from Wisconsin Avenue just south of Woodley Road. A fee ranging from $4 to $16 is charged depending on day of the week and length of stay. Sundays are free of charge!

Alternatively, take the Red Line Metro to Cleveland Park and approach the Cathedral from the east. It is an eight-block walk from Cleveland Park to the Cathedral. On leaving the station, take Porter Street west, then turn left on 34th Street and right on Woodley Road. The Cathedral will be on your left. However you travel to the Cathedral, you will find it well worth the exertion.

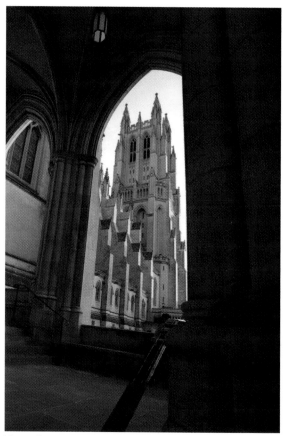

View of a turret through the arches of the Women's Transept.

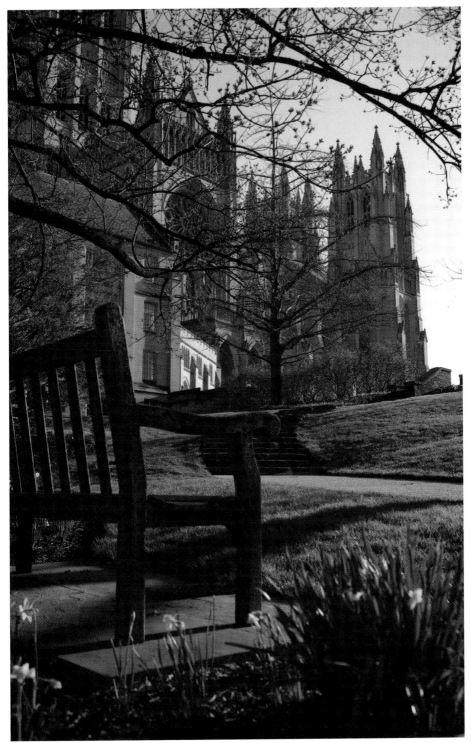

Focal length 35mm; ISO 100; aperture f/5.0; shutter speed 1/500; April 5:00 p.m.

When to shoot: morning, afternoon, evening

U.S. Navy Memorial

As one of the more recent additions to the DC ranks, the U.S. Navy Memorial is constructed as an open environment in which to honor the dedication to duty of America's sea services. Although such a memorial was envisioned in L'Enfant's original plans for the city, it was only late into the twentieth century that such plans came to fruition. During the 1980s and in conjunction with the overarching Pennsylvania Avenue redevelopment program, the Memorial site was chosen at Market Square facing the National Archives. Construction was completed by 1987 when the site was dedicated as a continuing appreciation of the work and sacrifice of the U.S. Navy's service personnel.

The design of the memorial is airy and spacious, featuring an open amphitheater. The floor of the space consists of a 100-foot-diameter map of the oceans of the world—"The Granite Sea." Twenty-eight bronze bas-relief panels surround the southern hemisphere, depicting historic events, activities, and personnel of the Navy. These are offset by the centerpiece of the memorial—a statue of the Lone Sailor, standing resolutely on watch and representing the self-reliance and strength of character of the members of the force. The Memorial site is completed by the Naval Heritage Center, which houses the service records of more than 230,000 Navy personnel.

One of the bronze relief sculptures that encircle the plaza.

The Memorial Plaza balances somber respect for the personnel of the Navy with an outdoor public space for the use of the people of DC.

The Shot

Understandably, when the subject of your photograph is a flag (or a sail or a windsock, for that matter!), it is by far best to photograph it on a dry, windy day, when the sky is an azure blue with white clouds. Spring in DC serves up many of these fresh, clear days, and the flag standards that flank the Naval Memorial, against this backdrop of a sky and clouds, make ideal maritime subjects.

I used a fast shutter speed to capture every whip and furl of the fabric, and the triangular shape of the flagpole makes for a solid and balanced composition. The low angle from which I photographed the flags lends a heroic aspect to an already patriotic scene, and the saturated and contrasty colors of these flags do more than just make pretty pictures—they are the five colors that can be readily distinguished at sea. Nautical flags (or international code flags) include 26 square flags that correspond to the letters of the alphabet. This photograph shows the message N-A-V-Y M-E-M-O-R-I-A-L topped by the red-and-white-striped Navy Jack flag.

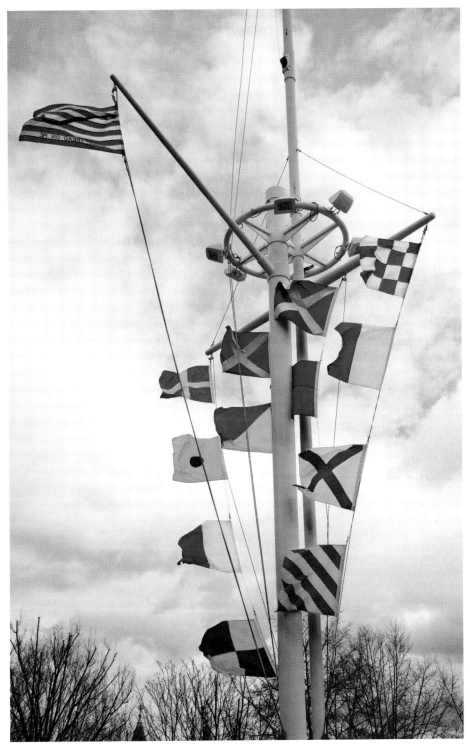

Focal length 50mm; ISO 100; aperture f/5.0; shutter speed 1/2500; April 2:45 p.m.

The Shot

One of the really eye-catching characteristics of
Washington, DC is the tableau of important and histor-
ical structures that exist as backdrops to quotidian cul-
tural and sporting events. A rock band playing outdoors
on a Saturday afternoon becomes a completely different
visual experience when you find yourself composing the
instruments and singers against the flags of the Navy
Memorial and the columns and pediment of the
National Archives building. This band, Gaslight Society,
would, I am sure, have preferred a larger and more
appreciative audience, but for me, from a photographic
standpoint, the empty chairs make a simpler and more
striking backdrop behind the lone guitar. I crouched
low, right behind the band, and pointed my camera a
little up to capture the Archives, and I was careful to
center the neck of the guitar between the flagpoles.

The bronze statue of the Lone
Sailor.

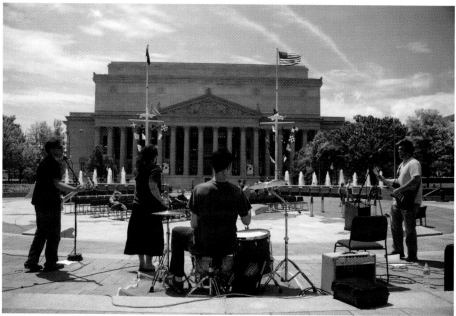

The band Gaslight Society playing at the Memorial.

Getting There

The U.S. Navy Memorial is tucked between some of the major government buildings just
to the north of the Mall. It is located between 7th and 9th Streets on Pennsylvania Avenue.
It is most readily accessed from the Archives Metro Station on either the Green or Yellow
Line. Exit the station and walk half a block north, turn left on Pennsylvania Avenue, and
the Memorial plaza will be on your right.

Focal length 47mm; ISO 100; aperture f/4.5; shutter speed 1/500; May 11:22 a.m.

When to shoot: afternoon

The Supreme Court

In balancing and blending the need of society for order with the rights of individuals, the framers of the United States Constitution created three independent and coequal branches of government. The Supreme Court of the United States holds the position of primacy in the legal branch. The ultimate responsibility of the Supreme Court is emblazoned on the pediment of the Court building: "EQUAL JUSTICE UNDER LAW." As the final arbiter of the law, the Court stands to ensure that all American people receive fair and equitable treatment under the Constitution.

Despite its major role in the nation's government, the Supreme Court spent its first 146 years without a home of its own. Only in 1935 was the current building completed and occupied—the Court had previously shared space, mostly in the Capitol building. The white marble, neoclassical design speaks to democratic ideals, and its peak is embellished with a sculpted figure of Liberty flanked by strong guardians and sage advisers.

More than 10,000 petitions annually are filed with the Court for consideration by the Chief Justice and the eight Associate Justices and their staff. About 100 of these cases reach the stage of oral argument before the Justices.

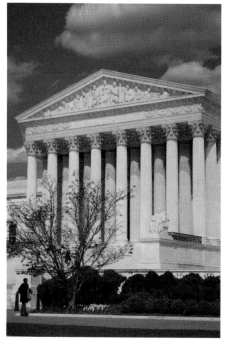

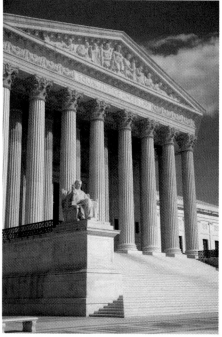

A view of the building from the southern approach.

Another composition of statue and building.

The Shot

This kind of shot takes a sense of purpose and a bit of contemplation in order to achieve your desired composition and arrangement of people as props. I can't tell you how many folks I saw walk quickly by the building, look to the right, and exclaim, "Oh, the Supreme Court building!" and snap off a rapid frame without even looking through the viewfinder. This is no way to capture a pleasing image—you have to take a breather to think a little bit about what you are actually putting into your frame.

To accentuate the enormity of the Supreme Court building, I purposefully included a few people at the front of the building. The edifice is *so* large that these folks almost look like toy figures, which is a nice effect. I stood on the sidewalk in front of the building, made sure that my horizon line was straight, and included a small bit of the left side to add depth and show the double columns. I waited patiently until the number of people on the stairs was just enough for effect but not too much for distraction, and then I pressed the shutter as the sun was emerging from a cloud to give me soft contrast that brings out all the carved relief.

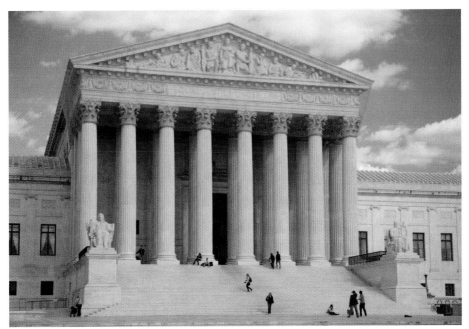

Focal length 65mm; ISO 100; aperture f/6.3; shutter speed 1/200; April 3:19 p.m.

The Shot

This statue, Contemplation of Justice, makes a wonderful companion shot to the previous image of the Supreme Court building. There is a great deal of classic sculptural interest in this building, and closer-up detail shots such as this really help to give your viewer a broad overview of what you were experiencing.

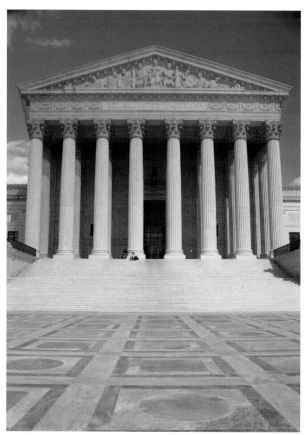

This shot looks very much like a traditional portrait view of the statue. The curtain of fluted columns works beautifully as a consistently patterned background, showing a wide range of grays in what most people would probably describe as all-white columns. The three-quarter view of the figure conveys the depth and shape of the sculpture and the black grillwork adds nice contrast to the soft gray and white tones of the marble.

Make sure in a shot such as this that you compose with a straight horizon line—this does much to further the impression here of solidity and gravitas.

Getting There

The Supreme Court of the United States is located at One First Street, NE. It faces the U.S. Capitol and is adjacent to the Library of Congress.

A full frontal view of the building with its large expanse of stone plaza.

The building can be reached using the Metro. The most convenient Metro stops are Capitol South on the Blue and Orange Lines (walk north for four blocks on First Street) and Union Station on the Red Line (a similar distance south on First Street).

Street parking near the Court is extremely limited.

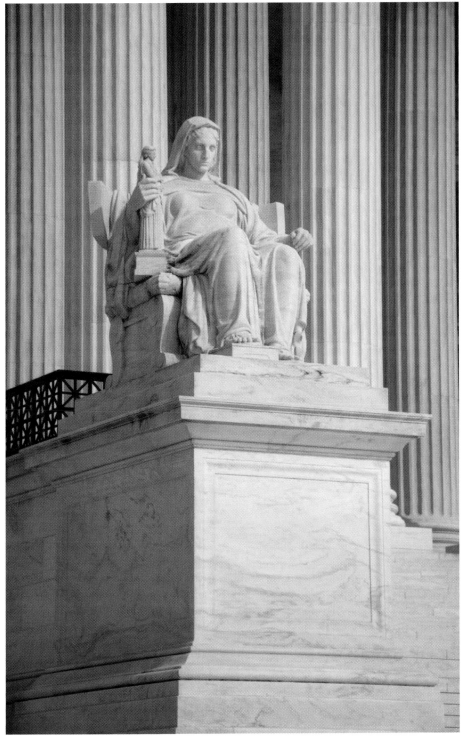

Focal length 135mm; ISO 100: aperture f/6.3, shutter speed 1/400; April 3:20 p.m.

When to shoot: afternoon

The White House

The White House is one of DC's oldest and most renowned buildings. A "palace" for the President was included in L'Enfant's original design for the city, and President Washington initiated construction in 1792. However, the first President to take up residence was President Adams in 1800. As the private home of Presidents, the building has been continually modified by the succession of residents, most notably by President Harry S. Truman, who completely renovated the interior. The building consists of 132 rooms on six levels. The external white-painted stone walls are the original structure. Landscaping of the 18 acres of grounds was largely carried out in the first 80 years, with completion of the Ellipse between the White House and the National Mall in 1880.

The White House is the official and personal residence of the President and First Family. It includes the offices of the President (Oval Office) and the Vice President and, in the West Wing, the offices of the staff of the Administration. This important building is highly visible through the daily press briefings outlining the Administration's policies and responses to the political environment.

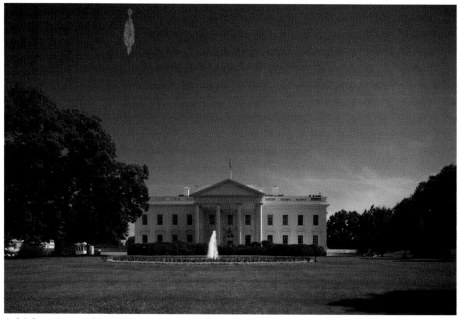

A full frontal shot of the White House on a clear, sunny day.

The Shot

The White House is the third most photographed attraction in the United States, second to the Statue of Liberty and the Empire State Building. This figure, combined with the fact that the building is surrounded 360 degrees by a tall wrought-iron fence and guarded by government snipers, means that the barriers to making a ground-breaking photo might seem insurmountable! This shot approaches the dilemma with a sense of humor. You need both a very wide-angled lens and a bright day, because good depth of focus and a short enough shutter speed to avoid any hand tremors are essential. Stick your left hand (or your right, if you shoot with your left hand) with the folded $20 bill through the wrought iron fence (I assure you that the security guards will not bat an eyelash) and match up the actual and rendered sides of the White House. This is not as easy a task as it sounds— the scale of the image is minute, and the slightest error in match will ruin the effect. Now, steadily put your camera right up to the fence, frame your photograph, and shoot away. Take several, if not many, exposures to ensure that you capture a steady hand and a good matchup. This shot looks best if the sun is falling on the near side of the bill, so the afternoon is a better time to set up.

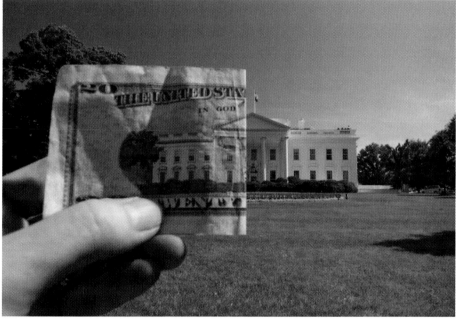

Focal length 24mm; ISO 100; aperture f/22; shutter speed 1/60; June 3:06 p.m.

The Shot

This shot is a rear view of the White House and also involved a bit of logistic derring-do. Don't fool yourself for a minute into thinking that the crowds at the rear side of the building will be more manageable than those at the front. They will not be! If you try to capture this shot from the sidewalk, you will not only be fighting for elbow room, but you will also have the surrounding iron fence in your line of sight. The only way to get this image is to be about four feet taller than all the other tourists (and to have a telephoto lens)—a feat easily accomplished by taking a quick jump up on the Zero Milestone that sits on the north edge of the Ellipse in President's Park. Adjust your camera settings while you are standing on the sidewalk, because you don't want to waste any time when you are standing atop the marker. A partner for this exercise is helpful, both for reconnaissance and for a helping hand with balance and clambering. Be brave, jump up, frame your shot, shoot away, and you will be back on the sidewalk before anyone has time to make a fuss.

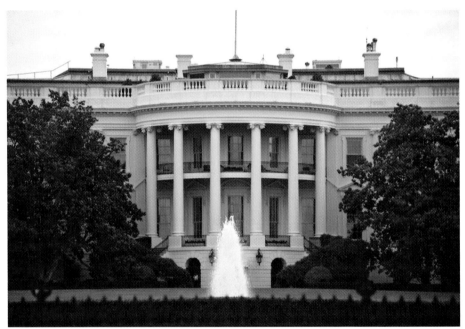

Focal length 230mm, ISO 100; aperture f/5.6; shutter speed 1/160; May 2:42 p.m.

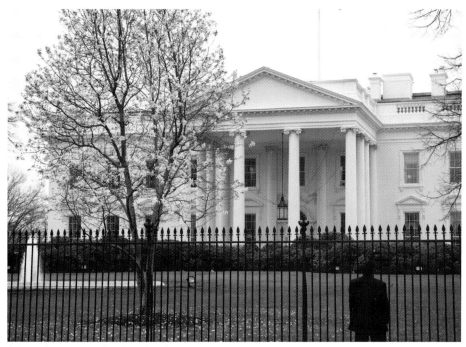

A lone viewer on a cloudy spring day.

Getting There

The formal and well-known address of the White House is 1600 Pennsylvania Avenue, but the street layout around the White House is somewhat chopped up by the park grounds surrounding the residence. The front entrance is best found by positioning yourself on G Street between 15th and 17th Streets, and the White House will be to the south. The closest Metro stations are Farragut West and McPherson, both on the Orange and Blue Lines.

The rear of the building can be reached from the front by following either East or West Executive Drive around the White House grounds. Alternatively, the rear can be approached from the National Mall by walking through the Ellipse, which is located to the north of the Washington Monument.

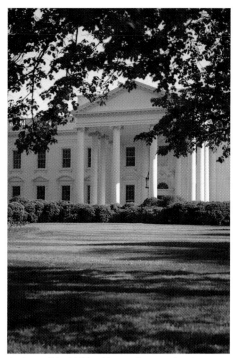

A view of the White House from under the trees.

When to shoot: morning, afternoon

Union Station

A visitor to Union Station today will experience a well-preserved and thriving establishment. The building features lofty vaulted ceilings, and the marble stonework vies for attention with any of the capital's main structures. However, behind this dignified façade lies a more turbulent past.

Completed in 1908, the building was constructed as a gateway to the capital and indeed was one of the earliest buildings designed to present a stately visage for the city. Its splendor was also reflective of the pre-eminence of rail travel at that time. When constructed for the cost of $125 million, it represented the largest building in terms of covered ground area in the United States.

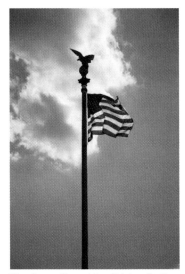

The flag staff outside of Union Station.

Through several decades the station and enclosed shops and offices thrived, but with the decline in rail travel, driven by competition from the airlines, usage of Union Station fell away. The role of the station was revived by inclusion of a National Visitor Center in 1976, but this was poorly attended and closed in 1978. In 1981, after rain caused part of the roof to collapse, the poorly maintained building was sealed. After much debate around the role of the station, Congress took action, and a $160 million, three-year renovation plan was instituted. In 1988, the building was reopened in the magnificent state you see today. Exhibitions, cultural events, shops, and restaurants combine with train services to attract more than 30 million visitors every year. Union Station is back in the game!

The Shot

Union Station is one of the places in Washington, DC where I feel that including people in your photograph is an aid rather than a hindrance. The grand structure of the station functions as a solid and attractive backdrop juxtaposed against the hustle and bustle of Washington, DC commuters at rush hour. Travelers seem focused on their destination and tend to completely disregard the camera, conveying a sense of urban anonymity.

For this shot, I centered myself under the arches, outside and just to the right of the main entrance. You have to plant yourself relatively securely, since in their goal-oriented state, the crowds can get a little pushy. I set my camera on shutter priority mode and chose a shutter speed of 1/8 second so I could get a little bit of motion blur on the folks that were moving rapidly and close to me. The light stones reflect quite a great deal of light, and I was able to shoot with a small aperture, maintaining focus on both the foreground and background elements of the picture. A tunnel effect is created from the use of the wide angle lens, and the long passageway of arches diminishes rapidly into a forced perspective, where the people in the rear of the photo mill about in the human rat race!

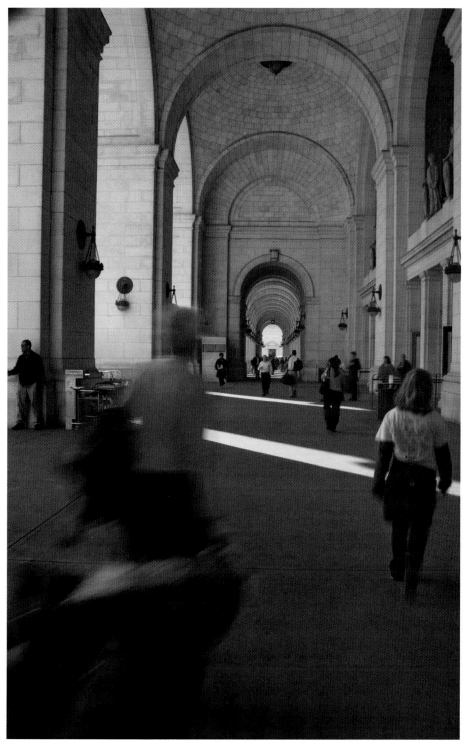

Focal length 28mm; ISO 100; aperture f/18; shutter speed 1/8 second; April 3:38 p.m.

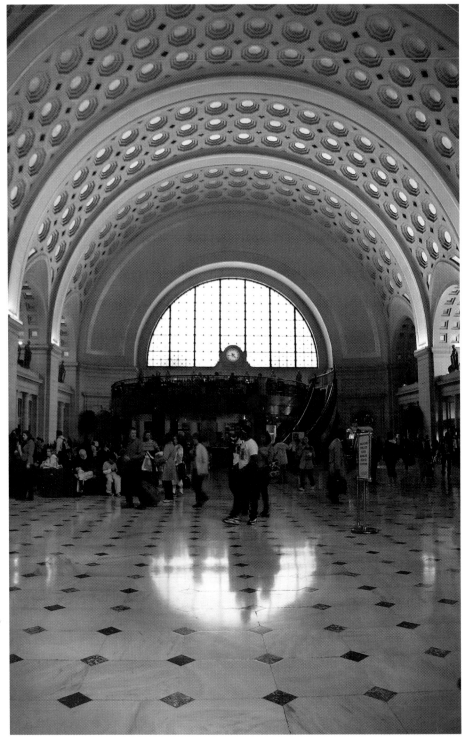

Focal length 28mm; ISO 200; aperture f/5.0; shutter 1/25 second; April 3:49 p.m.

The Shot

Once again, the imposing architecture—this time of the station's interior—makes an elegant background for the rail-weary travelers. The Rule of Thirds helps to make the composition of this picture solid and pleasing to the eye. This rule is a historically proven and traditional method of composition to ensure well laid out paintings, photographs—any art form, for that matter. The enormous vaulted arch of the ceiling and paned glass window falls into the top two-thirds of the frame, while the bottom third comprises the mosaic marble floor, with a horizontal line of people dividing the two elements.

THE RULE OF THIRDS

The Rule of Thirds in photography is a basic rule of composition and refers to the division of your frame into thirds both horizontally and vertically. By placing the focal point(s) of your image either one third across or one third up or down into the photograph, you give the photograph movement and lead the eye across and over the frame.

Be sure to stand in the center between two columns when composing your picture and use a wide angle to be able to capture both the decorative floor and the beautiful golden ceiling. Since the inside of the station is somewhat dark, I increased my ISO to 200 in order to gain a stop of light, but I still had to be careful at 1/25 second shutter speed to hold my breath and not shake the camera during exposure. I love the way the diffused light from the large window illuminates the surface of the ceiling and makes each recess seem to have an inner golden glow of its own. The reflection of the curved window in the shiny marble floor breaks what could be a dull expanse and adds compositional interest.

A detail of the arched golden ceiling.

Getting There

How do you get to Union Station? Take a train, of course! Union Station is the arrival point for many visitors to Washington, DC, as it is served by Amtrak running up and down the East Coast and by local train services. If you are already in the city, then the Metro Red Line will bring you to the station. Union Station is located just to the north of the Capitol building, at the intersection of Delaware and Massachusetts Avenues. By the way, the station does feature a very reasonably priced food court with a wide variety of choices. This is located on the lower level below the ticket offices. Busy but convenient!

A horizontal composition of the ceiling in the main lobby.

When to shoot: morning, afternoon, night

Vietnam Veterans Memorial

The concept of the memorial was developed by a group of Vietnam veterans who wanted to acknowledge and recognize the service and sacrifice of all who had served in Vietnam. Construction of the memorial was funded from a variety of private sources after President Carter gave approval in 1980 for its installation.

The iconic memorial consists of two walls of black, polished granite, each 250 feet in length, angled obliquely to each other and set into the gentle slope. On each wall are painstakingly inscribed the names of the more than 58,000 dead and missing U.S. service members from the conflict.

FLASHING AT NIGHT

Using an on-camera flash at night can make for some dramatic photographs, and with the current advanced technology of equipment, it is nearly impossible to make an exposure mistake. The model I work with is the Canon 580 EXII, and its ETTL (Electronic through the Lens) metering is a wonder to experience. I work with my camera on both Av (aperture priority) and Tv (shutter priority) modes, depending on how much ambient light is available.

At this event, a candlelight vigil, I chose Av mode since it was early evening and the night sky was still somewhat illuminated. I also knew that in the photo of the motorcycles, the fancy lights on the bikes would create exciting photo opportunities. I set my aperture rather wide open, since the available light was low and I did not want the shutter to have to open for too long. The flash captured the foreground scene, and the camera set the shutter speed to capture the available light in the night sky, the glowing "candles" (night glow sticks in this photo), and the colored lights on the bikes. There could be camera shake, but I was aware of this and liked it very much, because it adds a dynamic and painterly quality to the photo. The light trails on the wheels of the motorcycle are particularly striking and could only be captured when the shutter was left open for a second or two.

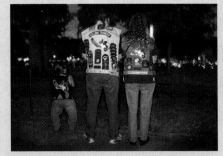

A shutter speed of 3 seconds.

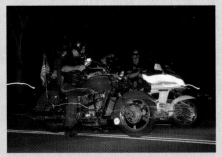

A shutter speed of 1 second.

One hundred fifty feet to the southwest of the apex of the wall stands the statue of Three Servicemen caught in action pose, apparently warily exiting a wooded setting. The bronze, larger-than-life statue was erected in 1984. The Memorial is completed with an integral, dedicated flag staff, which is grouped with the statue and provides an imposing entrance to the Memorial.

The Memorial is visited by millions each year, not least by many somber surviving Vietnam veterans.

The Shot

This memorial offers up photographic concerns unlike those of any other piece of architecture, memorial, or statue that you will find in Washington, DC. In addition to its prodigious length, nearly impossible to capture in one frame, it is one of the few places where a human leave-behind is a boon rather than a disadvantage. The seemingly endless list of soldiers, combined with a rose left by one who came to honor and mourn, has substantially more emotional impact than the dark, cold granite on its own. I photographed the Memorial at an evening commemoration, and my electronic flash was indispensable. In this shot with the rose, both the fall off of the light from the flash and the use of a wide angled lens serve to exaggerate the sense of the infinite length of the list of soldiers' names. I did not use a tripod here, but since there was no ambient light, my flash was the only light source , and I was able to keep the letters crisp and sharp with no evidence of camera movement.

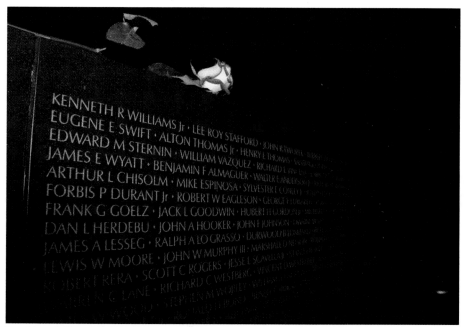

Focal length 28mm; ISO 100; aperture f/8.0; shutter speed 1 second; May 8:30 p.m.

The Shot

This photograph of the flag standards at the Memorial was taken facing southwest, into the sun, which, because it was early April, was still somewhat low in the sky. Normally, this would be a lighting situation you would want to avoid, but I capitalized on the effect of shooting into the sun by turning the flare into a dramatic element of the photo.

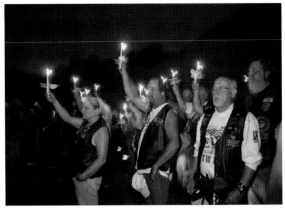

A crowd commemorating at a candlelight vigil.

I took quite a few exposures here, because it was a brisk and windy day, and the flags were moving turbulently. My exposure compensation was set at –1/3 to underexpose the shot 1/3 of a stop, keeping the rich blue of the sky. I wanted the light of the sun to be centered half behind the flag, so that the red, white, and blue fabric would be strongly backlit, yet still create a halo of flare above the flag. I positioned the flagpole on the left side of the frame so that when the flags were fully windblown, they would nicely fill the space of empty blue sky between the branches of the trees.

With patience (again, I must stress that patience is a *huge* factor in making good photographs) and multiple clicks of the shutter, I got exactly the shot I was looking for when a strong gust of wind came. The flags are extended with beautiful folds and curves, the acronyms POW-MIA are legible, and the flare created by looking directly into the sun frames the flags and creates a heroic and patriotic effect.

A visitor to the Memorial caught in an emotional moment.

Getting There

The Memorial is located at the western end of the National Mall, close to the Lincoln Memorial in West Potomac Park. The Memorial is just to the north of the end of the Reflecting Pool. It may take a moment to locate the Wall, since it is partially set below ground level and can be overlooked. As an alternative approach, the Wall is located directly across Constitution Avenue from the National Academy of Sciences, 100 yards into the Park.

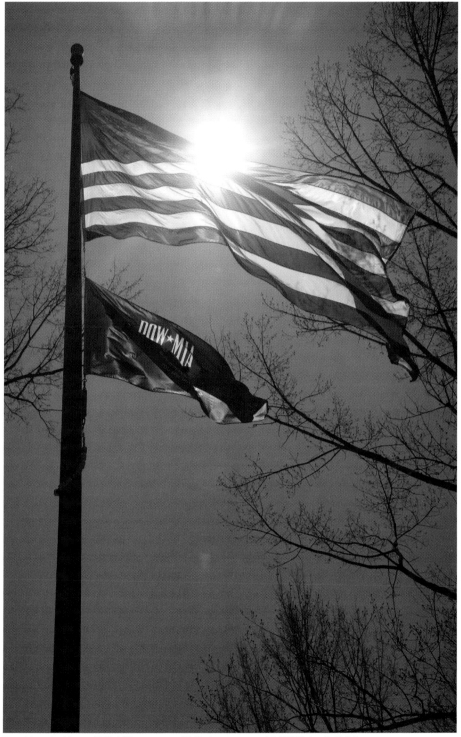

Focal length 44mm; ISO 100; aperture f/5.0; shutter speed 1/4000; April 12:28 p.m.

When to shoot: evening, night

The Washington Monument

The capital city of the United States of America proudly bears the name of the leader of the revolution that gave independence to the country and who became its first President. At the center of the city, a monument to the man and his leadership stands majestically, towering above the surrounding structures. Views of the monument can be found from many vantage points throughout the city—indeed, few cities in the world can boast such a visible icon.

Yet for some time after construction began, the fate of the monument was uncertain. In 1854, the initiators of the original construction, the Washington National Monument Society, ran short of funds.

The Monument framed by magnolias.

Political wrangling intervened, and construction activities faltered. For 25 years the monument sat with only the lower one-third of the obelisk built, until the U.S. government stepped in, finally completing the structure in 1884. A legacy of this delay can be seen in the manner in which the upper and lower portions, which were built using stone from different quarries, have weathered differently, giving a slight mismatch of coloration.

When completed, the monument stood as the world's tallest structure, a title held until 1889, when the Eiffel Tower in Paris was finished. At 555½ feet, it remains the tallest stone structure in the world. Visitors to the Monument can take an elevator to the observation level and enjoy views of up to 30 miles of the surrounding countryside. It is often

stated that no building in the District may be constructed that is taller than the Monument. In reality, construction height is limited by the Height of Buildings Act of 1910, which restricts construction to the equivalent of the width of the adjacent street plus 20 feet. Indirectly, this leaves the monument (and incidentally, the Capitol building as well) holding primacy over the majority of surrounding structures.

The Reflecting Pool situated between the Monument and the Lincoln Memorial allows a double view of the tribute to Washington's great achievements.

The Shot

Unlike the White House and other security-shrouded attractions, a creative and unusual shot of the Washington Monument is altogether possible. As you traipse around the Mall, keep your eyes and mind open, and you will invariably discover your own photographic angles and compositions, especially with all the trees, flowers, and decorations that you can include in your shot, both behind and in front of your placement of the Monument.

The plethora of American flags on display over Memorial Day weekend offered me the perfect chance to capture a patriotic and hopefully somewhat original image! The large flag was stretched in a frame at the top of a small hillock between the Reflecting Pool and the monument itself. I nearly laid down in the grass, so that I was actually looking up at my subjects, since I wanted to add a heroic quality to this image. The overcast sky acted as a light box for the flag and backlit it beautifully, making the colors vivid and bright. Following again the age-old Rule of Thirds, I allotted two-thirds of the composition to the flag and one-third to the Washington Monument. It is interesting how the vertical lines of the metal frame actually draw the divisions for you. Keep the monument vertical in all your photographs—it does not do well as a Tower of Pisa imitator.

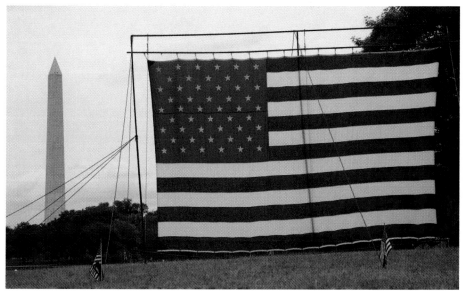

Focal length 80mm; ISO 100; aperture f/9.0; shutter speed 1/250; May 5:50 p.m.

The Shot

Pierre L'Enfant's classical layout of the Mall is perfectly referred to in this shot of the Washington Monument and the aptly named Reflecting Pool. If you squint your eyes, you could fool yourself into thinking that you are looking at a painting of the French Academy—balanced and controlled. I knelt very low on the edge of the Pool, just east of the Lincoln Memorial, and placed the monument in the upper center of my frame. Using the grid in the viewing screen of my camera, I was again very careful to keep the obelisk perfectly vertical, and thus the horizon line perpendicular to the edges of my frame.

A miscalculation here could ruin a lovely composition. By shooting from a low angle, I was able to keep the top of the monument's reflection in the frame. This combined with the reflection of the trees and people on the walkway is what gives the picture its tight composition. Patience, that much sought-after virtue that often eludes me, allowed me to wait for the moment when the mallard was perfectly situated in the left third of the frame.

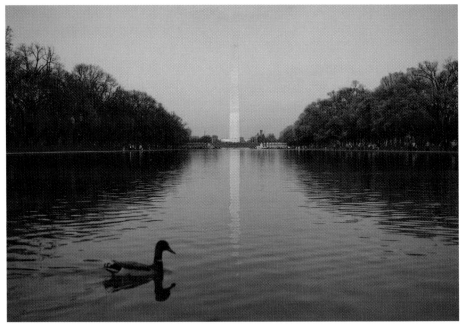

Focal length 55mm; ISO 100; aperture f/5.6; shutter speed 1/500; April 6:12 p.m.

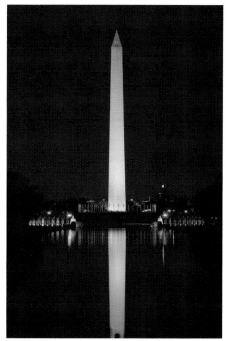

The Monument composed with trees in early spring.

The Monument at night.

Getting There

If you need information on how to find the Washington Monument in DC, you haven't been paying attention. It's that big needle thing in the sky that is ever-present in countless vistas of the city. (If you are still at a loss, try the middle of the National Mall.)

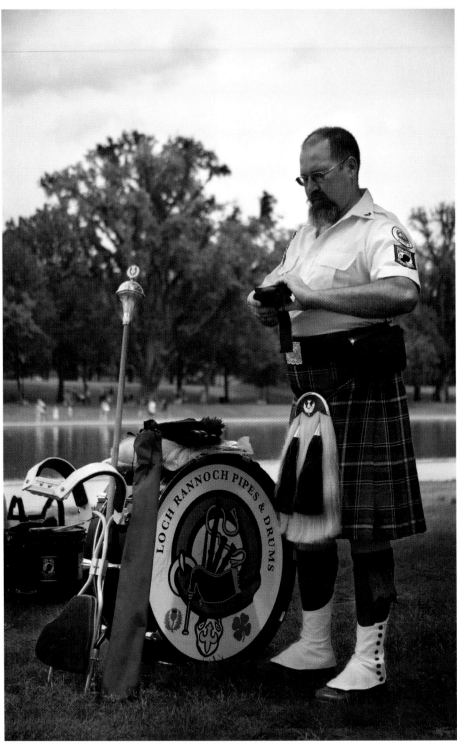
Irish drummer preparing for a performance on the National Mall.

CHAPTER 2
City Life

Washington, DC is a dynamic metropolitan region of more than five million residents. Add to that the estimated 15 million visitors annually, and you will recognize how it is that *people* breathe life into this elegant city. If the essence of a city can be defined by its people, then Washington, DC represents a complex fragrance with multiple notes and undertones.

The international and sophisticated temperament of the people of the city is vividly reflected in its wide array of restaurant cuisines, customs of dress, food markets, cultural venues, and the languages heard every day on the streets and sidewalks.

Adding to the distinctiveness of DC is its role as the nation's capital. Government and patriotism overlay the city. Nearly every vista will include the waving Stars and Stripes, a serviceman, or the purposeful stride of a suited policymaker. This chapter offers the insider information required to observe and capture images of the people who constitute this multifaceted metropolis and the photographic still lifes that they continually create.

Shooting Like a Pro

Travel photos that focus on indigenous people juxtaposed with details from the world they inhabit are, in my mind, the most successful and will elicit oohs and aahs from family and friends. Try to get in the habit of being aware of all of your senses when you are photographing. Think about blaring car horns, the drum beat of music, or pungent homemade cheese and fresh-from-the-vine tomatoes, and put the appreciation of these experiences into your photographs. Photography is not only about seeing, but it is about storytelling and evoking an emotional response from your viewer. An attention to sensory detail will become, with practice, a palpable force in your pictures. Exercise your personal aesthetic, and your photographs will stand out from the crowd's.

The Gear

My most oft-used lens when I am trying to capture the essence of a place is a 28mm–135mm zoom lens. A zoom lens like this obviously allows you the convenience of many focal lengths within one lens. You are able to shoot in a variety of situations without having to take the time to switch lenses, at the risk of losing a fleeting or time-sensitive photo opportunity. The telephoto end of the focal length allows you to really home in on what you are photographing and makes it a little simpler to capture intimate details. An aspect of the longer focal lengths that I am particularly drawn to when shooting these close details is the shallow depth of field that occurs if you shoot with a wide aperture. The backgrounds become beautifully soft and out of focus, which makes them less distracting, letting the eye really focus on the chosen subject matter. The 70mm–85mm range is perfect for portraits—you can be close enough to your subject to still communicate easily, but the subject will be separated from the background.

A view of the tranquil canal.

Youngsters fishing at a park outside Washington, DC.

The wide angle end of the zoom lens is perfect for including more of the surrounding environment in your photograph. These wider point-of-view shots, when combined with your detail photographs in a display of "city life" mementos, will tell a well-rounded and all-encompassing story of your vacation experience.

The Plan

More so than many types of photography, shooting people and their surroundings requires that you, to some extent, be a little adventurous and polish your interpersonal skills. You don't want to be solely a voyeur—making a positive connection with your subjects is the first step in taking good people pictures. To that end, do your best before you set out to prepare for that good impression. Make sure you are not wearing that old and tattered college T-shirt plastered with the offensive slogan you were so fond of. Dress in a relatively neutral and clean manner, and it will be your subjects who are at center stage, and not you.

A close-up of fresh tea and lemonade.

Be open, honest, and friendly. I am constantly amazed at how many doors one can open if you assess the situation and your potential model's personality quickly and sensitively, without being smarmy or overly intrusive. It does take a little practice, but you will find that if you adopt a forthright and slightly curious manner when asking to take someone's photograph, you will hear yes a lot more than no. You might let them know why it is that they caught your eye and perhaps communicate that you are an artist who enjoys photographing people. Most folks are actually flattered when asked to be photographed, and I guarantee that you will make some friends in the process. If your subject does decline your request for a photo, respect his or her wishes, be deferential, and move on to the next opportunity.

The most important quality to possess in this situation, however, is a razor-sharp awareness. Expressions, gestures, and situations can be incredibly fleeting, and you don't want to miss a trick. When you come upon a place that you sense has some photo opportunities awaiting you, put your sight and hearing into overdrive, and if there are people and moving things involved, once you have garnered permission, start shooting as soon as you can. The most photogenic mannerisms are often the earliest and least self-conscious on the part of the model. If you are shooting still lifes or details of a scene, be very inquisitive, explore many angles and views, and give yourself time to make an appealing composition. An unexpected point of view can often be the most visually arresting for a photograph.

Make sure all your gear is in working order (cards loaded, batteries charged, filters on) and that your settings are correct before you reach your location and start to shoot. There is nothing as maddening as finding yourself in the heat of the moment with a dead battery or a full memory card. Your model will also appreciate your preparedness.

When to shoot: morning, evening

Adams Morgan

This vibrant district in northwest DC has a character that derives from a fluid diversity of influences. For many years, the area and its typical row house architecture offered a first home to many Central American immigrants, followed in later years by Africans, Asians, and arrivals from the Caribbean. More recently, the district has seen significant gentrification, and price escalation has displaced many of the earlier residents. What persists, however, is an area still known as the heart of the Latino community but famous for its nightlife of bars and restaurants, all with a little boisterousness thrown in!

The district took on its current shape in the 1950s, when a redistricting program combined portions of surrounding areas to create the current community. The diversity of the district is reflected in its name, which derives from that same time, when the previously all-white John Quincy Adams and the all-black Thomas P. Morgan elementary schools were desegregated and gave their names to the current district.

The neighborhood reserves the second Sunday in September for the Adams Morgan Day Festival and presents a full-on celebration of its diverse and lively culture. However, for the remainder of the year, the thriving five-square-block area offers more than a dozen different ethnic cuisines and intriguing international shopping. At night, many of the bars and clubs feature live music—a magnet for the young professionals of DC.

The Shot

In the evening and into the wee hours of the morning, the spotlights and fluorescent signs of the restaurants and clubs in Adams Morgan make a flamboyant and colorful display. The façade of this Falafel Shop was an easy target, as the vivid crimson and bright white contrast beautifully with the emerald green leaves of the gingko tree in the foreground and make a strong, graphic photograph. The hustle and bustle of tourists and club-goers perfectly disguised my camera, tripod, and me, and aside from the occasional catcall of "nice lens," we were relatively ignored. I used my tripod and a cable release to prevent camera shake at this longer exposure, and my on-camera flash was set to expose the foreground leaves at a stop under my overall exposure. Do remember to keep an eye out for your equipment during nighttime shoots, however, as not all crowds can be so benevolent.

FLASH EXPOSURE

The reliability and adjustability of today's on-camera flash units (also called *speedlights* or *hot-shoe-mount* flashes) has improved drastically over recent years. Most models have settings for flash exposure compensation, which allows you to manually adjust the output of the flash without having to touch the camera's aperture or shutter speed. Most units are adjustable in one-third stop increments, giving you the freedom either to match your flash output to the ambient light of the scene or to set it anywhere from 1/3 to 3 stops under the ambient exposure. Your setting choice depends on the amount of fill light that you desire or how bright you want your subject to be in relation to the background.

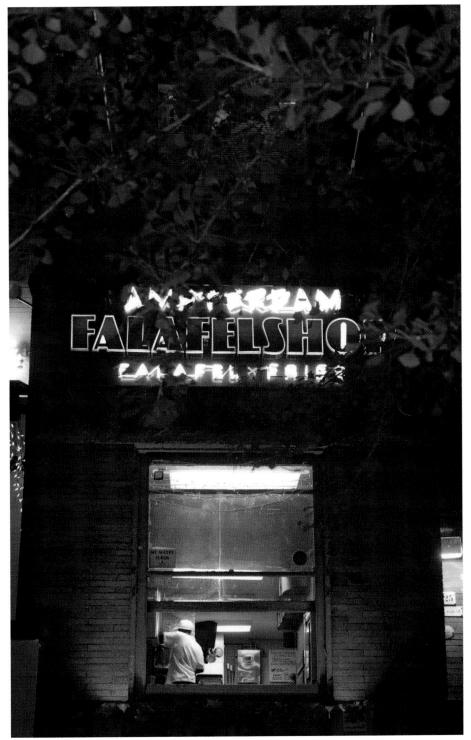

Focal length 53mm; ISO 100; aperture f/5.6; shutter speed 4/10 second; April 8:29 p.m.

The Shot

People are not always your only live and willing subjects for street portraits. This furry fellow is a regular and alert sentry at the window of this Adams Morgan apartment, and his gaze is deeper and more piercing than that of many humans I have photographed!

With animal portraits, it is crucial to either grab the sitter's attention and keep it focused on the camera or capture the animal in an anthropomorphic gesture as it wiggles and squirms. It is the very humanness of this dog's stare, body position, and task that make this photograph interesting. My tactic for capturing a charismatic expression from this mastiff was to watch and wait—he was very busy at his post, and he constantly looked and barked this way and that. My patience paid off, however, and after a few minutes he turned and gave me his best guardian glare.

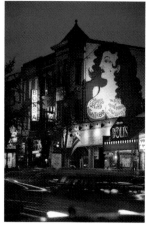
The Adams Morgan main drag at early evening.

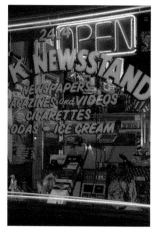
The window of an international newsstand.

A colorfully lit window at an empanada café.

Getting There

Parking is limited in the Adams Morgan district, and the Metro offers the best approach. The district is equidistant from four Metro stations. An approximately half-mile walk from the Red Line stations Woodley Park and Dupont Circle or the Green Line stations U Street/Cardozo and Columbia Heights will find you in the Adams Morgan section of town:

✣ Woodley Park Station: Walk 150 yards south on Connecticut Avenue and turn left on Calvert Street. When you reach Columbia Road, the Adams Morgan area will be ahead of you.

✣ Dupont Circle Station: Go north on Connecticut Avenue, and after 500 yards, turn right on Florida Avenue. Turn left onto 18th Street to enter the district.

✣ U Street/Cardozo Station: Follow U Street west for 800 yards and turn right onto 18th Street.

✣ Columbia Heights Station: Follow Columbia Road west/southwest for 800 yards and turn left onto 18th Street.

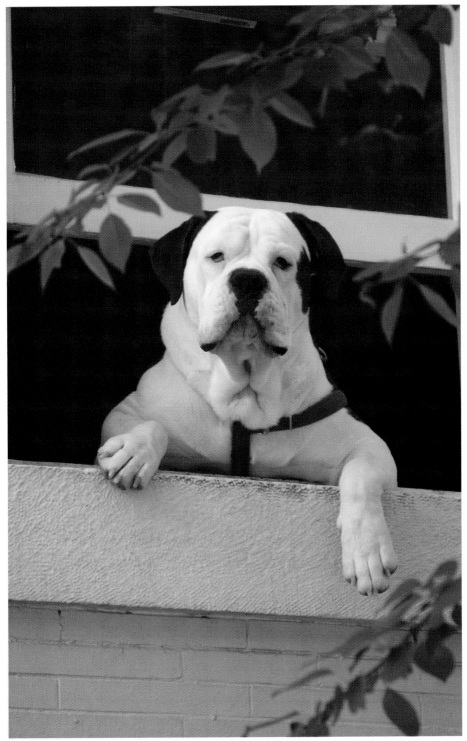

Focal length 105mm; ISO 100; aperture f/5.6; shutter speed 1/60; April 7:56 a.m.

 When to shoot: morning, afternoon

Batala Women's Percussion Group

A regular Saturday morning, a casual bike ride into the center of DC. Even on the weekend, the city bustles. It seems to own a powerful heartbeat. Wait a minute—it *does* have a heartbeat! Follow the pulsing sounds of the drumming rhythm to its source, and you'll discover Batala!

In Farragut Square, on Saturdays between 10 and 1 o'clock, you will find Batala, the all-women, Afro-Brazilian percussion band, perfecting their driving and enthralling rhythms in readiness for another of their acclaimed public performances. Batala Washington is the newest branch of a global family of samba-reggae percussion bands with sister bands in France, Belgium, England, and of course Brazil, from where the musical style originates. The band entertains at festivals, parades, and sports events throughout the city.

You will find that the visual images presented by this group of strong and independent women match their music in its power and captivating attraction.

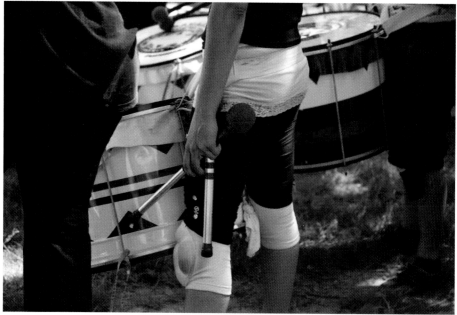

A moment of rare quietude.

 Want more exciting images? Exercise your design sense and play with unusual combinations of color and contrast.

The Shot

The heat is most definitely turned up when Batala performs at a public event, and the energy is intoxicating. As usual, at this shooting session, I heard Batala long before I saw them. In fact, the marching band I was actually taking photos of were so hypnotized by the drums and swaying bodies that they discarded their own sound and began to dance to the beat of Batala! To catch the women with a relatively crowd-free background (which is difficult—once they start walloping those drums, the hordes magically appear), I went to the staging area of this parade at Madison Drive NW between 4th and 7th Streets, about two hours before starting time. This gives you plenty of room to roam and find the best vantage point for a frame that is dynamically filled with their moving bodies. Listen to the beat, make sure your shutter speed is relatively short to capture the movement, and for the most energetic shot, press the shutter on the upswing of their sticks.

Show your appreciation.

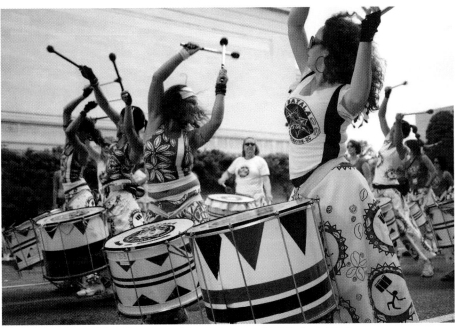

Focal length 47mm; ISO 100; aperture f/4.5; shutter speed 1/200; April 10:27 a.m.

The Shot

All that drumming, and these ladies get tired! A photo collection comprising only energetic shots would be powerful, but nowhere near as compelling as a series of pictures that tell the whole story of what actually goes into these performances and what happens behind the scenes. Keep your eyes open for details that give background information, and your viewers will be more captivated. I caught this shot of a dozing drummer during a break in a practice session one morning. She was so tuckered out that I had gobs of time to move around and compose her just as I wanted amongst the resting before she awoke, at which point we flashed big smiles at each other and had a good laugh.

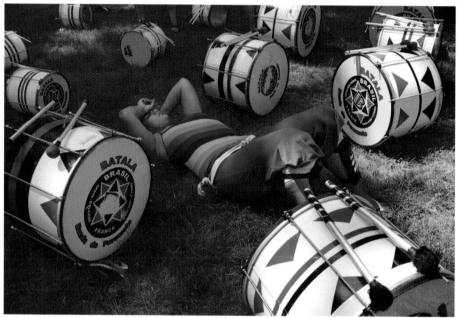

Focal length 33mm; ISO 100; aperture f/5.6; shutter speed 1/200; May 10:05 a.m.

Getting There

Farragut Square is located at the intersection of K and 17th Streets. The Square is served by its own Metro station—Farragut North on the Red Line.

The Batala website, www.batalawashington.com, has a schedule of practice sessions and events to allow you to use more than just your own sense of hearing to find them.

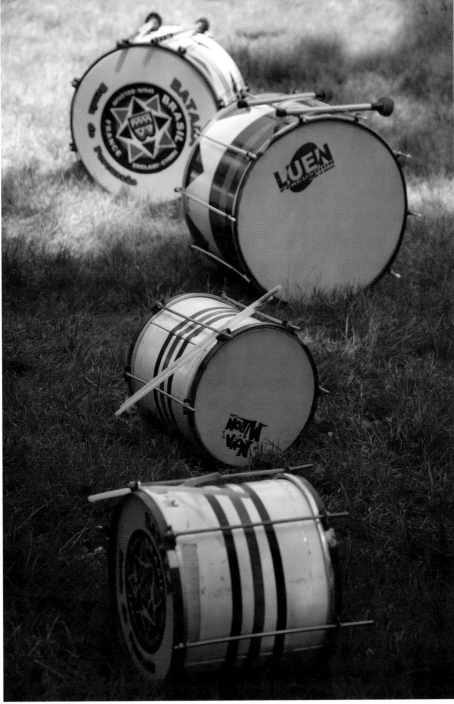

Tools of the trade.

When to shoot: morning, afternoon

Chinatown

The Chinatown area in DC, situated to the east of downtown, may be considered more of a three-course lunchtime special than a ten-course banquet. In the 1930s, the original Chinatown section of the city, to the north of the Mall, was replaced by the Federal Triangle complex, and residents of Chinese extraction congregated in the current area, setting up homes and thriving businesses, covering a dozen city blocks. Since its heyday, under pressure from urban flight, gentrification, and development of the valuable local real estate—for example, by the Verizon Center sports and entertainment complex—the community has shrunk in its scale, but what remains shows the distinct character of Chinese-American industry and culture.

Chinese characters grace a familiar storefront.

Taking pride of place, and powerful in its imagery, is the 60-foot Friendship Archway, a striking span reaching across H Street and signifying ties between DC and its sister city, Beijing. The dozen or so photogenic Chinese restaurants drive this sense of Chinese flavor as you pass through the streets. It is customary for much of the storefront signage to use both English and Chinese characters, and even on the multiple instances of the stores of national retail chains, you will find Chinese versions of familiar logos. On the appropriate date in late January or early February, the area hosts the Chinese New Year Parade. Chinatown bursts into life through a kaleidoscopic concoction of dragons and firecrackers, marchers and bands.

The Shot

This chef and her "office" are on display to all who stroll along 5th Street NW in Chinatown. Day in and day out, she plies the soft dough into swirled and tasty little noodle pillows, and it is a sensory delight to watch her wield her rolling pin amidst clouds of flour. One of the oddest impressions is the contrast of the boisterous and chaotic sidewalk to her absolutely silent machinations behind the thick glass window. She is no stranger, I am sure, to the lens, and she generously offers a knowing and omniscient mien. I found her to be an obliging model as I photographed her from many angles, and she was always there, working with the camera. My polarizing filter was indispensable in this situation, as reflections of the street in the window would have been extremely distracting without it.

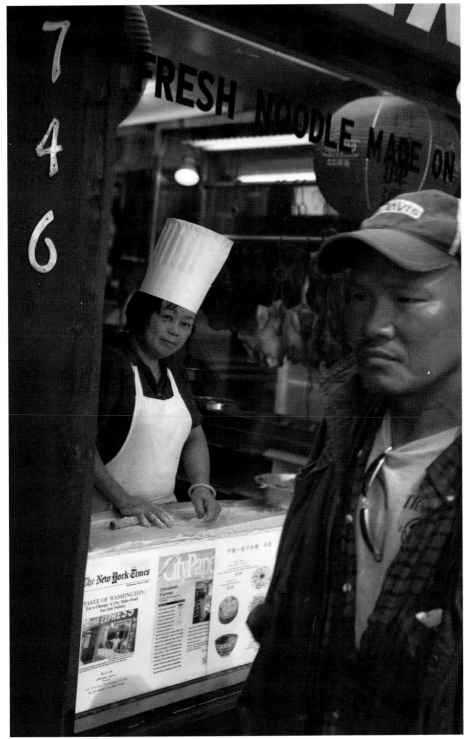

Focal length 50mm; ISO 100; aperture f/4.5; shutter speed 1/100; May 2:57 p.m.

The Shot

This beautiful Chinese-influenced building façade can be found on H Street NW, the main drag of Chinatown, near the corner of 6th Street NW. The proportional arrangement of the windows and the colorful combination of red, green, and cream literally beg to be recorded. The off-balance addition of only one upright lamp is a nice asymmetric touch to a picture that otherwise could be quite dull in its perfect geometry. I used a short telephoto lens length to keep the angles straight and stood on a low wall across the street, so that my camera was at the same level as the lower rooftop. In this type of photograph, it is crucial that you avoid converging lines, which would ruin the graphic quality of repetitive shapes.

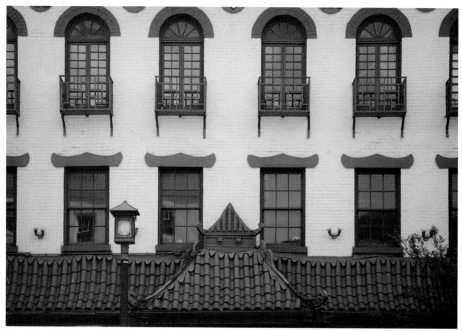

Focal length 85mm; ISO 100; aperture f/5.6; shutter speed 1/250; May 2:46 p.m.

 If faced with telephone wires and streetlamps that can be unavoidable when shooting a street scene, try zooming in and making a tight, graphic composition. This can be a great way to salvage an otherwise unattractive photograph.

A close up of dumplings.

CONVERGING LINES

Converging vertical lines (or *keystoning*, which is the technical term) will occur in your photograph when you tilt the camera up or down. This phenomenon becomes most exaggerated when you're photographing a very tall building from the ground—the building will look as if it is falling backwards, with the vertical lines of the structure *converging* toward the top. This effect happens regardless of the focal length of the lens that you use and will be even more severe with a wide angle, since creating a sense of perspective is an inherent quality of the wide lens. The simple answer to avoiding converging lines is to hold your camera level. On the more complex side, there are three shooting solutions to avoiding converging lines:

1. Try to shoot the building or structure from mid-height. See if there is a window at mid-level across from the building you are looking to photograph and, if so, try to get permission to shoot from there. This solution is usually impractical, though.

2. Shoot the building with a wider angle lens and include the foreground, composing it in an attractive manner. Even if an appealing foreground is impossible, shoot with it included anyway, and if your megapixel is large enough, the foreground can be cropped out in an image editing software.

3. Use a PC, or perspective control, lens. This lens has shifting glass elements that behave in much the same way as a 4×5 view camera and allow you to adjust the placement of the image on the camera's sensor by shifting the front element of the lens up or down.

Getting There

Chinatown is located east of downtown Washington between H and I Streets NW and 5th and 8th Streets NW. The Gallery Place/Chinatown Metro Station (Red, Yellow, and Green Lines) is sited on H Street and allows you to emerge directly onto the southern side of Chinatown. The Friendship Archway spans H Street by 7th Street.

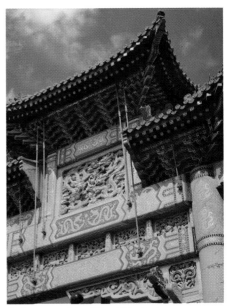

A close-up of the Friendship Archway.

When to shoot: morning, afternoon

Convention Center Area

The grandeur of downtown Washington, DC has been developing for more than two centuries; that development has consisted of dramatic national and governmental structures contrasted by modern commercial buildings. This process continues as the downtown area pushes outwards into the District as a whole and can be observed in the area around the intersection of 7th and M Streets. To the north and east of this point lie older row homes and small businesses; to the south and west lie modern commercial structures. The Walter E. Washington Convention Center (opened in 2003 and named after the District's first home rule mayor) stands at the edge of redevelopment, constituting one further, large step in the outward expansion of the downtown area. This area of transformation provides superbly contrasting architecture and opportunities for varied subjects.

The Shot

Serendipity and a perceptive eye will bring home photographs of delightful scenes such as this. One morning during cherry blossom season, this tableau greeted me immediately as I emerged from the DC Guesthouse, a B&B in the neighborhood. The crystalline aspect of the light, the appearance of snowfall in April, and the odd composition of car and tree are what drew me to make

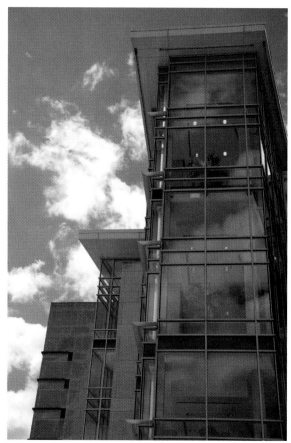

View of the new Convention Center.

a picture. I am particularly keen on the way in which the long diagonal shadows cast on the building across the street, combined with the light dusting of petals on the car and the tree trunk, trick the eye into seeing the movement of actual snow falling. As I do with most still life shots, I recorded several frames, changing my composition and framing slightly so that I could choose the most appealing one when editing at home. But, I must admit, what happened here—and what does happen about 90 percent of the time—is that the initial view was the best.

Focal length 44mm; ISO 100; aperture f/5.6; shutter speed 1/200; April 11:46 a.m.

Focal length 70mm; ISO 100; aperture f/7.1; shutter speed 1/1600; April 1:12 p.m.

The Shot

The United House of Prayer for All People on M Street is a striking building, and the thunderous clouds, strong sun, and intense blue sky in this photo only exaggerate its odd, yet powerful appearance. Drama is the overriding theme, and one can almost hear the resounding boom of the preacher and the boisterous, appreciative reverence of the congregation. Lucky timing came into play again—the curve of the clouds almost perfectly mirrors the curve of the brass railing and repetitive line of the bushes. I stood across the street from the church, at the top of the entrance stairs to a residential brownstone. This slightly elevated stance kept the parallel lines of the turret from converging, which would have marred the strong geometry of the photograph.

Getting There

The area is readily reached by the Metro Green Line. The station at Mount Vernon Square and 7th Street brings you immediately to the Washington Convention Center with access to the sights in this section.

The Convention Center and the Historical Society, juxtaposed.

The Historical Society seen through modern buildings.

When to shoot: morning, afternoon

Farmers' Markets

Historically, farmers would find an outlet for their produce at the local market, perhaps spending a day hauling their goods to the nearest town in the hope of finding enthusiastic customers for their fresh wares. In time, with the advent of efficient transportation, most produce was shipped into all-embracing distribution chains and could appear for sale throughout the country. A few farmers, perhaps, continued to sell at least some of their goods at the farm gate or on a busy road close to the farm. With the emergence of food trends in which consumers have developed a keener interest in the providence of their food, its freshness, and the impact of its production on the environment, farmers' markets across the country have emerged as an opportunity for farmers to once again sell locally. Washington, DC is no exception, and many markets can be found throughout the region. Within these markets you will see fine, and often exotic, produce displayed against interesting and fluid backdrops. Farmers' markets: an opportunity for farmers and consumers, but also for photographers.

The Shot

A farmers' market is a feast for every appetite. No matter what the season, the stalls are brimming with colorful produce and locally manufactured goods, and during springtime, the bounty of flowers is almost overwhelming. At the Eastern Market, I was drawn to a stall filled with red and pink dianthus, a relative of the carnation. The diffused light created by the white tent cover makes a beautiful situation in which to photograph and mimics the light that pro studio photographers covet. Into my field of view strolled a mother and a little girl with a pink balloon, both wearing magenta dresses. I felt for a moment that there was a set stylist nearby, putting all the pieces of my shot together! When you spy moments such as these, you *must* act quickly. Children do not stand still for long. Again, a reminder to have your camera prepped and ready to shoot, with spare batteries and memory cards at hand. This way, shots such as these will be yours to grab.

A tableau of green vegetables.

The temptation of fresh tomatoes is not to be ignored.

Fresh cheese at the interior of the Eastern Market.

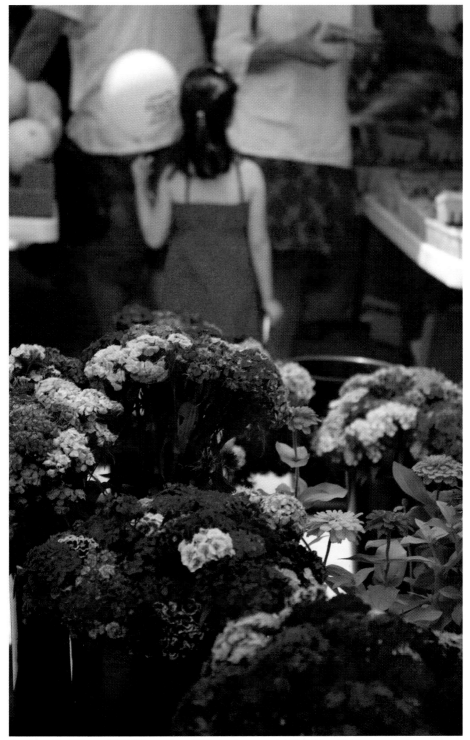

Focal length 135mm; ISO 100; aperture f/5.6; shutter speed 1/200; May 12:11 p.m.

The Shot

In addition to fostering vegetable voyeurism, farmers' markets are also a perfect opportunity for people watching. I find that shoppers are so engrossed in their own activities and so food-focused that they really don't notice me or feel self-conscious of the camera. This shot was taken inside the food hall at the Eastern Market, which, like the stalls outside, has an enormous translucent white roof, filling the space with lovely soft, bright light for shooting. This group of three in their matching white T-shirts made an attractive and monochromatic composition with the black-and-white chalkboard above and the graphic shapes of the stools and legs below. Notice that I followed the Rule of Thirds here, with areas of black sandwiching a strip of white in the middle.

Getting There

Judicious use of the Internet will quickly give you the location and timing of more than a hundred farmers' markets within the Greater Washington region.

A variety of mushrooms at a market on E Street NW.

Some of the photos in this section were taken at the Penn Quarter Farmers' Market, located at the north end of 8th Street between D and E Streets NW. Markets have stood on this spot for more than 100 years. From the Archives Metro Station (Yellow or Green Line), walk north on 7th Street for one block and then turn left on D Street. The market will be on your right, one block farther. The market is open on Thursdays from 3:00 to 7:00 p.m.

The other shots were taken in the Farmers' Market section of the Eastern Market. The Eastern Market is located at the intersection of C Street SE and 7th Street SE. Exit at the Eastern Market Metro stop (Orange and Blue Lines) and walk one and a half blocks north on 7th Street. The farmers' produce is displayed on Saturdays and Sundays from 7:00 a.m. to 4:00 p.m.

A stack of fresh-picked raspberries at the Eastern Market.

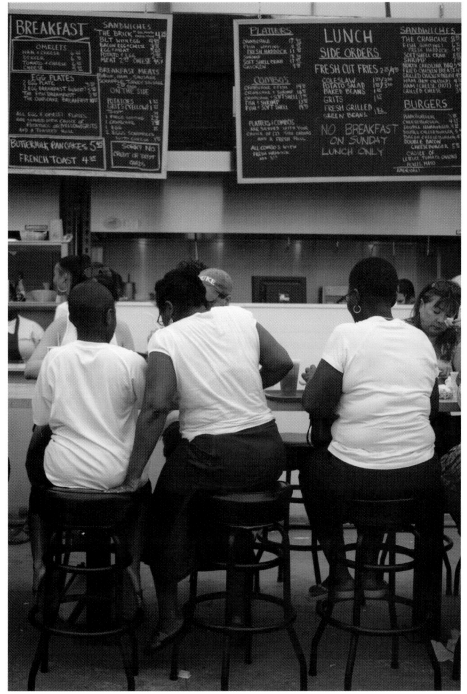

Focal length 30mm; ISO 100; aperture f/3.5; shutter speed 1/160; May 12:58 p.m.

When to shoot: morning, afternoon

The Fish Market at Maine Avenue

If you are looking for a change of pace from DC's grand sights, make your way to the Washington Fish Market—or, as it is also known, "The Wharf." Here you will find a briny slice of life and meet many local Washingtonians relishing their purchases of raw fish or fish-restaurant offerings.

The market has the air of a well-kept but elderly nautical theme park, with the bright and colorful shop fronts competing with the equally showy displays of fish and shellfish. The fishmongers themselves complement the displays and take very little persuasion to pose with their wares. At many of the stalls, you can purchase ready-to-eat foods, and the lines for these treats attest to the quality and freshness of the food. Jimmy's, beside the entrance to the Market, is famous for its crab cakes and also does a mean sideline in desserts.

The Market is open daily, but on weekends the displays are at their finest.

The Shot

This salty dog of a fellow gets the blue ribbon for being one of my most willing and enthusiastic photo subjects ever! He morphed into his pose with such ease that I know he has done this before—especially when he asked me if I worked for the Discovery Channel! The Fish Market, much like the Eastern Market, boasts a beautiful and diffused lighting scenario that wraps your subject with soft light and shadows, which was flattering to both the gentleman and his colorful wares. I filled the bottom of the frame with the abundant display of crabs, which lends this image texture and a beautiful range of natural colors. Notice, also, the multiple touches of bright blue that take your eye around the photo—the hundreds of crabs' legs, the seller's T-shirt, his eyes, the sign behind him, and last but certainly not least, the pen behind his ear! After your shoot, a fresh seafood lunch beckons you!

Edge to edge blue crabs.

Another type of patron enjoying his free lunch.

A tidy arrangement of red snapper.

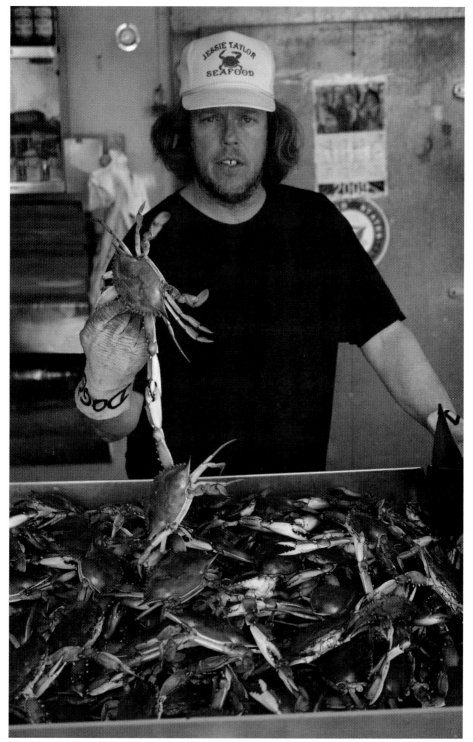

Focal length 60mm; ISO 100; aperture f/5.0; shutter speed 1/80; April 11:02 a.m.

The Shot

If gaping mouths, exposed flesh, and shiny silver skin are your game, then you will be right at home at the Fish Market! This scene is at the left-hand side of the U as you enter the wharf, and it is the main fish sales area. I really wanted this picture to communicate the overwhelming abundance of seafood, so I placed the camera lens just on the edge of the display. To do this, I had to step off the sidewalk and actually down into the stall, which is no problem with the vendors. They are friendly and do not mind in the least. Compose your frame so that the signs butt up against the left edge of your frame, and try to maintain a bit of space on the right to include a touch of humanity in the form of a paying customer.

Getting There

Although perched on the bank of the Washington Channel of the Potomac and adjacent to the Jefferson Memorial, the Washington Fish Market is not the most easily found of sights. It is located off Maine Avenue where the I-395 Freeway crosses overhead. The most straightforward approach, using the Metro, is to go to the Smithsonian station on the Orange and Blue Lines and then walk half a mile south on 12th Street to the intersection with Maine Avenue. You should be able to see Captain White's sign ahead of you below the overpass. Alternatively, you can find your way from the Tidal Basin and/or Jefferson Memorial using trails and sidewalks to get onto Maine Avenue and then to the Market.

The Market does feature free parking, and this may be one Washington visit for which using your car may be a good bet…especially if you end up with a fishy purchase to carry away.

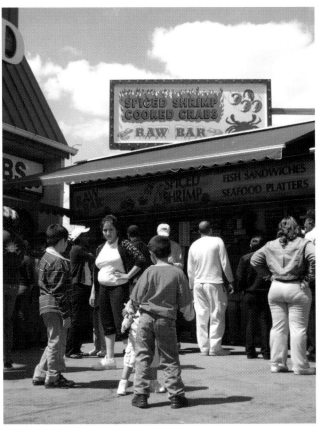

A view of the busy raw bar.

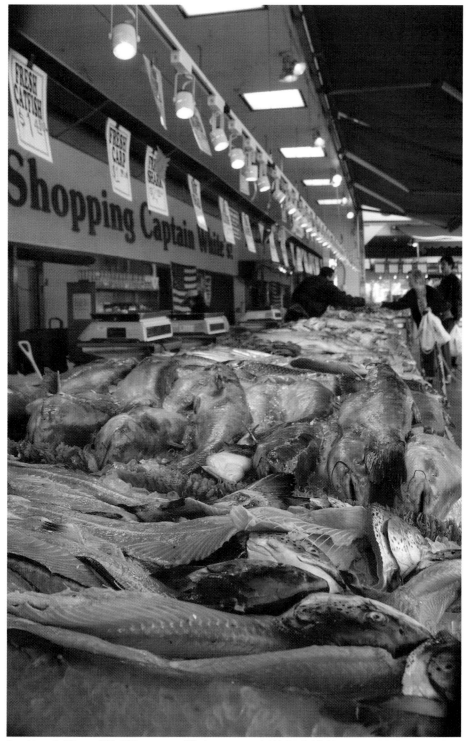

Focal length 28mm; ISO 100; aperture f/8; shutter speed 1/4; April 10:41 a.m.

When to shoot: morning, afternoon

Georgetown

And before there was Washington, DC, there was Georgetown. Established in 1751, when the Maryland Legislature purchased 60 acres of land bordering the Potomac River for 280 pounds sterling, the town was named after the monarch of the time, George II. (Patriots may prefer the alternative explanation that the previous owners were both named George and passed their name on to the town.) Georgetown represented the highest navigable point on the Potomac and developed as a valuable port. Remnants of canals used in the distribution of goods dissect the town.

When the plans for DC were drawn up, Georgetown was included as an integral district, and in the early days of the capital, the previously established town was the cultural center of the city. It retained its technical independence as a municipality until 1871, when it was completely assimilated. The cultural status of the town has waxed

The sign at the eastern edge of Georgetown, at Pennsylvania and M Streets.

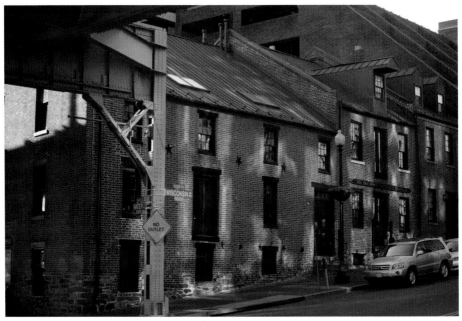

A scene with old and new next to the riverfront park.

and waned throughout intervening years with the development of other parts of DC. At the present time, Georgetown, while retaining the major part of its older character, has experienced tremendous gentrification and is a much sought after business address and residential area.

Within the town limits, you will now find high-end shops, bars, and restaurants offset by upscale condominiums and offices. On the quieter streets, attractive, historical architecture abounds, constituting the major part of the housing stock. Bordered to the south by the Potomac, Georgetown features a new waterfront park in which to relax and enjoy the splendor of the river.

The Shot

The small side streets and alleyways of Old Georgetown near 28th and 29th Streets NW are a treasure trove of architectural gems, and ivy and old brickwork abound. This particular home caught my eye, as one side literally seemed to be a mirror image of the other. Aside from rush hour, the streets are quite free of traffic, and it is easy and safe to stand in front of the homes and compose your photographs in a relaxed fashion. The impact of this type of picture is crucially dependent on accurate composition, so do use your tripod, if you have it, to ensure that the lines of the fence and walls are horizontal and that your framing from left to right is symmetric and centered.

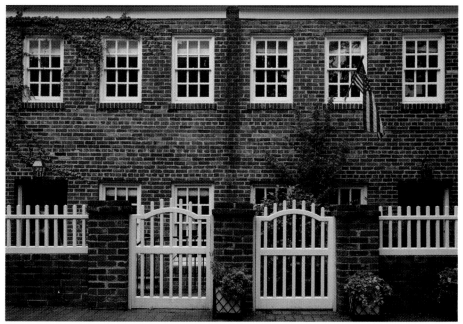

Focal length 44mm; ISO 200; aperture f/5.6; shutter speed 1/200; July 3:15 p.m.

Focal length 300mm; ISO 100; aperture f/6.6; shutter speed 1/60; April 5:13 p.m.

The Shot

This adroit athlete was teaching a phys-ed class in the park on the waterfront promenade. His energy was frenetic, and I think he must toss that soccer ball in his sleep! I used my 300mm lens both to stay out of his way and to take advantage of the short depth of field, which, along with the nice edge light from the setting sun, separates the subject from the background. I was careful to place him so that it seemed as if he was stretching up from the edge of the frame and to surround him with the urban architecture of the bridge. I also am glad I caught the approving smile from his student.

An equestrian-themed entryway. The canal in Old Georgetown.

Getting There

Georgetown is located to the west of the central part of DC. The town clusters around the intersection of M Street and Wisconsin Avenue. It is not well served by the Metro system, but if you do take the Metro to Foggy Bottom on the Orange or Blue Line, a Route 31: Wisconsin Avenue Line Metrobus will take you the three-quarters of a mile along Pennsylvania Avenue and M Street to the center of Georgetown. Alternatively, take the Georgetown Metro Connection bus from Dupont Circle; this leaves every 10 minutes and shuttles between Dupont Circle and Rosslyn Metro stations via Georgetown.

When to shoot: morning, afternoon, evening, night

Smithsonian Everywhere

The Smithsonian Institution may be one of the world's most prestigious complexes of museums, galleries, and research institutes, but to this day its founding origin is cloaked in mystery. The Institution comprises 19 museums, 165 affiliate museums, 9 research centers dispersed around the globe, and the National Zoo. All told, the Institution owns more than 136 million specimens and holds a place of high esteem in the academic world. Smithsonian establishments are located throughout DC.

When James Smithson, an accomplished British scientist, died in 1829, he left his substantial estate to his nephew. However, he stipulated that were his nephew to die without heir, the entire estate would pass to the people of the United States of America, "to found at Washington, under the name of the Smithsonian Institution, an Establishment for the increase and diffusion of knowledge…." The nephew did indeed die without heir, and the bequest, valued at more than $500,000, was, after much administrative debate, accepted by Congress. The Institution was formed in 1846. The motivation behind this bequest remains unclear, particularly since Smithson had never traveled to the U.S. and had no known correspondence with Americans. Speculation indicates that Smithson was unhappy with British society, given his treatment as an illegitimate son of gentry, and viewed the fledgling republic across the Atlantic as a more worthy recipient of his fortune.

The first Smithsonian building, located on the National Mall and popularly known as the Castle, was completed in 1855. It is aptly named given the crenellated Norman architectural style and the red sandstone building material. Remodeling in 1968–69 emphasized the Victorian character of the internal and external aspects. The Castle houses the Smithsonian Information Center, which serves as the focal point for information about the Institution's 17 museums and the National Zoo in Washington, DC and the two museums in New York City.

The Shot

Nighttime shooting is extremely gratifying for a number of reasons. It is quite a treat to roam the empty streets and sidewalks, and with the dearth of tourists and townspeople, many photographs are within your grasp that during the day would be next to impossible. And with the ability to use long shutter speeds, the elements of movement and motion blur can be added to your creative repertoire. What I reap the most pleasure from, however, is the unpredictable color palette that occurs as a result of the unusual and varying color temperatures of the after-hours illumination. It is this element of the unexpected that makes shooting in low light so interesting, and that is what I experienced at the flower garden of the Smithsonian Castle. The misty night sky turned mauve at the 10-second exposure, and the light from the sodium vapor streetlamps gives the scene an eerie, chartreuse glow. The long exposure turned the surface of the fountain into a soft mirror, and the flowers, nudged by a gentle breeze, are nicely blurred. Use of your tripod is critical here, and the cable release helps to avoid any camera movement.

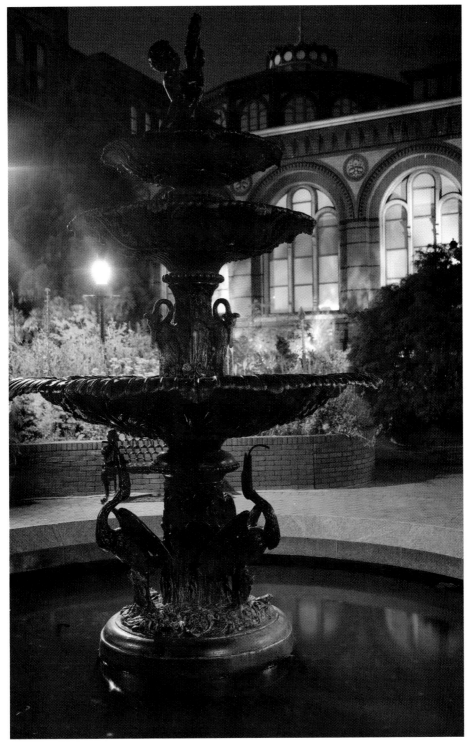

Focal length 44mm; ISO 100; aperture f/4.5; shutter speed 10 seconds; June 10:55 p.m.

The Hirshhorn during a party night.

The petrified wood display.

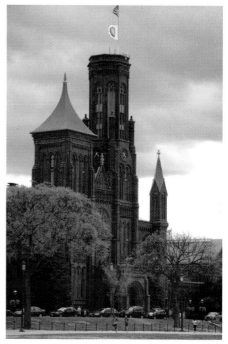

Another view of the Castle.

The Shot

The Castle is Gothic and romantic, and it makes a theatrical photograph from almost any angle, but in spring, with the leafless branches framing and tracing the scene, you are guaranteed some extra drama. The warm, late-afternoon sun beautifully puts the brickwork into high relief, and the grandeur of the towers is in striking contrast to the seemingly minute walkers and runners on the Mall below. I shot from across the Mall, directly northwest from the entrance to the Castle. Be sure to keep your camera parallel to the ground—the pale line of the sidewalk will help you with this aspect.

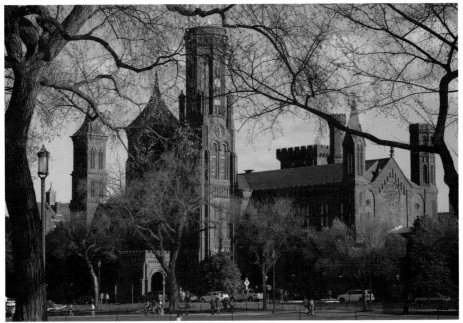

Focal length 100mm; ISO 100; aperture f/10; shutter speed 1/200; April 4:57 p.m.

Getting There

The Smithsonian Castle is located at 1000 Jefferson Drive, which passes east-west through the National Mall. It lies a third of a mile to the east of the Washington Monument. The Orange and Blue Metro Lines will take you to Smithsonian Station. From there, walk north into the Mall on 12th Street and turn right on Jefferson Drive. The Castle will be on your right.

When to shoot: morning, afternoon

Stars and Stripes

How does a nation's flag come into being? Looking closely at the advent and evolution of the national flag of the United States of America, you will see reflected stages of development of the nation itself. When the original 13 colonies were operating essentially as a group of businesses under the auspices of the British East India Company, they rallied around the company flag. This contained the version of the British flag in use at that time positioned in the upper-left corner of the flag. The remainder of the flag consisted of 13 stripes representing each of the colonies. In the minds of the colonists, the flag transitioned from the banner of a company to a symbol of the developing nation.

With the achievement of independence, the top-left corner (union) of the flag was replaced. The Second Continental Congress at Philadelphia on June 14, 1777, "resolved, that the flag of the United States be thirteen stripes, alternate red and white; that the union be thirteen stars, white in a blue field representing a new constellation." This description lacked specificity and left room for interpretation, particularly of the placement of the stars.

The Betsy Ross design (of which Betsy's input is uncertain) with 13 stars in a circle is one of the versions from that time. With the country's growth through the addition of new states, the flag was updated, 26 times to date. The inclusion of Alaska and Hawaii in 1959

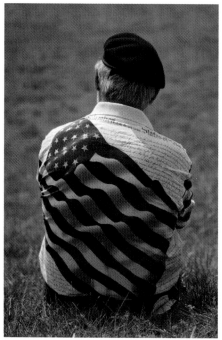

A patriotic by-sitter.

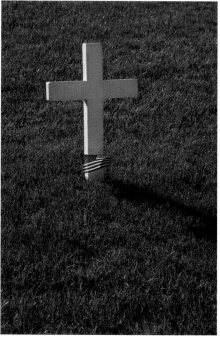

A simple cross and flag at Arlington National Cemetery.

led to the addition of the 49th and 50th stars, giving the nation its current flag. Provisional designs have been prepared for the addition of further stars—perhaps those who have referred to Britain as the "51st state" know something.

And how should a nation treat its flag? Much loved, often affectionately referred to as the Stars and Stripes, the Star Spangled Banner, or Old Glory, the flag elicits a strong emotional response. U.S. Federal law defines appropriate use of the flag in the Flag Code. Among other things, this bars use for advertising purposes and also use "on such articles as handkerchiefs, napkins, boxes or anything intended to be discarded after temporary use." You may consider from your experience how well this code is policed. Indeed, the Supreme Court has supported arguments that the right of freedom of speech can override elements of the Flag Code. Despite the ebb and flow of such debate, the Stars and Stripes remains to most Americans the beloved symbol of the nation and is displayed and worn with pride in a multitude of ways.

The Shot

What a perfect way to avoid the harsh and high-contrast shadows of midday—shoot underneath a flag, and an enormous one at that! It was the red, white, and blue glow on the asphalt that caused me to point my camera in the direction of this scene, and I am still transfixed by the striped and starred shadows that are evident. I also enjoy the "photo within a photo," as the image of the flag on the road could, in some senses, be construed as a "photograph." It *is* "drawing with light," after all, which is what the word "photography" derives from. The wide angle of my lens captures the vast expanse of the flag, and the fast shutter speed keeps the flapping fabric crisp and sharp.

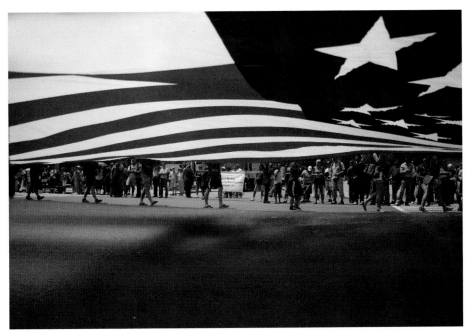

Focal length 28mm; ISO 100; aperture f/4; shutter speed 1/1250; July 12:08 p.m.

The Shot

Another playful use of light is the reflection in this motorcycle helmet. The convex shape gives you almost a 180-degree view, and of course, I am visible also. The gray of the overcast sky maintained the "silver" tone of the metal—this shot would have looked very different and not as effective if the sky had been a cloudless blue. The saturated colors of the flag are in stark contrast to the black leather and silver chrome of the motorbikes, and I like the fact that the flag is almost the only spot of color in an otherwise duotone background. My choice of a wide aperture, and thus a shallow depth of field, maintains focus only on the flag, keeping it again as the focal point of the shot.

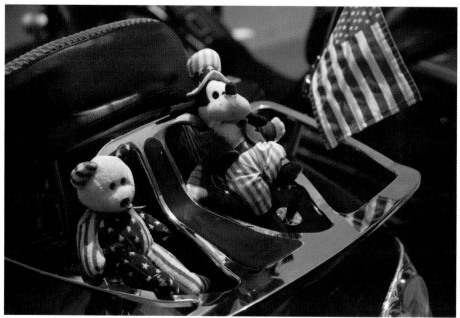

A bit of humor lightens the patriotic touch.

Getting There

Imaginative and creative, casual and formal, but almost universally patriotic portrayals of the Stars and Stripes can be found throughout the District. Keep your eyes open around the National Mall, which attracts many Americans keen to display their colors.

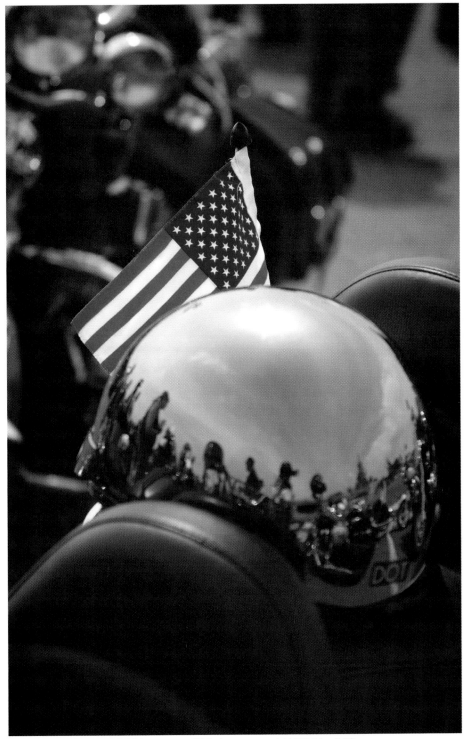

Focal length 125mm; ISO 100; aperture f/5.6; shutter speed 1/400; May 9:50 a.m.

 When to shoot: morning, afternoon

The Colors of Woodley Park

Woodley Park is a charming neighborhood of historical residences and a wide diversity of restaurants. It is intersected by Connecticut Avenue and sits between the National Cathedral to the west and the National Zoo to the east. Indeed, it might easily be overlooked in the shadows of these popular DC destinations. However, stop and take a look. See how many of the residents of this leafy suburb have embellished their fine early twentieth-century homes by adding subtle color and design twists to generate an elegant and attractive environment. In addition, observe how many owners have expanded the envelope of home decoration while boldly reflecting their partisan views in this most political of cities.

The origins of the symbols of the country's two main political parties—the elephant and the donkey—are seated in the nineteenth century. Neither was created by a high-priced PR company nor benefited from a splashy launch. Rather, they both came into being through the medium of the political cartoon and gradual adoption.

In 1828, while running for the presidency, Andrew Jackson was labeled a "jackass" by his opponents. In the time-honored tradition of politicians turning a negative into a positive, Jackson adopted the donkey as a symbol, emphasizing his characteristics of stubbornness and commitment. In 1837, the donkey was again used in a derogatory manner, but this time in a cartoon referring to the Democratic Party as a whole.

In 1870, Thomas Nast, contributing in *Harper's Weekly*, cemented the donkey's role as party icon by repeatedly using it in his cartoons. Nast is also credited with entrenching the elephant as the symbol of the Republican Party. In 1874, building on two earlier cartoons, he used a cartoon elephant, headed toward a tar pit of inflation and chaos, to represent the Republican vote and its interest in supporting Ulysses S. Grant in running for a third term.

The party symbols in their own way represent the nature of much political debate. Both parties see the noble qualities of their adopted beast while deriding the character of the other party through the negative attributes of its chosen symbol. However, through witty and creative use of the icons, the people of Woodley Park have made a fine effort at enlightening and entertaining neighbors and visitors alike.

The Shot

These figures of the donkey and the elephant grace the expansive front lawn of the Swiss Chancery at 2900 Cathedral Avenue. Since 9/11, massive fences unfortunately have sprouted up in front of many international properties, and this one is no exception. As a result of this obstruction, there is no spot to stand with your camera where you can get a full view of both of the figures. As a second-best solution, I found that by standing on the street nearest the corner of 29th Street NW, the view of the statues was good, and the light at early evening highlighted the parts of the statues I could see beautifully.

When composing, be careful to notice the many humorous aspects. Note that the elephant sports a Swiss alpenhorn as his trunk and has the barrel from the Swiss St. Bernard dog attached to his collar. The donkey, Swiss-Key, was vandalized in late 2002 and almost buried for dead, but it has since been repaired and assumed his rightful spot.

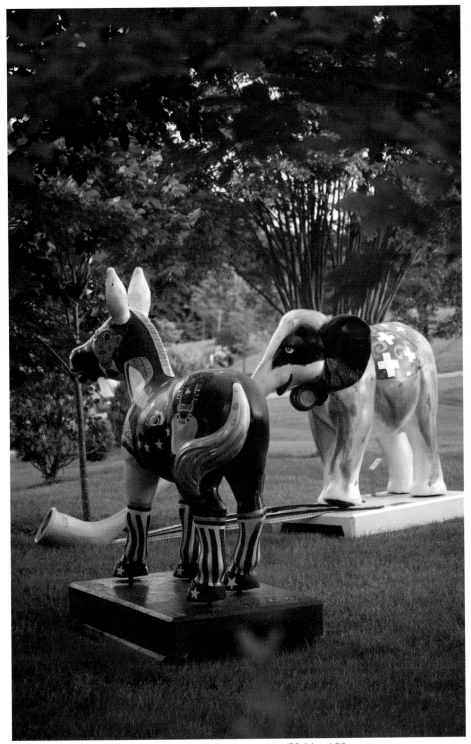

Focal length 85mm; ISO 100; aperture f/5.6; shutter speed 1/50; May 6:30 p.m.

The Shot

The Woodley neighborhood in springtime is an absolute plethora of color. This scene on Klingle Road near the Klingle Valley Park stood out as unrivaled, however, not for its profusion of blooms, but for the alternating arrangement of pink and white between the houses and blossoms. The anonymous gardeners and house painters worked in perfect synchronization to provide the passerby a visual trick *and* treat. I stood across the street from the scene and composed carefully both to crop out street wires and poles and to convey this pattern to its full effect. I set my aperture as small as possible given the dim light of an overcast morning in order to reap the most depth of focus and still be able to handhold with security. This shot looks best with as much of the scene in focus as possible.

Focal length 105mm; ISO 100; aperture f/7.1; shutter speed 1/50; April 7:11 a.m.

Getting There

Woodley Park is served by the Woodley Park-Zoo Metro station on the Red Line. It lies on either side of Connecticut Avenue to the north of the station. Most of the single-family residences lie to the west of Connecticut Avenue. In this vicinity, you will find guest-houses offering a peaceful environment to act as your base of exploration of the District.

A "Party animal" of a different texture.

TIP

Many murals are so interesting and witty that it is nice to have a photograph of your own. This mural, off Calvert Street, right near the Duke Ellington Memorial Bridge, is just such a painting. Your method of shooting is dependent on how large you will display the image at home. For a small reproduction, just stand back and compose the entire mural in your frame and crop out in post-production any distracting elements, such as cars. For a much larger file, you can shoot the left and right halves separately—stand at the center of the entire mural—and stitch them together in an imaging program, such as Photoshop.

Mural of the latest 11 Presidents with Mama Ayesha.

Another "Party animal."

Springtime color in Woodley Park.

Thin Blue Line

FBI statistics indicate that Washington, DC is a city like any other when it comes to the occurrence of crime. This may cause you to feel that the local police have their hands full with traditional police activities. However, rarely does a metropolitan police force conduct itself with as much helpfulness to the law-abiding citizen as does that of DC, and therein lies opportunity for the photographer.

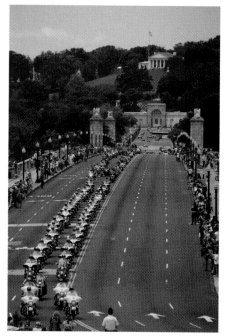

The Metropolitan Police Department was established in 1861 with around 150 constables. The unit has grown to today's complement of more than 4,500 members (officers and civilians) with a budget of more than $500 million. The first three women officers were sworn in in 1918, and nearly one-fourth of the current force is composed of women officers. History was made when Cathy L. Lanier was named the first female chief of police in 2007. Mirroring the makeup of the resident population that it serves, about 70 percent of the force is black, Hispanic, or Asian.

A police escort across the Arlington Bridge.

Areas such as the National Mall and Memorials and the President's, Rock Creek, and Anacostia Parks fall under the jurisdiction of the U.S. Park Police, who, in their turn, have been charged with protection of the National Parks for more than 200 years.

The compact and diverse nature of the northwest quadrant of DC and the activities that take place there require that police officers utilize a variety of means of transport, leading to a wide array of interesting photographic possibilities.

The Shot

There is nothing like a shot of police vehicles from foreground to infinity to elicit a feeling of security. No infractions were going to occur here, that is for sure! I saw this shot from quite a distance, and I knew that a long line of such repetitive shapes would make a striking picture. I positioned myself at the beginning of the line and stretched up on my toes to see as much of the tops of the motorcycles as I could and to capture the feeling of infinity. I was very careful not to include too much extraneous background at the top of the frame—this would have ruined the effect of the Harleys going on forever. I shot with both a small f-stop and a medium focal length in order to have deep focus, and I composed with the path of black leather seats in the middle of the composition.

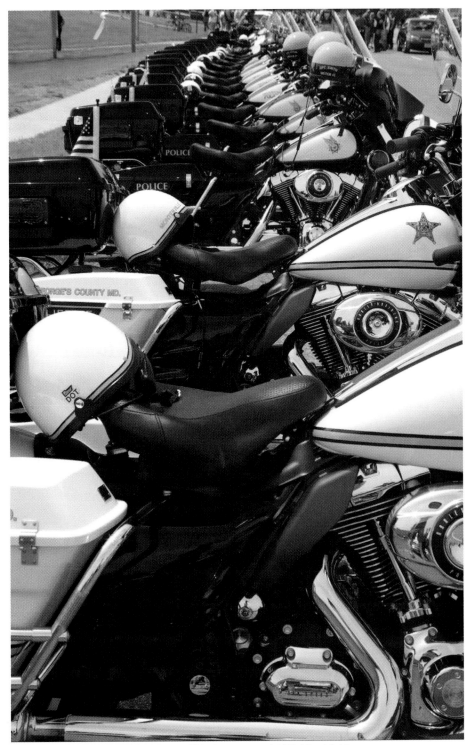

Focal length 53mm; ISO 100; aperture f/11; shutter speed 1/60; May 10:44 a.m.

The Shot

This is one of those photographs that really gives you a feeling of synchronicity and that, possibly, the subjects in the picture had conversed beforehand and worked out their lines and placement on the set, with each subject gazing in a different direction and seemingly unaware of one another. I sensed that I had a striking picture, as the light filtered through the trees in a lovely way and the policeman on his horse made such a commanding figure. It was not until I downloaded my files, however, that I noticed how each figure in the frame looked frozen in time. Even the cyclist, who was obviously riding forward, seems to be standing motionless. Learn to trust your instincts, and when you do feel there is a picture in front of you, there probably is!

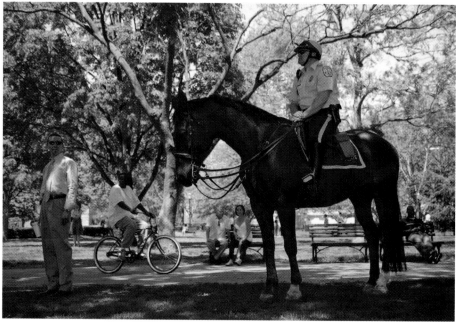

Focal length 47mm; ISO 100; aperture f/5; shutter speed 1/200; April 12:29 p.m.

Getting There

The Washington, DC police force is remarkable for the cheerfulness and approachability that their officers exhibit—particularly so for a major city force. You will find them fulfilling their duties throughout the District, but most of the photographic opportunity is to be found in the northwest quadrant.

An alternative means of transportation.

A more traditional two-wheeled transport.

One half of a police duo resting up.

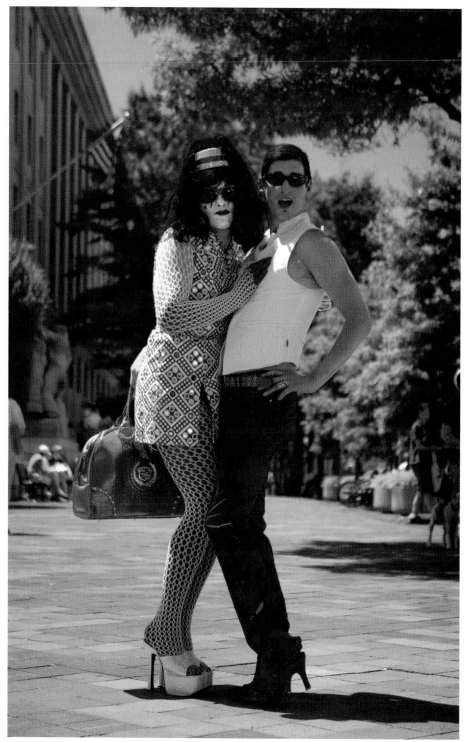

Sirena Sparkle and companion at the Capital Pride Festival.

CHAPTER 3
Events

A full dance card is a common occurrence for a visitor to DC. On any given day or night, the list of happenings is long and varied, and you will be able to pick and choose what type of affair suits you to photograph. From political demonstrations to patriotic parades to cultural festivals and international sporting competitions, there is no dearth of event-oriented photo opportunities here in this country's capital. Many of these events are annual traditions that attract visitors from across the globe, and it is not unusual to find yourself celebrating with 250,000 other tourists. A selection of some of the most popular and those that offer the most interesting photo opportunities are presented here, with tips on how to bring home photographs you can be proud of.

Shooting Like a Pro

Arranging your travel itinerary around events that occur in a city other than your own could be a taxing project, but, just as if you were a photo shoot producer, with prudent use of the Internet and a few telephone calls, your schedule should fall easily into place. If you are running on a constricted timeframe, do not depend on the web alone for accurate information. A quick phone conversation to garner the correct starting times for, directions to, and logistics of an event can save a lot of heartache and missed opportunities. But, most importantly, be absolutely sure that your camera bag is packed with all the gear you need and that it is in good working order. Pros (or their assistants!) have learned through experience to check and clean their cameras and accessories thoroughly before embarking on a trip. As mundane as it sounds, this should become a habit for you, since a complete once-over the night before can ward off a lost photo opportunity the next day.

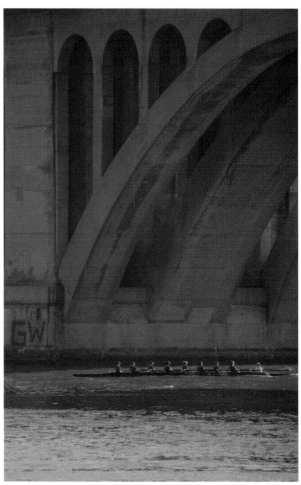

The Gear

While shooting at an event, you will more than likely be restricted with regard to your choice of vantage point and may find yourself farther away from your subject than is optimal. Longer focal length lenses are in order here. Unfortunately, the more specialized the equipment becomes, the higher the price tag that accompanies it. For this reason, a camera rental house (such as Penn Camera) is a great boon. You can rent a long telephoto lens or a current on-camera flash for a very small fraction of the retail price, assuring that you will have the proper gear on hand.

Rowers under the Francis Scott Key Bridge.

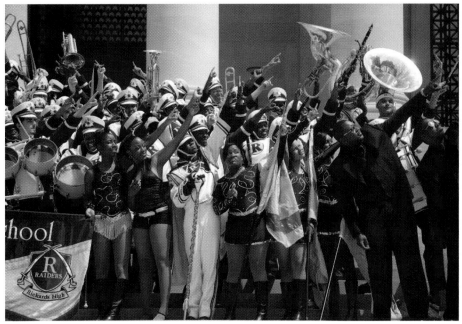

Pointing to Freedom! (Statue atop the Capitol Building.)

This is essential when you are shooting an event where you will have limited access, and the photograph here of a rowing regatta on the Potomac River is a perfect example. The river is long and wide, and you just cannot get close enough to the action with anything but a lens of 300mm or greater. I chose the 300mm in this case, because my aesthetic concern was to show the huge scale of the bridge and how it dwarfed the boat and rowers. Standing on the edge of the river with a shorter lens would yield completely different results.

The Plan

When exploring and shooting neighborhoods, parks, and scenes, to some extent you are on your own schedule, and aside from the weather and operating hours, you are free to shoot when you desire. You are also at liberty, in most cases, to study your subject matter and take the time to compose and choose the best angle. A parade, demonstration, or sporting event, on the other hand, is a photographic assignment of a completely different animal. When taking photos in situations such as these, you must work within a time-frame—you are restricted not only by start and end times, but, in the instance of a parade or sporting event, by the fleeting moments that your subject is actually within your frame of view. Planning ahead and scouting your location and subjects will greatly increase your chances of capturing beautiful photographs. If it is a parade you are shooting, find out where it begins and plan to be there at about an hour before start time. This gives you plenty of chances to shoot the revelers as they are warming up and to capture the first steps of their promenade unhindered by rows of people. The same goes for sporting and other events—make good use of your time and be bold and adventurous in searching for the best place from which to shoot. You will be glad that you did so when you see the results.

 When to shoot: afternoon

C2EA Demonstration

The goals and purpose of the Campaign to End AIDS are outlined on the organization's website at www.c2ea.org. This brief quote summarizes their work:

> The Campaign to End AIDS (C2EA) is a diverse, exciting coalition of people living with HIV & AIDS, their advocates and their loved ones. Together, we're demanding that our leaders exert the political will to stop the epidemic, in the U.S. and abroad, once and for all. In small towns and big cities across America, we're mobilizing to ensure the best treatment and care for all HIV-positive people...and HIV prevention methods backed by good science.

The pictures in this section were taken in April of 2009 at a rally organized by the Campaign to End AIDS and its sister organizations, DC Fights Back and NAPWA. Representatives from throughout the U.S. were present, making a graphic stand.

The Shot

This demonstration was particularly poignant and absolutely rife with powerful and emotionally wrought images. The cross alone is compelling, yet when combined with the black outfit, purposeful stance, and passionate expression, it all makes for a significant photograph. For this shot, I knelt on the sidewalk and shot from a very low angle, both to ensure my background was only blue sky and to "heroicize" my subject matter. The stark contrast of the cross against the sky, the anonymity of the protester, and the color scheme of black, white, and blue all contribute to an image with strong emotional impact. The graphic quality of a shot like this is somewhat reminiscent of Russian propaganda posters. If you look closely, you can see a touch of humor in an otherwise somber presentation—there is a computerized SKU number on the wood used to make the cross.

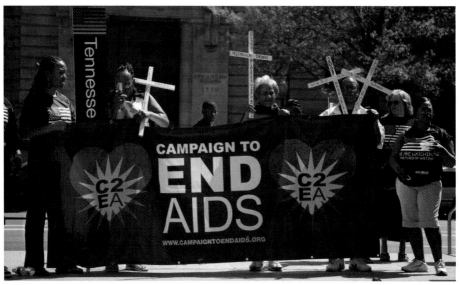

The C2EA banner.

Focal length 95mm; ISO 100; aperture f/5.6; shutter speed 1/250; April 1:57 p.m.

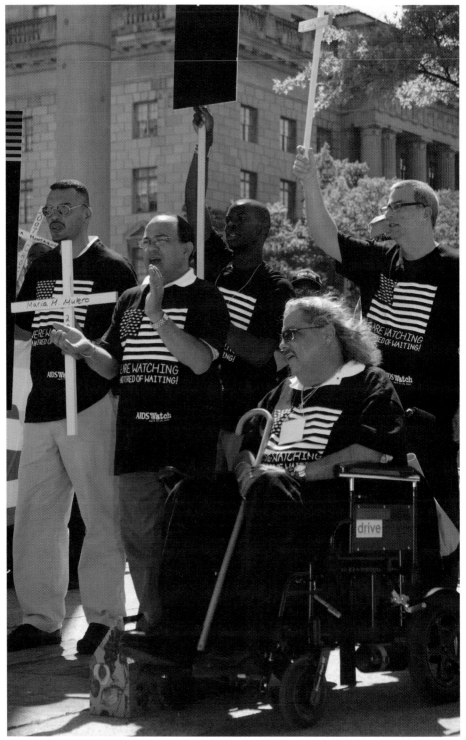

Focal length 56mm; ISO 100; aperture f/5.6; shutter speed 1/250; April 1:56 p.m.

The Shot

These participants were charismatic to say the least, especially the fellow in the wheelchair with his resigned look and the strong diagonal line of his cane. I saw him from quite a distance and knew immediately that I should hover in his vicinity, as there was most definitely a picture here for me to uncover. I find demonstrators very willing to be photographed, since dissemination of their image only furthers the cause for which they are impassioned. I caught this fellow's eye as I circled innocently around him and his companions, and when the moment was right, as crosses were raised and the wind lifted their hair, I pressed the shutter. In situations such as these, when someone is essentially "performing," you will find that if you make eye contact and engage with them in a pleasant manner, your photographs will reflect the energy and empathy of the moment.

The main speaker and viewers.

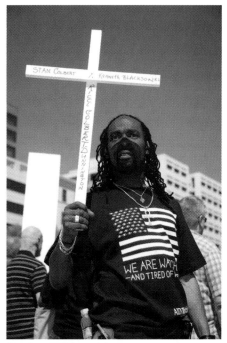

Another C2EA participant.

Getting There

These shots were taken on the Freedom Plaza at the intersection of 14th Street and Pennsylvania Avenue. This raised area is a popular site for political protests and civic events and is worth visiting, particularly on weekends. The nearest Metro station is Federal Triangle, serviced by the Blue and Orange Lines. Walk north from the station and then left on Pennsylvania Avenue for one block to approach the Plaza.

 When to shoot: morning, afternoon, evening

Capital Pride

The Gay Rights movement has fought a lengthy battle to have its voice heard and equal rights granted. Decades of Gay Rights activism and the gradual and uneven transformation of public opinion have brought us to the attitudes of the present day. In Washington, DC in June, on the anniversary of the infamous Stonewall riots that, in 1969, brought Gay Rights to the attention of the public, the Capital Pride Parade and Festival holds its head high in the nation's capital.

Ten days of Capital Pride events culminate in the Pride Parade, in which more than 130 contingents march, and in the Pride Festival, which features more than 30 bands and acts celebrating the diversity inherent in the gay, lesbian, bisexual, and transgender community. Most recently organized by the Capital Pride Alliance, supported by donors and a 300-person-strong volunteer army, the events attract more than 250,000 visitors. These are events where pictures truly speak for themselves.

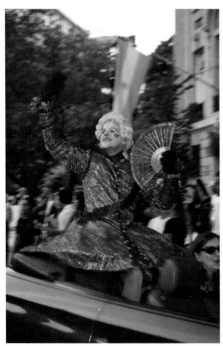

Mozart on parade.

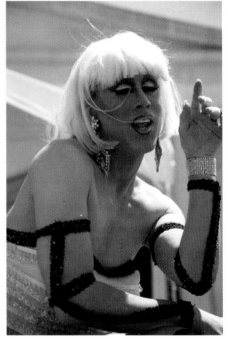

Another performer on the catwalk.

The Shot

Capital Pride is a veritable and overabundant buffet of photo opportunities. The festival-goers literally clamor over one another to have their likeness immortalized, and these folks seem as if they were born to pose. At the Pride Parade, near Dupont Circle on 17th and P Streets, the main problem is how in the world you focus and choose which photo to take. The parade starts at dusk and ends in the early evening, so out of my gear bag I pulled my 580 EX flash, since the available light would be too low for shooting an event with such wild movement without it. I shot at 1/25th of a second in order to keep the background from going completely black, which it would have if I had synced at the normal 1/60 or 1/125. I headed toward the main viewing stand at 17th and Q, and I parked myself firmly in a spot right on the edge of the street about 30 minutes before the parade was to start. The whistle blew, and the hordes of paraders in various states of dress and undress were off! The color and shape of this fellow's garb was impossible to resist, and the slow shutter speed gave me some nice movement on the outer edges of the yellow balloons, which adds to the frenetic energy of the scene.

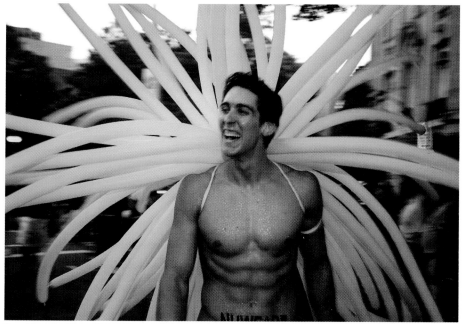

Focal length 47mm; ISO 100; aperture f/4.0; shutter speed 1/25; June 7:19 p.m.

The Shot

At the Pride Festival on the last Sunday of the festivities, there is a fantastic drag queen and king (yes, *king*) catwalk, where performances start at about noon and continue on until about 3:00 p.m. *Performances* is the key word here. The music is thumping, the crowds are wildly appreciative, and the men and women strut their stuff and lip sync with aplomb. I managed to elbow my way right up to the front row, and my view of the performers was blissfully unobstructed. This gal really filled my frame, and my low angle gave me a perfect clear-sky background. The contrast of her rust outfit against the blue is nice and strong, and I love the details of her rhinestone jewelry and black alligator belt.

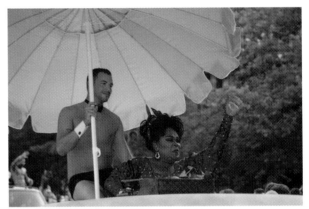

An essay in rainbow and purple—the Pride colors.

Getting There

You will be able to find specific dates for Capital Pride activities on the organization's website: www.capitalpride.org.

The parade route starts at the intersection of 23rd and P Streets. It proceeds along P Street to the Dupont Circle, turns up New Hampshire Avenue, then takes R Street to 17th south, returning to P Street. The final turn takes the parade onto 14th Street, south to the intersection with N Street.

The festival takes place on a sectioned-off portion of Pennsylvania Avenue around the intersection with 6th Street. The entrance to the festival is located near the Archives Metro Station (Yellow and Green Lines).

A behind-the-scenes view at the festival.

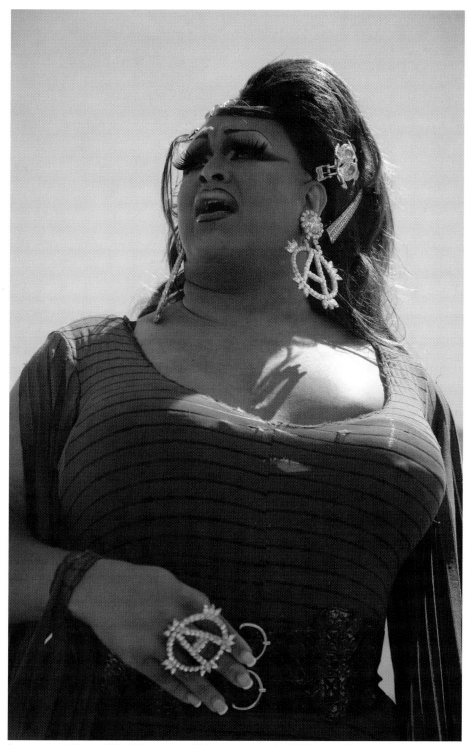

Focal length 125mm; ISO 100; aperture f/6.3; shutter speed 1/125; July 1:35 p.m.

 When to shoot: morning, afternoon

Cherry Blossom Festival

As with many tree species, cherry trees are cultivated as a wide variety of types. The most notable division of these cultivars is into the edible and flowering varieties. Whereas the fruit tree industry is responsible for the production of the delicious summer crop of cherries, the flowering cherry tree experts bring us a product more poetic even than the flavor of Grandma's special cherry pie.

The flowering cherry tree, which produces complex flowers but no fruit, is a native of Asia and has been grown and developed there over many centuries. The Japanese have raised the flowering cherry, the *sakura*, to an exalted level and celebrate this unofficial national symbol in the annual festival of Hanami. More than 200 different cultivars are grown in Japan. During the January to April period, flowering cherry gardens throughout the country receive multitudes of visitors who schedule their visits to coincide with peak viewing times, much in the same way as Americans follow the emergence of leaf colors with the onset of fall. To the Japanese, the flowering cherry reflects the splendor of life, but also, given the transient nature of the blooms, its fragility. During Hanami, parks and areas around shrines and temples are crowded with families and friends holding flower-viewing parties.

In 1912, Japan made a gift to the United States of 3,000 cherry trees as a token of the emerging friendship between the two nations. Part of the gift was planted in Sakura Park in Manhattan, New York, but the remainder found its way to the water's banks in West Potomac Park, surrounding the Tidal Basin. The gift was renewed in 1965 with a further 3,800 trees. Americans have embraced the beauty of the trees and the custom of springtime reverence

The Shot

Standing amidst a grove of cherry trees in full blossom is a sublime experience. So many abstract descriptions come to mind—cherry parfait, flowered clouds, cotton candy, pink pillows, rosy kimonos—it is almost indescribable. The air is filled with falling blossoms, the streets and sidewalks are littered with millions of paper-thin petals, and, most marvelous of all, the light is pink! This is looking through the world with rose-colored glasses at its finest.

The first thing you do is look up, and for this shot, my camera followed my eyes as I looked skyward to the blushing roof above me. I had my camera set on a wide aperture so that the depth of field would be very shallow. I only wanted the central blossoms in my photograph to be sharp, with the rest of them going into soft focus to further the effect of cherry blossom clouds. The sky was a classic azure blue, and the limpid light of spring beautifully backlit the few new leaves. Everything in the photo says fresh, new, and spring.

 Take note of the "bloom watch" website (www.nationalcherryblossomfestival.org), which will track and predict to its best efforts the peak bloom time for the cherry trees. This period varies every year but always falls toward the end of March and early April.

Focal length 135mm; ISO 100; aperture f/5.6; shutter speed 1/250; April 2:31 p.m.

The Shot

As an artist, I try to find beauty in every situation. The overwhelming impression here, while standing in the Tidal Basin with the cherry trees arching around you, is that you are actually living in a Japanese etching. The drab and monochrome light on this day in particular gave the scene at water's edge an old, art-world feel. Many photographers would have kept their cameras at home during this weather—the clouds were pregnant with rain, and the ambience was close to gloomy. What this did for me, however, was to strip away any of the romance that would have been translated by pure color and boil the image down to its pure graphic sense. The water is wet and metallic, the branches are arching downward, and there is great tension where they would meet, but the water laps haplessly at the blooms.

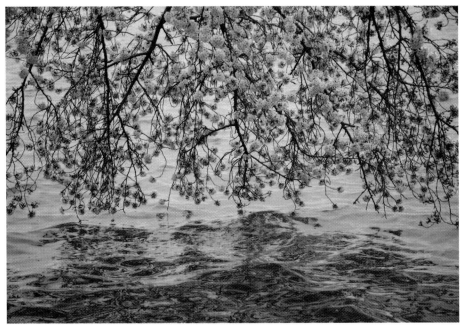

Focal length 85mm; ISO 100; aperture f/5.6; shutter speed 1/80; April 3:32 p.m.

Pink refuse.

Even the water is wearing petals.

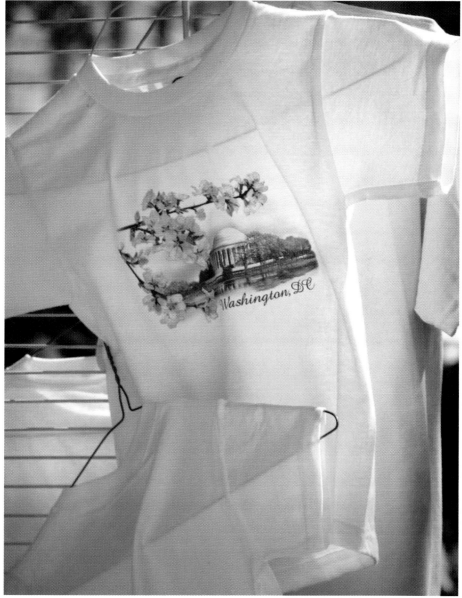

A souvenir.

Getting There

The Japanese Cherry Tree Garden is located in West Potomac Park, on a small peninsula constituting the southwest bank of the Tidal Basin. It can be reached by walking half a mile southeast from the Lincoln Memorial or by walking a quarter of a mile northwest from the Jefferson Memorial, crossing the bridge where the Basin opens into the Potomac River. For recommended timing to view the blossoms, go to the website of the National Cherry Blossom Festival.

When to shoot: morning, afternoon

Cherry Blossom Parade

Cherry blossoms are a renowned part of the spring calendar in DC, and Washingtonians don't let the opportunity pass them by without taking the chance to organize a festival and parade. The festival is brought to a close with fireworks over the Mall, but not before the National Cherry Blossom Festival Parade has worked its way along Constitution Avenue. The parade alone attracts around 100,000 spectators and has a decidedly lighthearted and energetic theme, welcoming in the spring and the promise of a bright year ahead. The parade is a celebration not only of the cherry trees and their pink profusion, but also of the arrival of good weather and the cycle of outdoor activities.

A blue-and-white-clad baton twirler.

The Shot

The crowds at this parade are enormous, and if you want to capture any really decent shots, you must plan accordingly. Arrive at the National Mall with enough time to stake your claim right at the edge of Constitution Avenue so that your field of view will not be hampered. Be prepared; every available horizontal surface—sidewalk, step, fire hydrant, lamppost, trash bin, or *any* protuberance that could possibly be construed as a place to sit—is enveloped with hordes of people trying to secure a better spot from which to witness the musical bands and costumed marchers.

Once the parade gets going, and if the security guards got out of bed on the correct side, you can actually walk quickly along with the parade right at the edge of the street. I think the bigger your camera is, the more you will have a chance to do this!

The sun is not overhead, even at noon, so the hats of these girls are beautifully backlit. The light-gray tarmac acts as a large reflector and bounces some light back up into their faces, filling the dark shadows and reducing the harsh contrast.

A smart way to get from here to there.

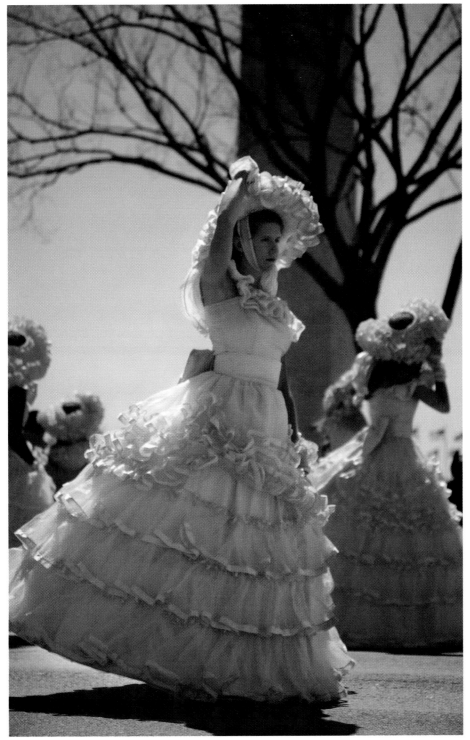

Focal length 109mm; ISO 100; aperture f/5.6; shutter speed 1/1000; April 11:24 a.m.

The Shot

By all means, do not pack your gear up and go home when the parade is over. Just as the preparations of an event such as this can offer up good photo opportunities, the behind-the-scenes activity can be equally as rewarding. Here, the performers let their hair down, and you can catch some very relaxed yet engaging moments. This tuba player was leaning against the travel bus in a state of quiet repose after having been marching and lugging his instrument for several hours. I approached him as I saw that he was preparing to unload his heavy equipment, and I was taken by his gentle expression and the connection that he so obviously had with his musical instrument. The proximity of the mouthpiece to his face, the gentle touch of his hand near the keys, and the ease with which he maneuvered the weighty piece all spoke of an intimate relationship. The stark black background of the bus perfectly outlines this musician and his beautiful brass tuba.

A fixture at every DC parade—the Pretzel Man!

Getting There

The parade passes along Constitution Avenue NW beginning at 7th Street and ending at 17th Street. The closest Metro stops are Federal Triangle (Orange and Blue Lines) and Archives (Green and Yellow Lines).

Listings, times, and locations of the festival events can be found under the Events tab on the National Cherry Blossom Festival website.

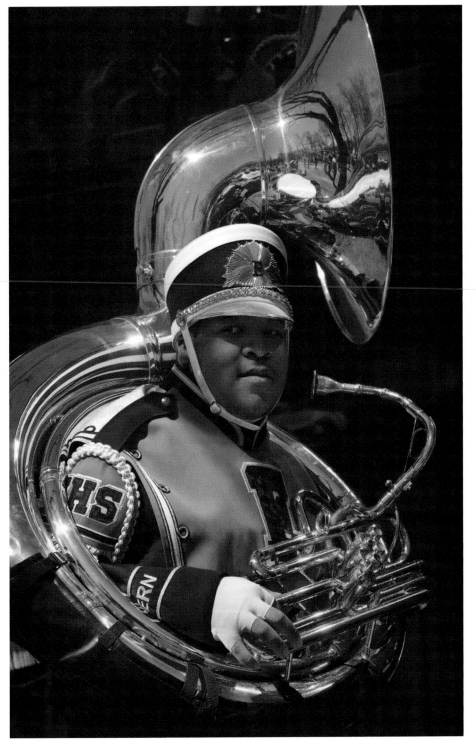

Focal length 135mm; ISO 100; aperture f/5.6; shutter speed 1/1250; April 11:50 a.m.

When to shoot: morning, afternoon

Independence Day Parade

Since 1777, the adoption of the Declaration of Independence by the Continental Congress has been celebrated on July 4th. From that first year onward, celebrations throughout the nation have included parades, fireworks, and summer festivities. The Washington, DC celebration follows that format but stands out as a national event through its goal of including in the morning parade representatives from every state in the nation. Competition by bands to represent their state in DC can be intense, with a formal procedure of recommendation by the state governor's office and video auditioning required. The DC parade is a well-choreographed affair featuring military units, floats, bands, giant balloons, notable VIPs, and a liberal sprinkling of patriotic nonconformists. The huge group of spectators along Constitution Avenue is treated to an exhilarating, flag-waving, red, white, and blue national birthday celebration.

The parade leads into a full day of events with the Smithsonian Folklife Festival on the Mall, followed by the evening's Capitol Fourth Concert, and culminating in a spectacular fireworks display over the Washington Monument.

The Shot

This shot was taken on the corner of Madison Drive and 7th Street NW, just at the very moment when these women were to start their parading. My on-camera flash, set at one stop below the ambient reading, beautifully enhanced the silky sheen of their scarlet outfits. The alabaster tone of their skin is a stark contrast to the intense red fabric and a perfect complement to the beige tone of the building in the background. The repetition of the red figures makes a strong composition, as does the triangular shape caused by receding perspective.

I was drawn to take this photograph for conceptual reasons in addition to structural ones. I could not resist the irony of the American flag neck scarves and fans juxtaposed with the very uniform-like and somewhat militaristic red outfits—a color that is heavy with political overtones. The martial aspect of this photograph is only exaggerated by the intense gaze of the women and their sense of being at the ready. It is just a lucky happenstance that even the very few stragglers who happen to be in this shot are also wearing red!

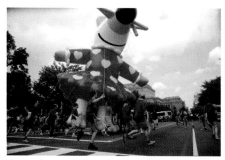

Energetic paraders.

Taking a break.

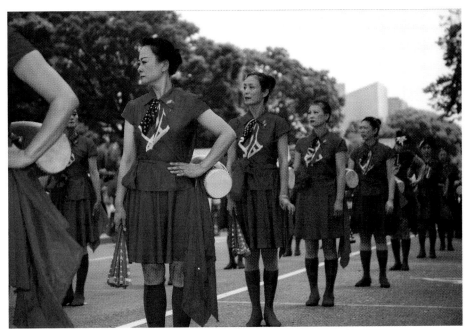

Focal length 109mm; ISO 100; aperture f/5.6; shutter speed 1/250; July 11:06 a.m.

Waiting to start.

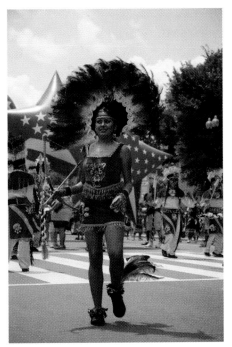

A member of a South American troupe.

The Shot

This shot also demonstrates an intensity, but of a significantly more playful and civilian genre. These girls are in a dancing troupe that hails from New Jersey, and what you see manifested in their expressions is the earnestness I witnessed in their attempts at mastering their steps. Again, I was shooting at the preparation area of the parade, on Madison Drive and 7th Street NW, with the spectators sparse enough to allow me the proximity and sense of intimacy captured here. The festive and patriotic balloons in the background frame the second girl perfectly, and again, the monochromatic outfits of the subjects lend an elegance to the shot that can sometimes be difficult to achieve in street photography. One must shoot instinctually and with speed to capture moments such as these—learn by repetition to trust your intuition and that gut feeling you have about a potential picture in front of your camera. At sports and public events, you do not have the luxury of time to compose your photographs with precision—you must go with your hunches and shoot quickly.

Focal length 90mm; ISO 100; aperture f/5.6; shutter speed 1/320; July 11:48 a.m.

Getting There

The parade route follows Constitution Avenue from 7th to 17th Streets. The Archives (Yellow and Green Lines) and Federal Triangle (Orange and Blue Lines) Metro stations are less than a block to the north of the route. Arrive early (the parade starts at 11:45 a.m.) to secure a place on the route or to gain access to the setup area on 7th Street as it intersects the Mall.

HORIZONTAL VERSUS VERTICAL?

Often when you come across a scene that you like, you might wonder whether you should frame your photograph horizontally or vertically. This is a very important aesthetic decision, as you can see from the two examples here. The vertical, or portrait, framing accomplishes usually just that—a portrait of your subject. This can be the most effective way of composing your picture when you wish to create a focused and intimate rendition of the scene you find in front of your camera—one with limited distractions the closer in that you crop. A horizontal, or landscape, framing, on the other hand, contains much more extraneous information. This inclusion of extra detail can work to your advantage because it puts your subject in a context and an environment. For this reason, be careful when you compose horizontally that what you are capturing has relevance and adds meaning to your photograph. A viewer will tend to linger longer on a landscape composition because, more often than not, they will scan a photograph from left to right.

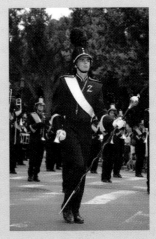

A horizontal versus vertical.

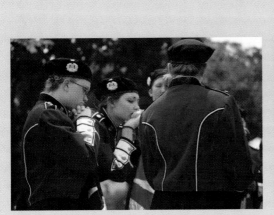

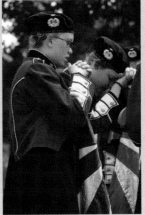

The same—horizontal versus vertical.

When to shoot: morning, afternoon

Rights Protests (ADAPT)

The governmental organization of the United States was designed around the democratic premise in which the elected representatives of the people would congregate in the nation's capital and on their behalf develop and pass laws. Wise people were elected to represent, to decide on behalf of the electorate how the country should be run. The electorate could influence their representatives through the ballot box or through discussion when the representative chose to return to his district or state. In the early days of government, distance, poor communication systems, and a simpler approach to life ensured the retention of this approach and a level of independence for the legislators.

Time passed, and people started to recognize that the activities of the world's most powerful government might not be best left to chance, and that there was an opportunity to be gained by giving them a helping hand in their deliberations. Two groups of people came to the forefront, attracted to Washington to push their agendas or the agendas of their employers into the minds and actions of the legislators: lobbyists and citizen groups. Such influence on behalf of certain groups can be viewed in two ways—either as unfair emphasis of special interest views or as provision of important and useful information to lawmakers.

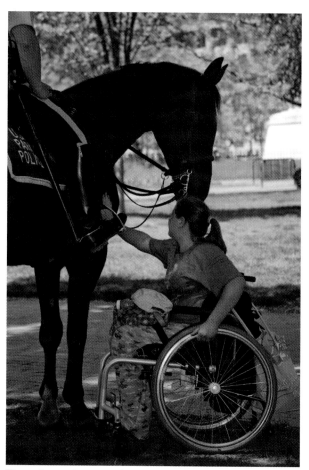

The policeman's mount draws some admiration.

Either way, the goal is to influence the lawmakers. While the majority of lobbying activity, carried out by well-remunerated Washington insiders, happens behind firmly closed doors, the work of citizen groups is often found on the streets of the city, attracting attention in a loud, colorful, and—dare I say—photogenic way. Keep your eyes open or scan the Internet to discover the work of some of the many citizens groups visiting the city to influence, protest, or demonstrate. They all have a story to tell, and almost all will be grateful to you and your camera for helping to tell it.

The Shot

This day and this event were like a gift to me from the photo gods. Conditions for shooting were perfect—clear blue skies, fresh green leaves, dappled light on the subject, bright and saturated colors, fill flash, a sense of humor, and willing subjects with a cause. What more could I have asked for? Oh, yes, and they offered me a bottle of water—did I mention hospitable and generous? As I wrote earlier, protesters and demonstrators are most often extremely willing to have their photograph taken, and the cooperation is welcome. A sense of positive energy exudes when there is a benevolent give and take between photographer and subject. I had my flash set here to fill at one stop below the ambient reading, which makes the bright colors really pop and helps to lighten up dark skin, but at the same time does not come across as too unnatural.

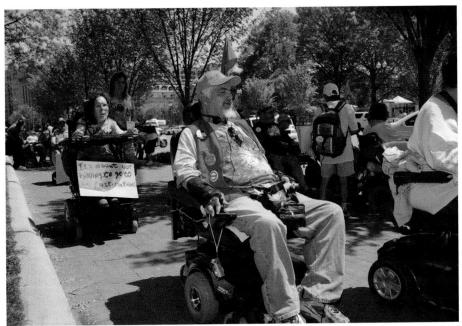

Focal length 41mm; ISO 100; aperture f/5.6; shutter speed 1/250; April 12:46 p.m.

The Shot

This shot could be described in almost the same words as the previous one, except here we add a much larger dose of humor, portrait-style. This fellow is a leading voice in the DC division of ADAPT, an organization that believes in Community Choice—an act that aims to ensure civil rights for those with disabilities. He was very willing to pose, interact, and share his passion for what he believed in.

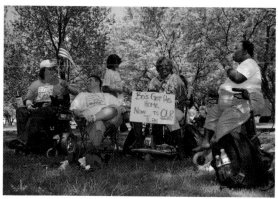

More colorful protestors.

Getting There

Protesters congregate in the open spaces in DC, depending on the cause to which they are bringing attention. Be alert around the Mall and main government buildings, and do not be shy about using your camera. The protesters themselves will not be shy about being photographed.

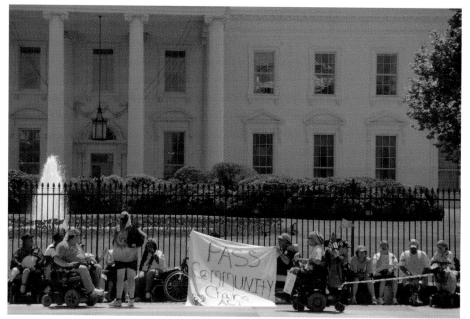

The White House plays host to many demonstrations.

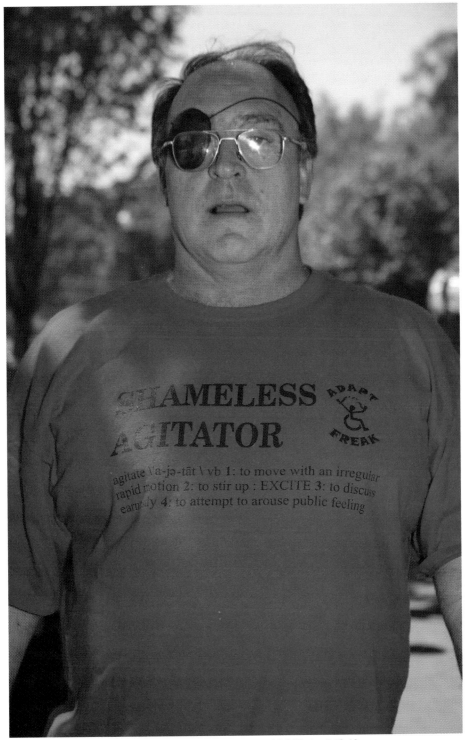

Focal length 80mm; ISO 100; aperture f/5.6; shutter speed 1/250; April 12:40 p.m.

When to shoot: morning, afternoon

Rolling Thunder

Washington, DC boasts a formidable array of art and architecture, sculptures and monuments, and parades and demonstrations, but there may be no more spectacular sight (and sound) than that of the annual Rolling Thunder Rally.

The motivation behind the Rolling Thunder Rally is to call for the continued recognition and protection by the U.S. government of American prisoners of war (POWs) and individuals missing in action (MIA)—a worthy cause, like many that are championed by visitors to DC. However, the means chosen to publicize the issue are of a type and scale like no other.

At midday on the Sunday of Memorial Day weekend, lead riders leave their congregation area in the vicinity of the Pentagon and forge a path for more than 400,000 motorcycle riders, the majority of whom are military veterans, each riding bikes of spectacular quality. The army of riders proceeds across the Arlington Memorial Bridge, around the Lincoln Memorial, and onto Constitution Avenue. From there they circle the Mall to finally recongregate on the grass of West Potomac Park.

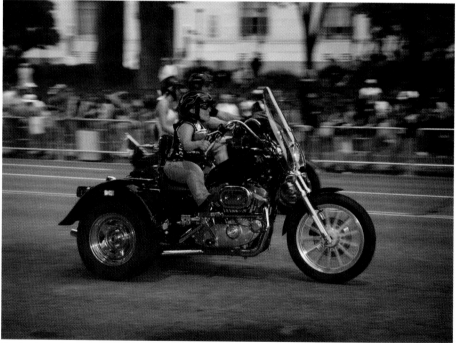

A tricycle and rider.

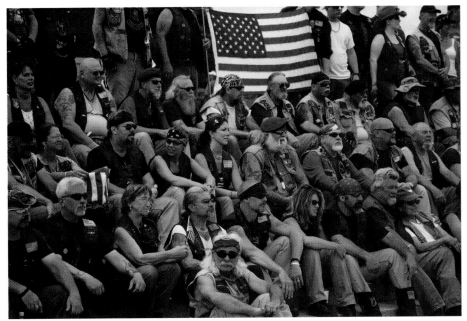

On the steps of the Lincoln Memorial.

The sight of this volume of two-wheeled advocacy is dramatic; the sound is overwhelming and entirely lives up to the name of the event. And finally, take in the sight of the characteristically attired bikers, their vests proudly declaring their allegiance and loyalty and their commitment to the fates of their brother servicemen. You will find the veterans attending events throughout the weekend: the candlelight vigil at the Vietnam Veterans Memorial on Friday evening, the wreath-laying ceremony at the U.S. Navy Memorial on Saturday morning, and the salute to our troops at the Reflecting Pool on Saturday afternoon.

The original Rolling Thunder Rally, named after a 1965 air campaign, was held in 1988 and was attended by 2,500 riders. Since that time, the continuing growth of the rally attests to the ongoing strength of concern for our troops and those making major sacrifices on our behalf. The event organizers have committed to continue the annual rally until all POWs/MIAs are accounted for.

The Shot

A sea of leather, chrome, and bearded bodies is what it was, and that is just what it looks like in this photograph, taken on the Saturday morning of the Rolling Thunder demonstration. The bikers and their cohorts gather in the Pentagon parking lots, across the river from DC in Arlington, on a first come, first served basis, with as many as 500,000 arriving by midday, when the "rolling" begins. From 5:00 a.m. until noon, you are free to roam and shoot this cooperative and hospitable bunch to your heart's content. I climbed up to the overpass of Highway 27, stood on a concrete divider, and pointed my camera north. The 300mm lens flattened the perspective of the scene, and I was sure to fill my frame edge to edge with the crowds to properly convey the expanse of the crowd.

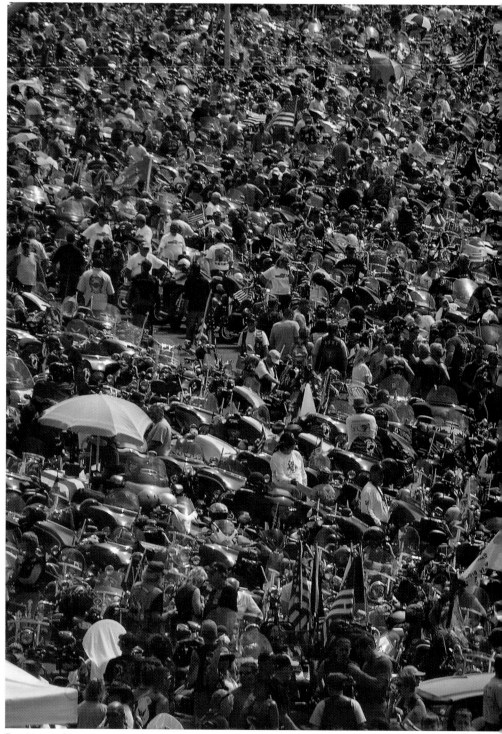

Focal length 300mm; ISO 100; aperture f/11; shutter speed 1/160; May 10:08 a.m.

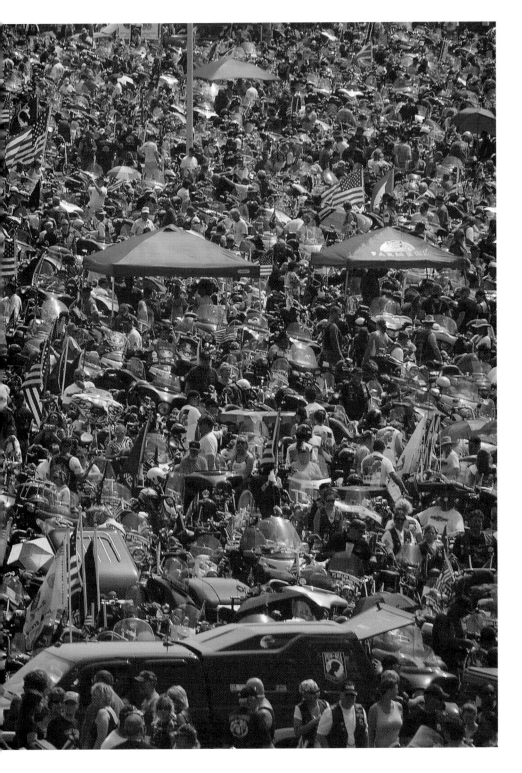

The Shot

I enjoyed myself tremendously while taking this series of pictures. I sat down literally smack dab in the middle of Independence Avenue SW, which borders the National Mall and is the last stretch that Rolling Thunder moves down before the bikes are parked and the festivities begin. The riders were not going very fast, so it was not as dangerous as it sounds. And, my shooting partner was standing right behind me, arms akimbo, to make us obvious to the drivers. The long telephoto lens proved invaluable again here, because it brought me in so close to my subject, who seemed straight out of Central Casting, and maintained a soft and non-distracting background. The flattened perspective forced the effect that the riders were almost right upon me. I had about 15 minutes of free and entertaining shooting, wondering all along when the security would cut my efforts to a halt. Sure enough, a policeman on horseback vociferously chased us away, but not before I got some really compelling frames.

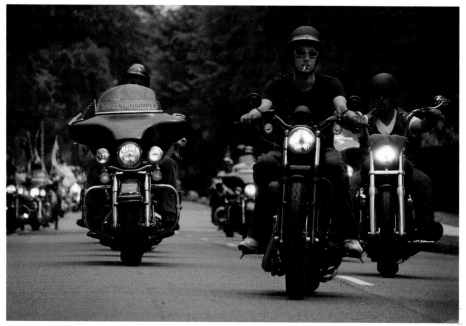

Focal length 275mm; ISO 100; aperture f/9; shutter speed 1/160; May 12:19 p.m.

Getting There

Viewing the rally and the bikes in full flow is easiest on Constitution Avenue, north of the Mall, but interesting viewpoints can be found on the Arlington Memorial Bridge or on the west side of the Lincoln Memorial. The congregation area at the Pentagon is reached by crossing the Arlington Memorial Bridge and turning left on the Jefferson Davis Highway. The mass of bikes and riders is readily identifiable in the Pentagon parking lot three quarters of a mile from the bridge.

A collage of leather and chrome.

TIP

Occasionally when framing and shooting your pictures, you will feel a sense of frustration because you *know* there is a shot there in front of you, but you just can't seem to find it. You may find that zooming in and focusing much closer on your subject matter is the solution. A tighter crop can bring some power to your photograph and accentuate details that were unnoticed from a more pulled-back point of view. Experiment at the same time with changing your crop from portrait to landscape or vice versa.

A Vietnam vet from a pulled-back view.

The same situation zoomed in and horizontal.

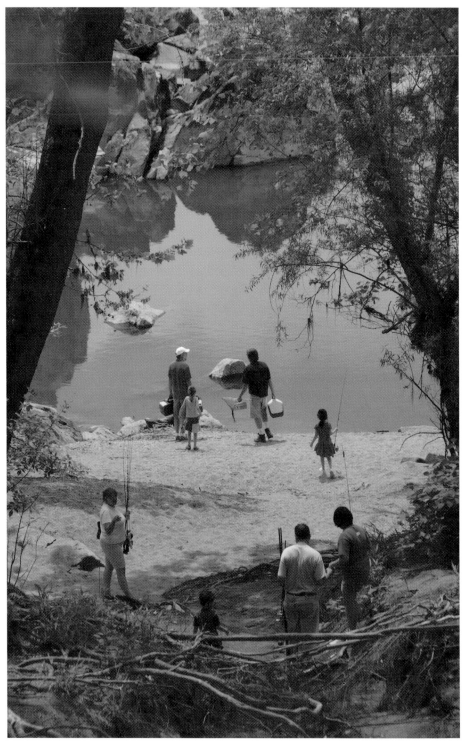

Fishing on the Potomac at Great Falls Park.

CHAPTER 4
Urban Oases

Unlike many American cities that architecturally evolve, Washington, DC was, for the most part, created. The lifeblood of DC is its politics, commemorative responsibilities, and international leadership, and as a result of this, aesthetics and the artful appearance of the town have always been a serious consideration in its formation. It is not a city based on industry or manufacturing, but of presentation, and the abundance of gardens, parks, finely landscaped and manicured mansion estates, nature preserves, and window boxes that we will explore in this chapter attests to this. You would be hard pressed to not encounter some flora or fauna in your sight line—Mother Nature and Washington, DC are the best of friends.

Shooting Like a Pro

By learning to recognize and appreciate beautiful light and trying to capture this quality in your own photographs, you will make enormous strides toward shooting in a similar mode to which professional photographers approach their craft. A pro knows that any scene, recorded at different times of the day, can look vastly different. Very early morning is a lovely time to shoot almost anything. Just before the sun appears, the air has an ethereal glow, whereas the hours immediately following sunrise are radiant with a delicate warmth. The low angle of the sun shortly after it has risen creates long shadows, and these, combined with the possibility of mist, will fill your images with depth and texture. During late afternoon and early evening, depending on the season, you will also see similar qualities. The color of the light toward sunset is even warmer than that of near dawn and is often referred to by pros as *sweet light*. The light just as the sun sets can be soft and flattering, and with the increased sensitivity of today's digital chips, you will be able to avoid long exposures. Try to arrange your schedule to shoot at these times, and you will be well rewarded.

If you find yourself out at midday, when the sun is the harshest, with creative thinking there are still ways to bring home professional-quality photographs. Using a polarizing filter will reduce reflections on non-metallic surfaces and will darken the sky. The use of a polarizer is also very effective in reducing reflections off vegetation, which has the effect of saturating leaves and foliage. Shooting in the dappled light from overhead foliage can be a handy way of avoiding noonday sun, and if you take advantage of your fill flash here, you will be especially pleased.

Overcast and even gentle rainy days are perfect for shooting gardens and flowers. The light is diffused and even, keeping shadows to a minimum and saturating the colors. Many photographers, including garden specialists, will hose or mist the surfaces they are shooting to increase color saturation. Leave your hose and mister at home, but do take advantage of a damp and overcast weather forecast by shooting greenery and foliage that day.

The Gear

The only photo op in this chapter that requires a lens that you may not have in your usual bag of tricks would be the National Zoo. A long telephoto lens is indispensable in shooting portraits of many of the animals. If you do not own one, it is simple to organize the rental of one (and of any other gear you may need) at a camera store such as Penn Camera in the downtown area.

Do remember, however, that the use of a long telephoto may change your normal shooting style. The "shoot from the hip" or quick journalistic approach that you may be familiar with when using a wide to normal lens length is not appropriate when shooting with long lenses. For handheld pictures that have minimal camera shake, be aware of and try to follow the rule of thumb that suggests you set your shutter speed at no slower than the reciprocal of the focal length of the lens. For instance, with your 35mm lens, you may shoot with a shutter speed of 1/35 or faster, whereas with a 300mm lens, you will need to shoot no slower than 1/300 to avoid camera movement.

Working with a tripod and cable release would allow you to skirt around this rule—just be vigilant of where the use of such may be prohibited or inconvenient. I have found that with a very long lens, a little creativity can help you to gain several stops of exposure. Keep your eyes open for places to rest your body and camera while exposing—walls, fences, and gates can all provide firm support. Remember to hold your breath, keep your elbows at your sides, and give yourself stable support by keeping your feet shoulder-width apart. All these techniques will help to keep your images sharp.

The Plan

Many of the locations in this chapter are secluded enough to allow you to take time and care with your photography. This is a perfect chance for you to play with and really apply some composition and framing techniques that you may have learned. Use this opportunity to hone your skills. Be studious and really *look* through the lens. Take note of what you are seeing and learn to *make* photographs rather than simply record a scene.

Experiment with both shallow and deep focus fields and test horizontal and vertical compositions. Do not be afraid to make mistakes, because it is often through these errors that you will serendipitously discover a method that works for you.

TIP

Take advantage of willing models and benevolent shooting environments to experiment with more artful types of shots. Play with purposefully moving the camera at slow shutter speeds to render some movement or compose and focus in a different manner than you normally would. Through trial and error, you may come upon a shooting style for which you have a real affinity.

A black seal—a different focus than usual.

A Brazilian Arapaima fish—a little soft and lovely.

When to shoot: morning, afternoon

Great Falls

The positioning of the nation's capital along the Potomac River was not an arbitrary choice. Just 10 miles north of Washington, DC stands the Great Falls—a formidable obstacle to river travel and consequently the farthest limit upstream that a major city might be built or advantageously positioned. It's good news, however, for current residents and visitors to DC, because not far from the city's refined museums and imposing seats of government stands a quite rugged natural spectacle. Dropping nearly 100 feet in a sequence of 20-foot cascades, the Potomac presents a very different face to its wide and tranquil visage just a few miles downstream. Area residents visit the Great Falls as they tumble through the Mather Gorge and within its environs take advantage of opportunities for hiking, picnicking, kayaking, rock climbing, bicycling, and horseback riding.

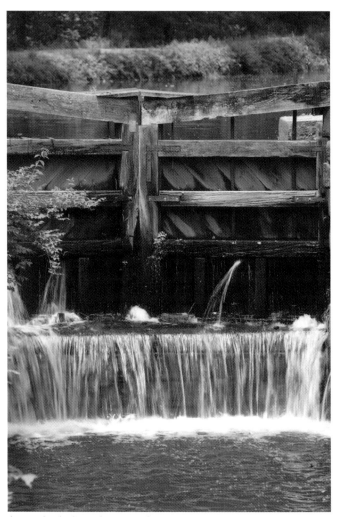

Access to the falls can be obtained from the Great Falls Park on the west bank or from the Chesapeake and Ohio Canal Park on the east bank. Approaching the Falls from the C&O Canal Park allows you to spend time viewing the historical remains of the canal from the well-maintained canal towpath, which forms the backbone of the park. Built in the

A wooden lock on the towpath.

1830s and operated until 1924, the canal provided a solution to the "problem" of the Great Falls and other elevation changes to the north. Running parallel to the Potomac, the canal allowed navigation and a farther 185 miles upstream through a sequence of 74 locks, 150 culverts, 11 aqueducts, and a tunnel of more than 3,000 feet in length.

On your visit to Washington, DC, find your way to the Canal Park, follow the boardwalk to the Great Falls viewing areas, and picture yourself in an altogether different place.

 Waterfalls will look silken and smooth if you shoot the rushing movement with a slow shutter speed. A setting of 1/20 (employed in the image of the wooden lock) or 1/10 of a second will give you a nice flowing wall of water, which will add to the peaceful feel of a scene.

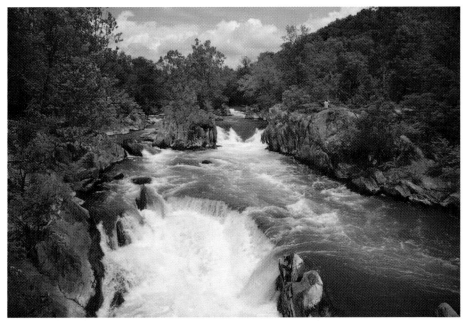

The rapids at Great Falls.

The Shot

As I was peering through the viewfinder while taking this photograph, I felt immediately transported to the coast of South Africa or as if I was witnessing a Japanese watercolor come to life. The majesty of this bird, a Great Blue Heron, took my breath away, with his seven-foot wingspan and supremely graceful flight. Patience and good timing allowed me to capture this image—I must have had my lens trained on him for 25 minutes while he canvassed the rapids for his fishy dinner. I assumed that he would eventually, whether successful in his quest or not, fly away, and I had my finger at the ready on the shutter release button. My short shutter speed caught both his rapid movement and that of the water as it roiled underneath him.

Focal length 300mm; ISO 100; aperture f/5.6; shutter speed 1/1600; May 12:36 p.m.

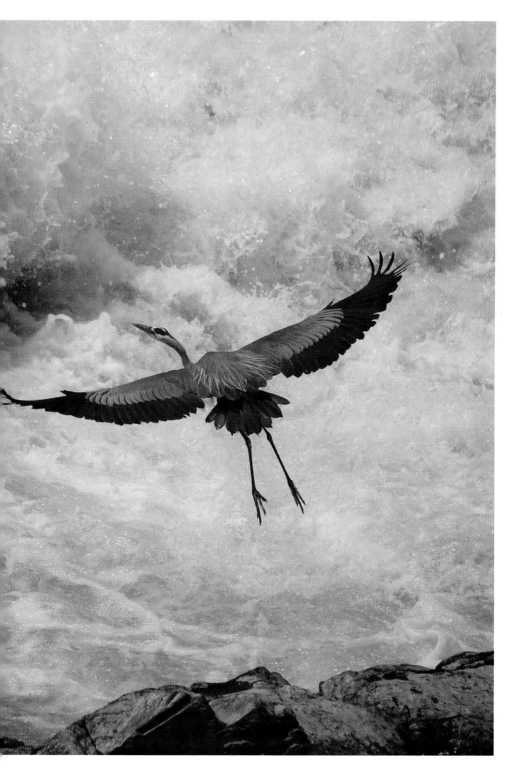

The Shot

A walk along the C&O Canal towpath will proffer many serene and bucolic scenes that are in stark contrast to the rapid waters of the Great Falls themselves. The shoreline and trees are mirrored in the brackish water, and strong, painterly compositions can be found at many points on the path. I liked the way the trees here had a kind of dynamism—they almost looked as if they were growing rapidly before my eyes, and the intensity of their green foliage was striking. The concrete structure in the water balances the strip of sky above, and the gray of the tree bark adds strong diagonal lines.

Getting There

The C&O Canal Park can be most readily reached by car. Leave Georgetown traveling west on Canal Road. Follow Canal Road as it turns northwest, parallel to the old canal route. After three miles, at the Chain Bridge, the road name changes to Clara Barton Parkway and continues for a further six miles, passing Route 495 (the Capital Beltway at Junction 41), until it reaches a T junction at MacArthur Boulevard. Turn left and continue for one additional mile and look for parking spaces on the street and access trails down to the canal. From here, you can walk along either of the canal banks to reach the boardwalk to the viewing platforms. Continuing by car two miles farther along MacArthur Boulevard will bring you to the park Visitor Center, which allows for the closest approach by car to the Falls.

A view of the canal from the wooded side.

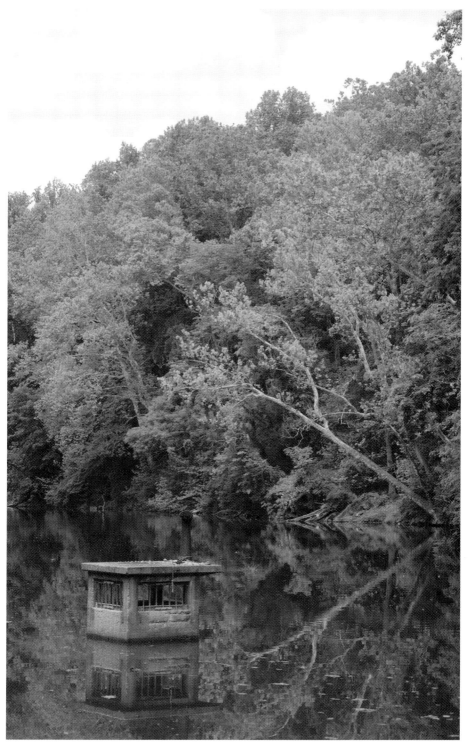

Focal length 90mm; ISO 100; aperture f/8; shutter speed 1/50; May 11:29 a.m.

Hillwood Estate Gardens

In 1955, Marjorie Merriweather Post, heiress to the Post cereal empire, purchased the Arbremont Estate located in northwest Washington, adjacent to the southern end of Rock Creek Park and north of the National Zoo in Woodley Park. Ms. Post transformed the estate inside and out. The mansion was internally remodeled to allow for the display of an extensive collection of 18th- and 19th-century French art and a large collection of Russian Imperial art acquired when the owner's husband served as the American ambassador to Russia. Today, these collections form the centerpieces of a formal museum.

The gardens underwent a spectacular metamorphosis. Twelve of the twenty-five acres were converted to formal gardens, each featuring a separate theme—French, Japanese, Rose, and for formal outdoor receptions, the Lunar Lawn. An extensive greenhouse was built to support the gardens and to house a glorious collection of 2,500 orchids, while a separate Cutting Garden was established as a source of cut flowers to enhance the museum. The estate is now supported and managed by the Post Foundation and is open to the public from Tuesday through Sunday throughout most of the year. The gardens are at their most spectacular in the spring and fall.

Marjorie Merriweather Post passed away in 1973. Visit Hillwood and savor the legacy of intense beauty and elegance that she left behind.

One of the outdoor gardens.

The Shot

This is a view of the western flank of the Hillwood House from the Rose Garden, which was designed by Perry Wheeler, a landscape architect who had also worked on the same at the White House. Mr. Wheeler was widely known for his cutting-edge use of pavers, creating intricate patterns in paths, and for using a grand variety of materials. His playful array of organic elements is what gives this photograph such interest and keeps the viewer's eye moving back and forth to absorb it all. There is a plethora of objects in this composition, yet they are so artfully arranged that the final design is complex and still beautiful. The delicate play of light and shadow on every surface and the spots of complementary colors only add to the visual appeal.

Focal length 70mm; ISO 100; aperture f/5.6; shutter speed 1/160; April 1:14 p.m.

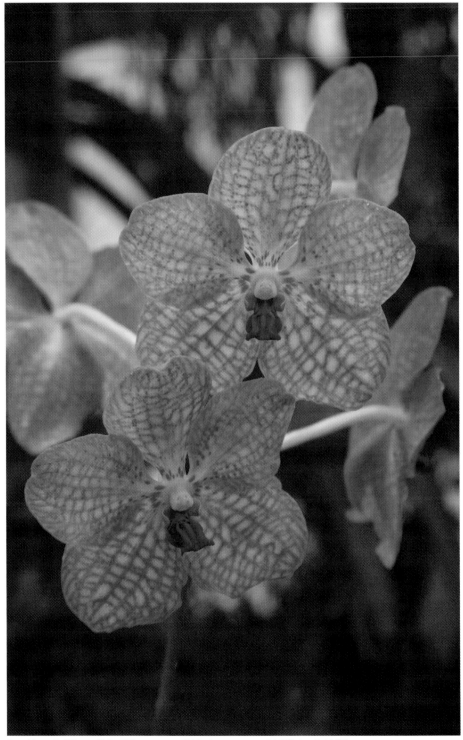

Focal length 90mm; ISO 100; aperture f/7.1; shutter speed 1/80; April 11:56 a.m.

The Shot

Blue orchids are uncommon, and this one, with its unusual checkered petals, made quite a statement in the Hillwood greenhouse. The color is an odd one to encounter in nature, and bathed by diffused light, the flowers seemed to emanate an unearthly glow, especially in contrast to the deep green of the leaves. Zoom in close to the flowers to show the texture and design. When shooting at such proximity to a subject like flowers, which have depth, a midpoint aperture such as f/7.1 is necessary to keep the facing petals in focus but still allow the background to go soft. This relieves distraction and keeps viewers' eyes on the flowers. The condensation that lines the greenhouse glass keeps the light level inside quite low, so be sure to have your tripod on hand.

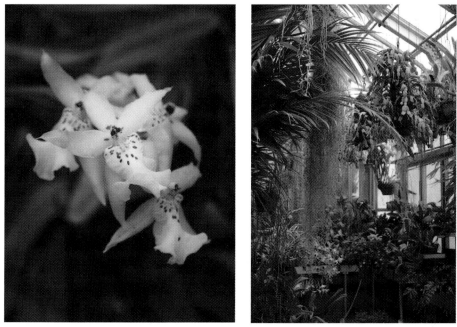

Another beautiful specimen. A tangle of hanging plants in the greenhouse.

Getting There

Hillwood Estate, Museum, & Gardens is located at 4155 Linnean Avenue NW. It is one of the few destinations in Washington where travel by car is recommended. The estate provides complimentary parking and easy access. Proceed north on Connecticut Avenue from downtown DC. Go through Woodley Park and past the National Zoo and then turn right onto Tilden Street. Take the second left onto Linnean Street. The estate will be on your right.

The estate is closest to the Van Ness Metro station (Red Line). From the station, walk south on Connecticut Avenue and turn left onto Upton Street. Turn right onto Linnean Avenue. The entrance to the estate will be on your left.

When to shoot: morning, afternoon

National Zoo

Through its 120 years of existence, the National Zoo has presented to visitors a fascinating array of fauna. The zoo has stood as a characterizing element of Washington, clearly living up to its status as the *National* Zoo.

The zoo was established in 1889 by an Act of Congress, and the park was designed and built at its current location in Woodley Park. Through its first 60 years, coinciding with the era of the big game hunter, the role of the zoo was very much as a presenter of exotic and spectacular wildlife.

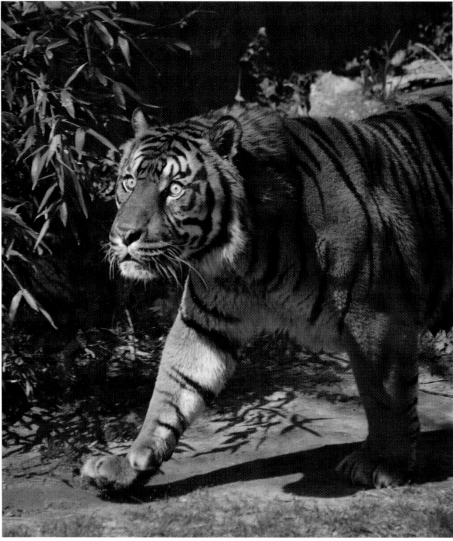

A tiger on a prowl.

In the 1950s, the Smithsonian Institution took on sole responsibility for the zoo. In the '60s, the zoo's personnel refocused on the study of animal breeding and the protection of threatened species.

The zoo has been famous for its efforts to secure the future of the Giant Panda. Much research effort and support has been given to Ling Ling and Hsing Hsing (and more lately, Mei Xiang and Tian Tian) in their efforts to become panda parents. Development of the zoo has continued with installation of the Kid's Farm in 2004 and more recently the Asia Trail, providing a habitat for seven rare Asian species, including the sloth bear, red pandas, and cloud leopards. Elephant Trails—a major new program—includes extended facilities at the zoo and expanded research programs aiming to aid endangered elephant populations around the world. The zoo presently stands tall among the ranks of those committed to the protection of the Earth's threatened biodiversity.

The Shot

Some people will do almost anything not to have their photograph taken, and the same goes for some members of the animal kingdom. This giant anteater, for instance—she is so shy that in the wild, when her habitat is near humans, her behavior will change from diurnal to nocturnal in order to avoid human contact. And, take note of her camouflage—which appendage is her head and which is her leg? She would much rather quell attention than attract. Needless to say, in order to get this picture, I had to arrive at her pen right at mealtime, when she and her baby (see the little one riding piggy-back?) paced the enclosure in anticipation of their insect-laden dinner. Photographing animals is all about patience and good timing. You must wait and wait with your camera at the ready for that photogenic instant, and when it happens, be fast! Anticipate the moment and take several frames to cover yourself. You probably will not get a second chance.

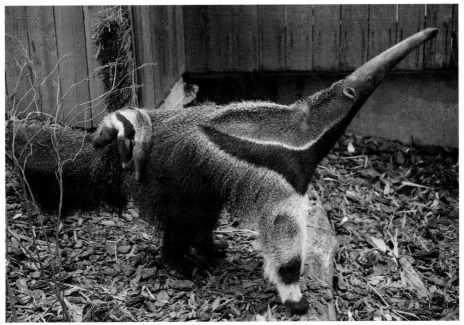

Focal length 70mm; ISO 100; aperture f/5.0; shutter speed 1/50; April 2:48 p.m.

The Shot

This gray seal, on the other hand, was as outgoing as a high school cheerleader. He and his mates played games and performed at a ferocious pace for the onlookers. The vantage point for spectators is very close to the enclosure, and since the seals move so quickly and unpredictably, it is somewhat difficult to capture them in "flight," even with a wide-angle lens. Again, as with most of the zoo animals, feeding time became a perfect opportunity for a portrait. This shot was taken from the walkway at the perimeter of their pool, and the seal was so focused on the trapdoor through which would come his dinner that I was able to capture several good frames. A long telephoto lens enabled me to capture an intimate and anthropomorphic portrayal of this seal, with all his facial and dermatological aspects in great detail.

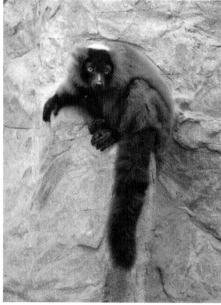

A red-ruffed lemur.

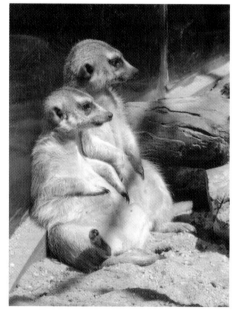

Meerkats, looking as if they're relaxing after a beer and a pizza.

Getting There

The National Zoo is located at 3001 Connecticut Avenue NW in Woodley Park. The zoo can be reached on the Metro Red Line, either from the Woodley Park/Zoo/Adams Morgan stop or from the Cleveland Park stop. The zoo lies halfway between these stops, and both are a half-mile or less from the zoo. From Woodley Park-Zoo station, walk north (gently uphill) on Connecticut Avenue. The zoo entrance will be on your right. From the Cleveland Park stop, walk south on Connecticut and look for the zoo on your left.

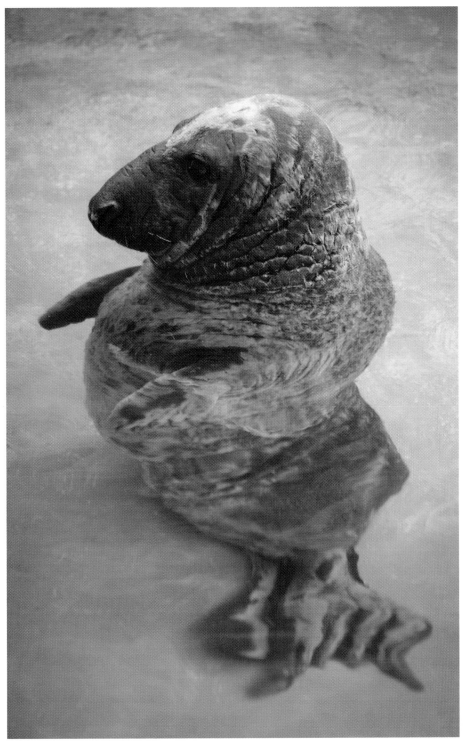

Focal length 250mm; ISO 100; aperture f/5.6; shutter speed 1/40; April 3:02 p.m.

When to shoot: morning, afternoon

National Aquarium

Reflecting the importance of the nineteenth-century fishing industry in the northeast, a National Aquarium was established in Wood's Hole on the coast of Massachusetts in 1873. Five years later, the aquarium came to DC, when it was moved to Babcock Lakes, a set of holding ponds located near the current site of the Washington Monument. This was followed in the 1880s by another move to holding pens and a small aquarium located at the current site of the Air and Space Museum on the south side of the Mall. When the Department of Commerce building was constructed in 1932, the aquarium was located in the lower level and has remained there ever since. Federal funding for the aquarium was withdrawn in 1982, but since then, the institution has been governed by the National Aquarium Society, a private nonprofit organization. In 2003, the Washington Aquarium entered into an alliance with the National Aquarium in Baltimore, allowing the aquariums to collaborate in the development of their collections and educational outreach.

The National Aquarium in Washington welcomes 200,000 visitors a year to view 1,500 specimens representing more than 250 species. Special exhibits feature environmentally sensitive aquatic environments. Through its displays and programs, the aquarium fulfills its chosen mission of seeking to inspire enjoyment, respect, and protection of the aquatic world.

A baby loggerhead turtle.

Keeping a watchful eye.

The Shot

Making photographs at the National Aquarium is a little like taking a vacation from your vacation. It is a surreal experience to wander in this subterranean fishbowl during the day, which is what happened to me when I had a yen to be creative but needed to escape the harsh light of noon in order to do so. Shooting the sea creatures below is all about having fun, playing with colors, and making art out of the crazy shapes and textures that surround you. This anemone, a *Heteractis crispa*, is in a tank on the left side of the entrance to the aquarium and is very well lit compared to many of the other exhibits. I did not use a tripod for this shot, but I did set my ISO to 200 to glean an extra stop and leaned my camera against the thick glass of the tank for support. Crop in very closely, which, in addition to highlighting the incredible color of the tips and translucent texture of the "arms," turns the photo into an abstract expression, rather than a simple document, which is what you would get if you included the anemone's environs in the crop.

Focal length 95mm; ISO 200; aperture f/4.5; shutter speed 1/100; April 12:23 p.m.

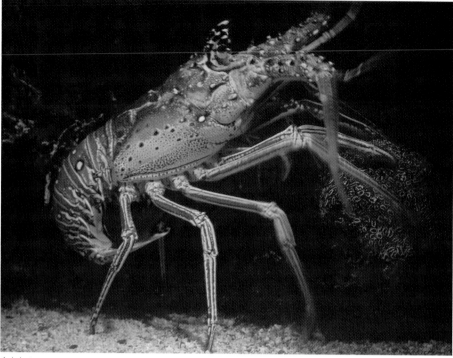

A lobster.

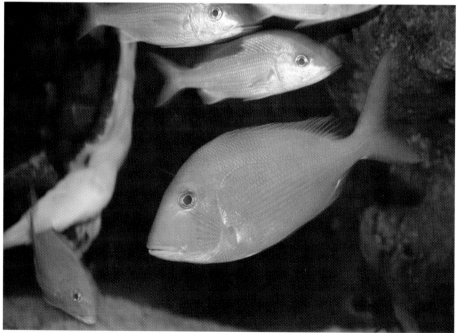

Friends of the loggerhead.

The Shot

I could not even truly believe that these things (sea anemones called *Tealia lofotensis*) were real when I rounded the corner and came across their tank. The colors and textures astounded me, and I must have shot at least 20 frames—I was so excited by their appearance! This tank was *very* dim, and I had to use my tripod to avoid any camera shake. To keep from bothering other visitors when in a public place such as this, I often do not spread the legs of my tripod but keep them tightly pressed together and use it more as a monopod. This gives me a great deal of steady support while still maintaining a relatively low profile. I also used my on-camera flash, but set at two stops under to keep its effect very, very subtle. If you do use your flash, to avoid any reflection from the glass, you must be very careful to always shoot at an angle of close to 45 degrees to front of the tank. Any more direct than that, and you will catch the reflection of the flash in the glass.

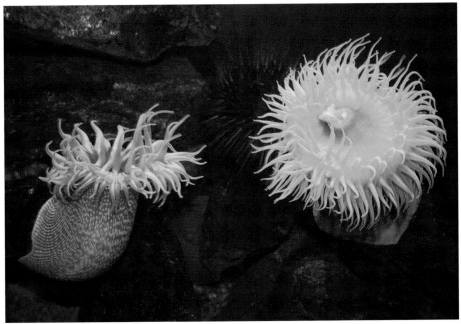

Focal length 95mm; ISO 100; aperture f/5.6; shutter speed 1/5; April 3:04 p.m.

Getting There

From the Federal Triangle Metro station (Orange and Blue Lines), walk south on 12th Street for a few yards and then turn right along Constitution Avenue. After one block turn right on 14th Street; the rather austere façade of the Department of Commerce will be on your left. The Aquarium is located in the lower level of the building. Be sure to ask at the front desk whether tripod use is allowed that day—they are flexible.

When to shoot: morning, afternoon

Old Town Alexandria

The early development of the American colonies owes much to the development of trade opportunities, equally as important to the colonists as their desire for political or religious freedom. The area at the navigable limit of the Potomac proved to be an attractive site for the development of commercial communities providing markets and trading centers for the interior regions of the new country. Georgetown, on the eastern banks of the Potomac, is one example, while the town of Alexandria, located across the Potomac, is another. The first colony on the current site was established in 1695, while the street plan that has survived to the present day was originally laid out in 1749. Alexandria remained an important port throughout the colonial, revolutionary, and Civil War periods.

Much of the sense of the original Alexandria persists within Old Town. This portion of Alexandria includes the original town and its grid plan and runs down to the waterfront. The area features a blend of historic buildings and museums with a revitalized community of modern shops, hotels, and restaurants.

The Shot

This is the type of photograph that is served up to you—as a result of classic architecture, good landscaping, and beautiful weather, this shot existed right before my eyes. My responsibility was to notice it, compose, and crop. An impression of "collage" occurs as a result of all the intersecting planes, lines, and textures, and the use of the telephoto lens, as short as it was, has flattened the photograph and given it a very graphic quality. A wide aperture gave me a very shallow depth of field, with only the leaves and finial at

A small park behind the Carlyle House.

midground in perfect focus. The polarizing filter converted the harsh light of midday to a lush and color-saturated view. This backyard scene is on Fairfax Street, very close to the intersection of Duke Street, and is readily visible from the sidewalk. Remember to keep your eyes open *all* the time, and you will discover photo ops in many surprising locales.

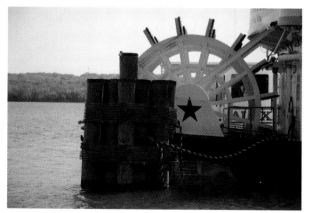

A paddlewheel boat on the Potomac.

Focal length 115mm; ISO 100; aperture f/5.6; shutter speed 1/400; April 11:57 a.m.

The Shot

At the intersection of Duke Street and the Strand, you will find before you a busy pier with restaurants, docked boats, and a waterfront park with a row of benches facing the Potomac River. The figure of this woman added a soft and organic element to an otherwise extremely hard and linear arrangement. I composed this photograph very purposefully and was conscious of placing all the elements exactly where I intended for them to be. The top of the bench in the foreground made a solid base for the picture, and I placed the woman close to the center of the frame. The two bright blue shapes add a touch of visual tension, as does the very small strip of water that is visible above the two upright posts. Details such as these are extremely important and can separate a mediocre picture from a very good one. This photograph contains a peaceful scene, but the eye is kept moving over the frame as the viewer's gaze follows the lines and shadows.

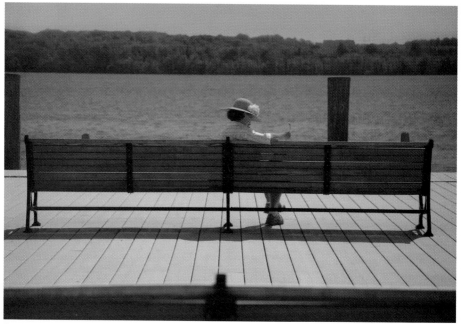

Focal length 109mm; ISO 100; aperture f/5.6; shutter speed 1/1000; April 10:21 a.m.

Getting There

The Yellow or Blue Metro Line will take you from DC into Virginia and south along the Potomac to King Street Station in Alexandria. The station is located to the west end of Old Town. Walking east on King Street will take you through the town, reaching the waterfront after about one mile. To avoid the walk, take the Red or Yellow Dash bus line that runs from the Metro station along King Street to the waterfront.

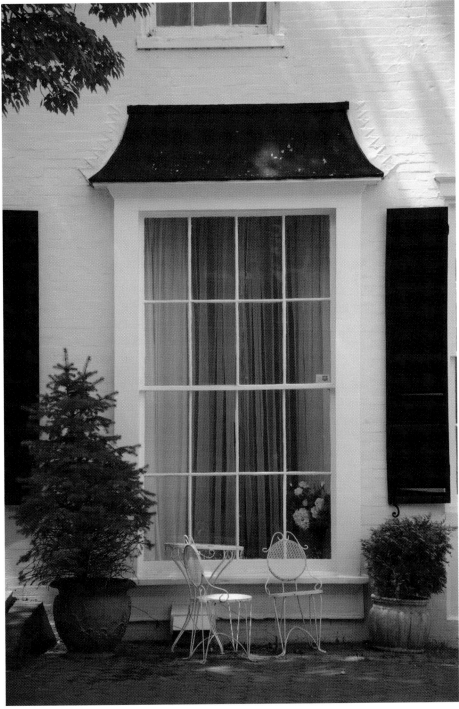

Classic Old Town Alexandria.

When to shoot: morning, afternoon

Rock Creek Park

Rock Creek, never more than a moderately sized stream, wends its way out of Maryland and cuts through northwest DC, finally joining with the Potomac just to the south of Georgetown and Foggy Bottom. The creek, however, forms the backbone of Rock Creek Park, a major feature of Washington, DC. At its southern end, below the National Zoo, the park is a fairly narrow band of land enclosing the Rock Creek and Potomac Parkway. On the other hand, the northern portion comprises one of America's oldest national parks, having been formally instituted in 1890. But, as a visitor, you might be excused for not initially recognizing its presence. Although Rock Creek Park, at 1,754 acres, is more than twice the size of Central Park in New York City, it is easy to travel around DC and not encounter its green attractions.

The park passes through a valley in the topography of the city, and many of the thorough-fares in its vicinity, particularly those nearer to the city center, pass over on bridges rather than directly through the park. However, finding your way down into the park is well worth the effort, as you will find a hiking, biking, jogging, and picnicking refuge close to the heart of the city.

The park is under the jurisdiction of the National Park Service, which oversees a wealth of recreational facilities and cultural exhibits, such as the Nature Center and Planetarium, the venerable Pierce Mill, and multiple relics of Civil War fortifications.

The Shot

It is more likely that a photograph such as this would be taken in the rural outskirts of a town, but no…I am standing literally smack dab in the center of vibrant and populated Washington, DC. This view is from the Duke Ellington Bridge that reaches over Rock Creek Park and carries Calvert Street from Woodley Park into Adams Morgan. The overpass that is captured in the photograph is the Connecticut Avenue Bridge. What grabbed my eye first was the verdant foliage and its incredible variety of tones, shapes, and textures—the bridge seemed to be bobbing along on a rolling sea of green leaves. This ocean of color constitutes a majority of my frame, as that is what I really wanted the viewer to focus on. The shape of the bridge is a solid and grounding element topped by a crisp, blue sky, whose primary hue is a perfect complement to the vibrant greens of the foreground.

> **NOTE**
>
> Take care to shoot with a fast shutter speed when photographing from bridges and overpasses. This will keep the vibration of the traffic from affecting the sharpness of your pictures.

Focal length 85mm; ISO 100; aperture f/5.6; shutter speed 1/200; April 8:10 a.m.

Focal length 135mm; ISO 400; aperture f/5.6; shutter speed 1/50; April 10:21 a.m.

The Shot

The Information Center at the northern end of the park boasts an interesting and quirky display of preserved indigenous flora and fauna. There is a plentiful selection of table-sized dioramas, all of which have slightly yellowed photographs as their backgrounds, lending a certain nostalgic feel to the ambience. This, in conjunction with the rust-colored carpet and bas-relief black-and-white plastic information labels, brought me back to elementary school science class days!

Making photographs of the displays is a nod to those artists who have photographed the larger, more complex, and much better known dioramas at the Museum of Natural History in NYC. It is half art and half documentary museum photography—your background is an existing photograph, and you are capturing someone's ready-made arrangement. The visual irony is that the scene is meant to be experienced live, not secondhand. The room is dim, so be sure to either bring your tripod or gain some f-stops by increasing your ISO.

A feathered friend in a diorama.

The shadow of the Connecticut Avenue Bridge.

Quince blossoms at the Pierce Mill.

Riding is one of many activities in Rock Creek.

Getting There

Unless you are an intrepid bike rider, Rock Creek Park is actually best visited by car. Beach Drive passes around the zoo and then through the remainder of the park to the north. It can be accessed from Connecticut Avenue just to the south of the Woodley Park Metro station by taking 24th Street down to the park level. The Rock Creek Nature Center and Planetarium is located at 5200 Glover Road NW, near the intersection of Military Road and Glover Road. Military Road intersects Beach Drive near the center of the park. When travelling north on Beach Drive, turn left on Military Road and look out for the signs indicating Glover Road and the Nature Center on your left.

When to shoot: morning, afternoon

United States Botanic Garden

The unusual proximity of the U.S. Botanic Garden to the seat of government can be traced back to its inception at an early date in the life of the capital of the new republic. In 1816, the Columbian Institute for the Promotion of Arts and Sciences promoted the inception of a botanic garden as a repository for plants that might be distributed throughout the country to the benefit of U.S. citizens.

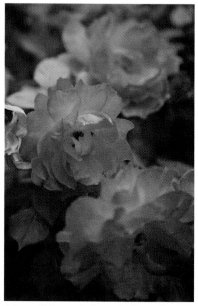

The garden was established at the eastern end of the Mall in front of the western face of the Capitol, but it fell into decline with the demise of its parent organization in 1837. In 1842, the Wilkes Exploring Expedition returned from the South Seas, and their collected bounty drove the need for and the rebirth of the Botanic Garden. The garden was fully stocked and reestablished by 1850 and has remained continuously in operation ever since. However, to realize the original design of the Mall as an open space at the center of the city, the garden was moved in the early 1930s to its current position, still adjacent but now directionally to the southwest of the Capitol.

Today's garden consists of three parts: the Conservatory, the National Garden, and Bartholdi Park. The recently renovated Conservatory houses more than 4,000 plants from widely varying climes and features exhibits

A beautiful sample from the Rose Garden.

and educational programs throughout the year.

The National Garden is a 2006 addition to the complex. It serves as an outdoor learning center and features the First Ladies' Water Garden and rose and butterfly gardens against a background of local plants from the mid-Atlantic region. Opposite the Conservatory, Bartholdi Park majors in decorative landscaping organized around a classical fountain whose designer, Frédéric Auguste Bartholdi, also created the Statue of Liberty. It is unlikely that any other world capital features such botanical diversity so close to its center.

The Shot

If you are a fan of Edward Weston's black-and-white photography, you will recognize immediately here my homage to his inimitable work. This plant is a Parry's Agave and can be found in the Succulent section of the Botanic Garden. The lighting in the plant conservatories is beautiful—a huge expanse of frosted-glass ceiling makes it seem as if you are in your own personal north-light painter's studio. The light can get dim here during an overcast day, and your exposures may get too long for shooting handheld, so be sure to bring your tripod with you. Once I found this plant, I worked with it for a good length of time to find the most comfortable composition—it looked best off center both left to right and top to bottom.

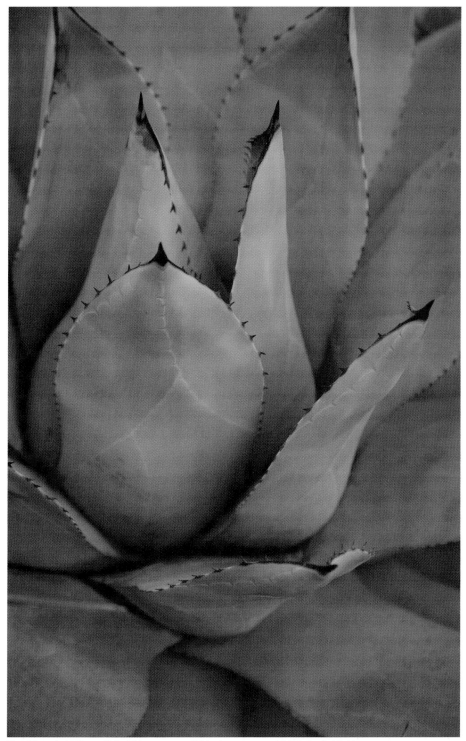

Focal length 135mm; ISO 100; aperture f/7.1; shutter speed 1/50; April 11:44 a.m.

The Shot

In some respects, the formal layout of many parts of the garden leaves your photographic compositions to the ready and waiting. All that is left is for you to find the best vantage point. This pool can be found in the very front of the conservatory and is surrounded by colorful plantings throughout the year. Park yourself at the easternmost end of the pool and face into the center of the central lobby. Again, your tripod will be handy if it is a dark day. Frame your photograph so that the fountains are central, and focus on the far end of the pool. The plants in the foreground that frame your edge will become nicely soft-focus. You will need infinite patience to wait for your photograph to be free of passersby—the garden is a popular place.

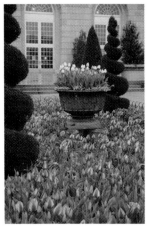

The entrance to the gardens in spring.

Easter lilies.

A display at Bartholdi Park.

Getting There

To find the Botanic Garden complex, aim for the intersection of 1st Street SW and Independence Avenue to the southwest of the Capitol building. The closest subway approach is Federal Center SW on the Orange and Blue Lines. From the station, walk north on 3rd Street for two blocks and turn right on Independence Avenue. This will take you past the National Garden on your left and then position you between Bartholdi Park and the Conservatory. In general, if you are strolling through the area, the parks are accessible through gates on several sides.

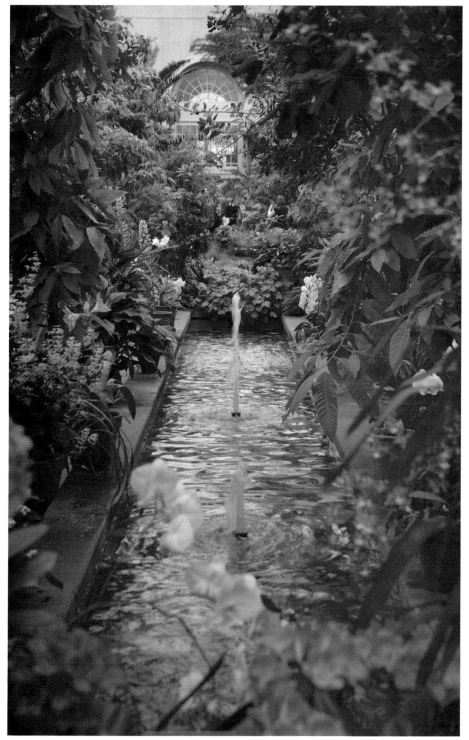

Focal length 70mm; ISO 100; aperture f/5.6; shutter speed 1/25; April 12:01 p.m.

When to shoot: morning, afternoon, evening

Urban Gardens

Washington, DC is a great capital, with a dramatic layout and majestic federal buildings. The downtown area, with its wide streets and avenues, is the equal of other major American cities, while the northwest suburban areas and boulevards speak of refined opulence. Yet the residents of DC do not rest on their laurels. Throughout the District, the horticultural arts are on fine display with embellishment of buildings large and small. Of unusual charm are the row houses dating from the earliest decades of the capital's development, often situated close to the center of the city but presenting a cottage-like appeal set off by old-world-style gardens. Be aware of opportunities to capture evidence of Washingtonians' green thumbs at every turn.

The Shot

The weather outside was overcast and gently misting, so rather than curl up with a good book, I *quickly* (in case of a downpour) packed up my gear and headed out to find some flowers. There are some moments when all the elements for perfect picture-taking fall seamlessly into place, and this was one of those times. The thinly clouded sky cast a beautiful diffused light over all beneath it, and the pinks and magentas of these Knock Out roses looked so intense in contrast to the dark green foliage behind them. But, the meteorological element I was most grateful for was the blanket of rain droplets that clung to every surface like miniature magnifying lenses. The drops contribute so much crystalline texture, lushness, and verdancy to the photograph.

Focal length 75mm; ISO 200; aperture f/7.1; shutter speed 1/10; May 6:04 p.m.

A *very* urban garden—sunflower in metal.

A vignette in Adams Morgan.

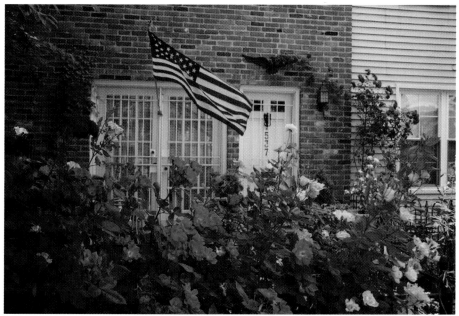

A patriotic garden near the Capitol building.

The Shot

It is difficult not to love shooting flowers—they are just so beautiful! Many of the homes immediately behind the Capitol building sport small but fertile lots, and in spring and early summer, there is a riot of color and variety. This white peony bush stood out as a real specimen. The flowers are backlit, which perfectly highlights the layout of the petals, their serrated edges, and the complex yellow stamens. This is an "environmental portrait," if you will, as opposed to the earlier beauty shot of the roses, and the composition is dynamic with the foliage forming a grounded triangle in the foreground. Because of my use of a wide aperture, the background is soft, and its shadowed areas frame the flowers and are not distracting. There is enough detail available to give some information about the locale—the wrought-iron fence, the vintage architecture, and the American flag all give a hint to the garden's personality.

Getting There

Row houses and their charming gardens can be found in many parts of DC, but look for some excellent gardens to the north of M Street in Georgetown or on Capitol Street SE to the south of the Capitol building. Further out into the northwest suburbs beyond Woodley Park, you will find a multitude of choice gardens.

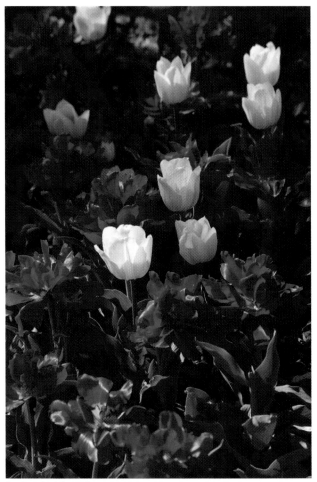

Red and white tulips.

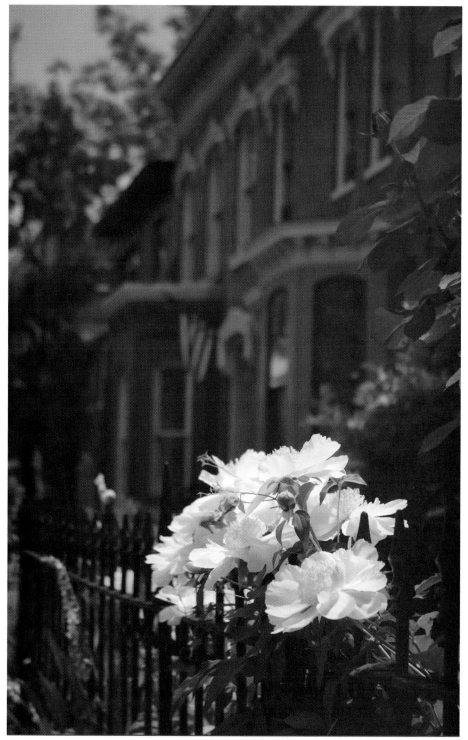

Focal length 70mm; ISO 100; aperture f/5.0; shutter speed 1/320; May 11:59 a.m.

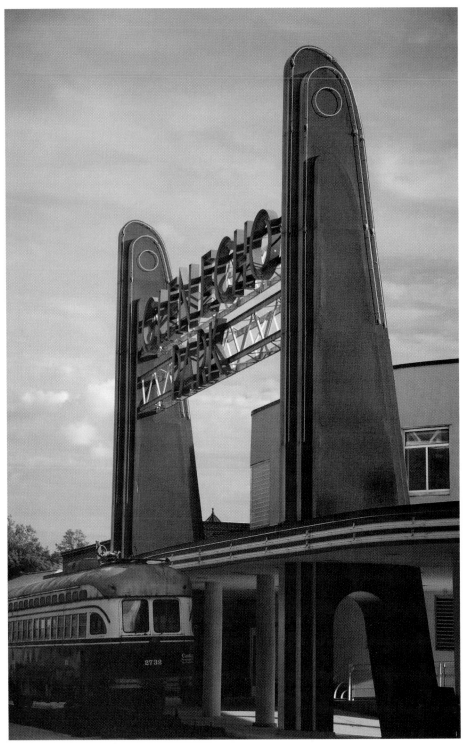
The main entrance to Glen Echo Park.

CHAPTER 5
Secret DC

Amid the hustle of politicos, the formulated streets, and the legions of populace, you can find unknown areas in DC that are tucked away, visited by few—both city dwellers and tourists alike. These places are photographic treasures—they boast visual opportunities that will, without a doubt, add fresh images to your repertoire that will be of great interest to bring home. In this chapter, we will discover newly developing areas in Washington, DC, pay a call to a landmarked commercial venture, take in a country resort from days gone by, and discover a bit of international culture. Set your lens on the sights at a few of these locales, and you will be impressing even some jaded Washingtonians with your geography know-how.

Shooting Like a Pro

The three most important elements to focus on in your travel photography are composition, narrative, and a passion for your subject. The first two aspects usually reside in the subconscious of a professional, but with time and practice you will find that your sense of artistry and your ability to be a visual storyteller will also become second nature. The third component, on the other hand, is an area where you actually have the better hand over the professional who makes his or her living taking pictures. A professional must travel to and shoot where his assignments and editors send him, but you, on the other hand, are completely free to choose whatever and wherever you would like to make images.

If artistic coaches could bottle anything and sell it to their students, it would be the ability to convey ardor and feeling into one's photographs. It is really an indescribable concept, and when looked at coldly and factually, this conveyance is almost physically impossible. But, it is there nonetheless, and it is what separates adequate photography from images that are memorable.

The Gear

If you cannot see your subject, you can be assured that you will not devote too much time to your compositions. For this reason (and others on which I will elaborate in the next paragraph), I advocate that if you are serious about improving your photographic and artistic skills, you invest in a digital SLR as your working camera, as opposed to a point-and-shoot. With a point-and-shoot camera, your actual "canvas" is visible only on the (probably) small LCD screen on the back of the apparatus. dSLRs, on the other hand, have viewfinders that are large, accurate, and bright. It is here, in the viewfinder, where you will be composing your images, and it is crucial that you be able to see as many of the elements in front of you as possible. Of course, there is the optional but cumbersome method that many professionals use, which is to shoot tethered. *Tethered* means that your camera is connected to a computer (laptop or desktop) via a FireWire, and the images are downloaded within seconds into a capture program and are then visible on the computer monitor. Viewing your captured image on a monitor obviously makes composition a relative breeze, but there are disadvantages, of course. In addition to the cost involved for the equipment, this shooting method requires that the photographer be quite stationary and/or have assistance with carrying the gear and fending off would-be thieves!

There are several other great advantages to shooting with a dSLR that I would like to mention. First, with a dSLR, you have the ability to turn off the auto focus and manipulate it yourself. With the bright viewfinder, you can see exactly where you are focused, and for artistic reasons, your focus point decision may be different from where the camera's automatic system decides to focus. You may prefer to have only a small object in the foreground sharp and leave the background soft. Using the manual focus makes this extremely easy and quick to do.

Second, you will find that most point-and-shoot cameras have a decided lag between when you press the shutter release button and when the camera actually fires. This lag can range anywhere from 0.6 seconds to an interminable 2.5 seconds, depending on the lighting situation in which you are shooting. (The auto-focus system in a point-and-shoot takes much longer to kick in under a low-light situation.) This shutter lag can be a serious detriment, particularly when you're shooting action, children, animals, or anything with movement. Even portraits can be disheartening when the shutter lag comes into play, since your subject may smile on cue for the camera, but then her expression might quickly turn when the shutter does not release!

And third (but definitely not last), the point-and-shoot is usually not adaptable to a quality external electronic flash. This can cause a lot of creative issues if you have taken a liking, as I have, to carrying an on-camera flash in your kit. If controllable creativity with light, composition, and focus is in your plan, then a dSLR should be your tool of choice. There are many pro-sumer models on the market today that are affordable and will more than suit your needs.

The Plan

The photo opportunities in this chapter are essentially "still life" in nature and will give you countless circumstances to hone your composition and narrative skills. The most important aspect when learning to compose is to really *look* and *see* what your camera is recording. If your apparatus has a nice and bright viewfinder, be sure to take the time to look at all four edges of the frame. If you use the LCD screen, do the same. Don't just point and shoot. Look for objects that may be distracting—traffic cones, extension cords, lampposts, car bumpers, and so on. If there is something entering into your frame that you deem unappealing, change your position and shoot the subject from a different angle. I find that crouching down and shooting from a lower angle than normal tends to clear up the background of some distracting elements and very often frames the subject against the sky. Experiment with wide and narrow apertures to change the focus of your backgrounds. With still objects, taking multiple frames is easy and great practice.

Learn to apply knowledge that you have gained from other parts of your life to your photography. If you have taken a creative writing course in the past, remember the literary metaphors that you learned and apply them to your picture taking. Did you study poetry in college? How about all the symbols and icons that apply there? They have just as much impact when used in photography. That apple you see on the table can represent temptation, and the black crow in the tree is imminent death or danger. A shadowed doorway can be an icon for the unknown future. Flowers can represent mortality, and those swans gliding on the lake are icons for alteration and change. Open your mind to all the arts, and your pictures will reflect the creativity and passion that you feel.

When to shoot: morning, afternoon

Apothecary Museum

Whatever your feelings on the current state of healthcare in the United States, you may care to visit the Stabler-Leadbeater Apothecary Museum to gain insight into a medical provider from earlier times. Since the 1790s, an apothecary has stood on Fairfax Street in Old Alexandria. Initially owned and run by the Stabler family and then in turn by members of the Leadbeater family (related through marriage), the Apothecary supplied salves, herbs, and tinctures to the people of Alexandria and Washington, DC until eventually succumbing to the Great Depression in 1933. At that point, rather than simply disappearing into the annals of lost businesses, the apothecary was jointly purchased and preserved by the Friends of the American Pharmaceutical Association and the Landmarks Society of Alexandria. In 1939, the building reopened as a museum and has entertained visitors ever since. The collection of exhibits includes shop furnishings, gold-leaf labeled bottles and formulating equipment, original medicinal herbs, and records of business transactions, many still in their historical settings. The displays provide a visually appealing window into the medicine of times past.

A view from the street to the interior.

The Shot

The Apothecary Museum is beautiful and interesting, but all interior and dimly lit. Your tripod is mandatory here for every shot taken inside the space. The small windows are north facing, and the light is reminiscent of that seen in Vermeer's and other Dutch painters' still-life works, while the composition mirrors the American *trompe l'oeil* painters, such as William Harnett and John Peto. It is times such as these when your college art history classes come in handy!

I had neglected to put my cable release in my gear bag, but with my tripod and a bit of ingenuity, I was able to capture sharp images. I put the shutter speed on 10 seconds and pressed the shutter release button while holding a dark-brown postcard from the museum directly in front of the lens, but not touching the camera. I knew that the shutter speed for a correct exposure was 2 seconds from a previous capture, so while the shutter was open, I whisked the card away for 2 seconds, replaced it, and then closed the shutter. Voilà—a sharp, long-exposure image without a cable release!

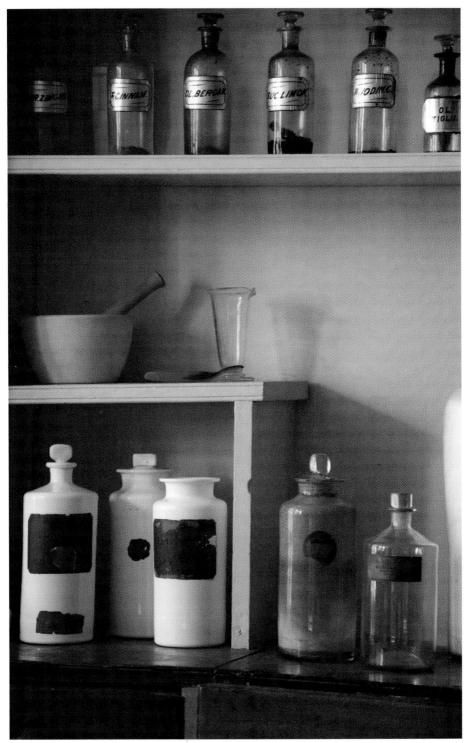

Focal length 135mm; ISO 100; aperture f/5.6; shutter speed 2 seconds; April 1:02 p.m.

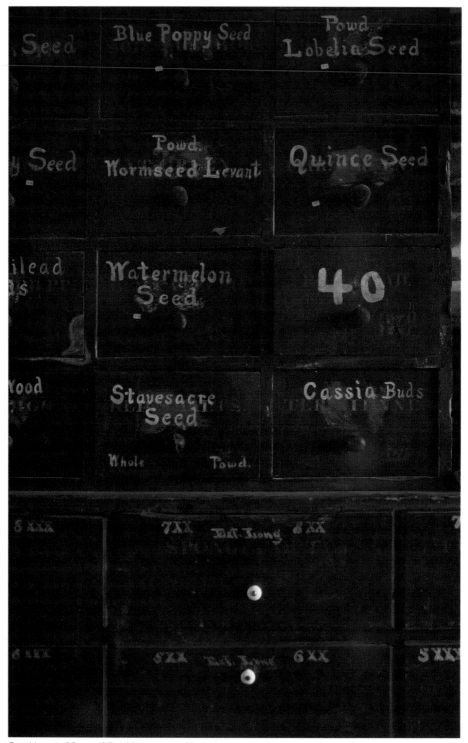

Focal length 35mm; ISO 100; aperture f/5; shutter speed 5 seconds; April 1:22 p.m.

The Shot

The second floor of the Apothecary Museum is just as interesting as the first, but, unfortunately, it is even darker! Two large bureaus flank the room, and each unit is hand-labeled with powdered and flaked homeopathic remedies that are actually still inside the drawers. The contents range from cuttlefish bone to watermelon seed to laundry bluing—quite an odd collection, to be sure. The lighting here is a combination of tungsten illumination from a small overhead electric fixture and a smattering of available window light. I followed pretty much the same technique as in the making of the photograph from the main room on the first floor. This time, however, my exposure was more than twice as long, but with the postcard exposure technique, there is no camera shake in the slightest.

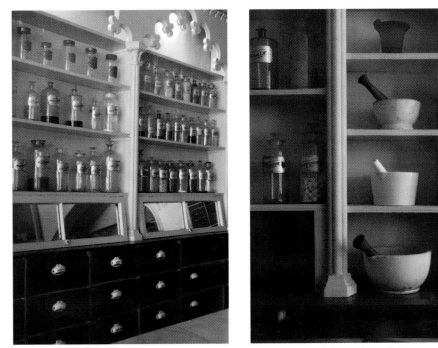

Bottles and drawers.

Vintage pharmacy paraphernalia.

Getting There

The Stabler-Leadbeater Apothecary Museum in Old Alexandria is located at 105–107 South Fairfax Street, Alexandria, Virginia. The Yellow or Blue Metro Line will take you from DC into Virginia and south along the Potomac to King Street Station in Alexandria. Walk east on King Street, toward the Potomac, and turn right onto Fairfax Street after about one mile. The museum will be on your right. To avoid the walk, take the Dash bus that runs from the Metro station along King Street and stops at Fairfax Street.

 When to shoot: morning, afternoon, evening

Behind the Scenes

Washington, DC is known as L'Enfant's planned city, and the results of that original vision exude grandeur and opulence. The city did not, however, come into being fully formed. For many years after the construction of major buildings, such as the White House and the Capitol, they stood isolated, surrounded by swampy and insect-infested lands. Filling out the city did not occur smoothly, and the landscape moved indirectly toward the modern city. Much low-cost housing in the form of alleyways interspersed between the main streets was built to house the incoming flow of new residents. Commercial enterprises sprang up to support the needs of the population. Much of this construction has come and gone in the ongoing gentrification of the city. However, remnants of this indirect path can be found throughout the city, from the remaining alleys to antique commercial signage to the lingering stables that housed the horses of days past. Keep your eyes open for evidence of the path of development, particularly in those areas north and south of the Capitol building that have avoided complete modernization.

The Shot

Tucked between 9th and 10th Streets and N and O Streets lie Naylor Court and Blagden Alley. The cobbled alleyway is lined with polished and unpolished architectural gems, this building among them. To capture this view, stand at the very entrance of the passageway at O Street, which is far enough away so that you will not have to look up at the building and get converging lines in your photograph. I was lucky to be shooting on a blustery spring day with its accompanying blue sky and fast-moving clouds, which makes for a dramatic backdrop. There are often cars parked in front of the garages, which can mar the scene—with the crop that I chose, I was able to keep the vehicles out of this image.

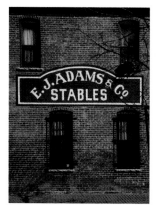
A sign on Blagden Alley.

Decorative brickwork in the alley.

African art at the DC Guesthouse.

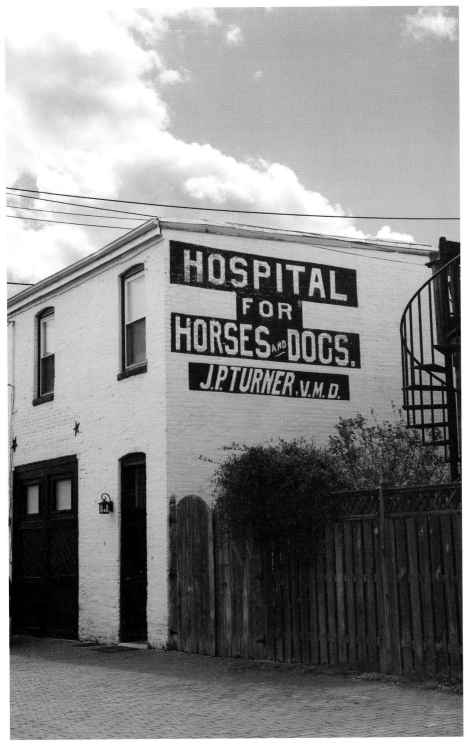

Focal length 53mm; ISO 100; aperture f/8; shutter speed 1/125; April 12:57 p.m.

Beautiful copper work at the entrance of Blagden Alley.

The Shot

You will find this vintage Coca-Cola sign emblazoned on the side of a building in the South Capitol Hill area. Be on the lookout—it is on a brick wall on S. Capitol Street SW between D Street SW and Ivy Street, amid highway crossovers and railroad tracks. You must use a wide angle lens, because the alley in front of the wall is narrow, and you can barely stand far enough away from the wall to capture all the words. Either use your tripod and spirit level or be *very* steady while hand-holding the camera, to be sure to render the sign perfectly horizontal. An overcast or cloudy day is the optimal condition for shooting this sign, because the shadows from the brick and mortar are kept to a minimum and do not distract from the painted words.

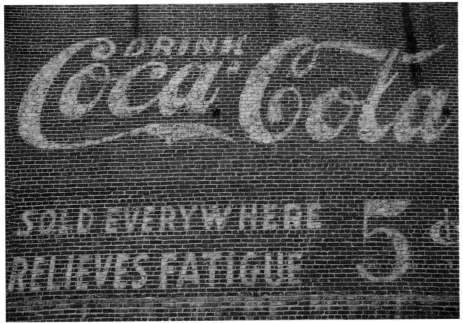

Focal length 28mm; ISO 100; aperture f/5.6; shutter speed 1/320; May 2:19 p.m.

Getting There

Naylor Court, a surviving example of the Washington alleys, is a network of lanes bounded by 9th and 10th Streets to the north of N Street. From the Mt. Vernon Square Metro Station (Green and Yellow Lines), turn north on 7th Street and walk along the face of the Washington Convention Center to N Street. Turn left on N Street and then right on 9th Street. Naylor Court will be on your left after about 50 yards.

When to shoot: morning, afternoon

Capitol Riverfront

Moving south from the Capitol area, you will shortly enter a region of DC undergoing much change. Bounded to the west by the Potomac and to the southeast by the Anacostia River, this southern part of central DC has for many years taken its tone from the Washington Navy Yard located on the north bank of the Anacostia. Its gritty, urban environment has for some decades featured commerce and light industry in a rather uninspiring setting. However, not for much longer.

The Capitol Riverfront, as it has been recently renamed, is the site of more than $3 billion of investment. Previously known as the Near Southeast, the 500-acre area has benefited from the 2003 Anacostia Waterfront Initiative, which targeted an increase in access to the mile and a half of riverfront and commercial development of the area incorporating environmentally sound initiatives. This has led in short order to a striking rebirth of the area and the construction of multiple new office and apartment buildings. Some government departments, most notably the Department of Transportation, have moved south into new accommodations in the area. In addition, and dominating the skyline, the new Washington Nationals baseball stadium stands looking out across the Anacostia as a testament to the new life of the area. No doubt the Nationals themselves will be able to reflect that new glory as time progresses.

Cormorants on the Anacostia River.

A visit to the Capitol Riverfront presents the opportunity to witness the transformation of a section of central DC and the expansion of the modern city to the water's edge.

The Shot

This picture is a testament to the fact that sometimes being locked out can be to your advantage! We were exploring the Riverfront by bicycle (the best way to do so—for all of DC, for that matter), and we landed at the Nationals Stadium far too early for any of the gates to be open. After repeated attempts to find one that had possibly been forgotten, I resigned myself to shooting from outside the fence. Lo and behold, when you are handed lemons…make lemonade! I stood with my camera about two feet from the wrought-iron fence and made a composition that included the "W" of the Nationals' logo in the foreground. I used a wide aperture in order to make this foreground graphic out of focus. This was an aesthetic decision, of course, but I think the black wrought iron acts as more of a framing element when it is soft and focuses one's attention on the background information. I centered the red flag between the bars and waited for the wind to gust. The inclusion of the Stars and Stripes to the right was a lucky accident.

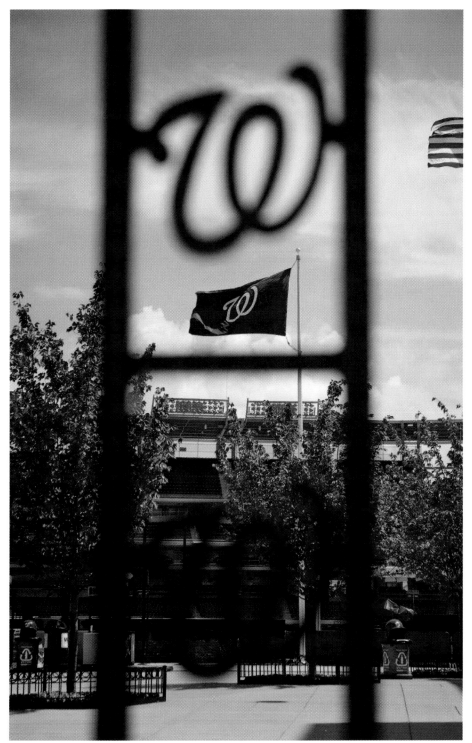

Focal length 85mm; ISO 100; aperture f/5.6; shutter speed 1/1250; May 2:04 p.m.

The Shot

This photograph is my ode to Charles Sheeler. For those of you who are unaware of Sheeler, he was an American painter and photographer of the early twentieth century who focused on machinery and structures. He called himself a "Precisionist"—one who emphasizes linear precision in his work. In this photograph, the bright, midday sunlight does just that—accentuates the textures and linear details of the industrial buildings. My vantage point for this shot was the apex of the Frederick Douglass Bridge, the southern extension of South Capitol Street that crosses the Anacostia River. I was particularly taken by the quality of the sky and clouds that day, as well as the sharpness to the light. The scene was unusual for a modern cityscape in that the rooftop horizon line was flat and unbroken by anything, save for the two immense smokestacks. The distinct lack of humanity, an odd characteristic for a thriving city, adds even more of a vintage feel.

The front of the Nationals Stadium.

Getting There

The Capitol Riverfront is conveniently located close to the Navy Yard Metro (Green Line) and within walking distance of the Capitol South Metro and Eastern Market Metro stations (both on the Blue and Orange Lines).

Walk west from the Navy Yard Station (400 yards) and then turn south on South Capitol

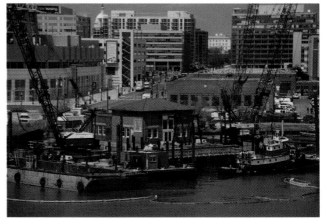

Looking north from the Frederick Douglass Bridge.

Street, passing the Nationals Stadium, and climb the bridge across the Anacostia River. From the pedestrian walkway, you can obtain fine views of the stadium, the developing waterfront, and the Navy Yards, as well as the human and animal life active on and around the river.

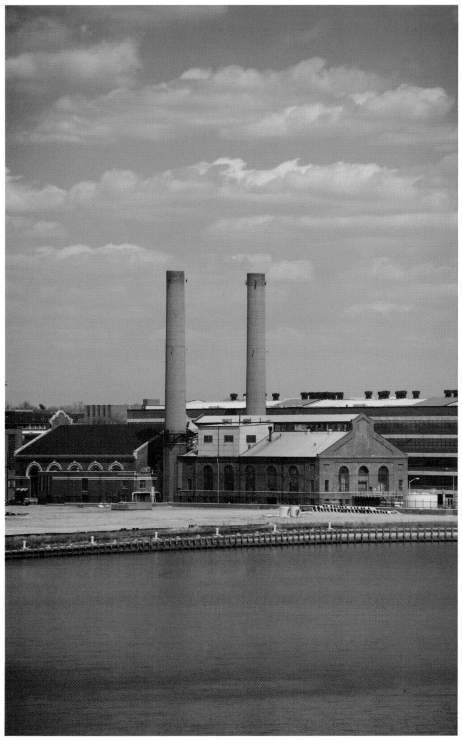

Focal length 150mm; ISO 100; aperture f/5.6; shutter speed 1/800; April 1:01 p.m.

When to shoot: morning, afternoon

DC Doorways

Doorways throughout DC present a glimpse of the individuality of buildings and of their owners. They are the made-up face of the personality of the structure and give us a public glimpse of how the inhabitants want to be known. In particular, the classic Georgian row home with its orthogonal structure often relies on its doorway to make its personality statement. The official structures of Washington employ their doorways to communicate and impress. Every doorway provides a signature of the occupants and thus provides a succinct opportunity to capture an impression of what lies in front of and behind that door. Throughout DC you will pass entryways that are artworks unto themselves, ready to be photographed and documented.

The Shot

A short video of this scene would have been my media recording method of choice, but, after all, this is a photography book, not a primer on the moving image! I make this comment because of the enormous and motile shadow of the flag that played vigorously across the façade of the building, the Embassy of Turkmenistan at 2207 Massachusetts Avenue NW. What made the image most arresting was the size of the shadow, how exuberantly the flag flapped, and the fact that the source of the shadow was out of view. I could not help but feel that there was a hand outside the frame waving the flag. Silly, I know, but true. My trusty polarizing filter again helped to saturate the harsh and dry light of the midday sun and keep the foliage green and without reflection. My vantage point was from the sidewalk across the avenue, and I was very careful to center the door evenly between the pillars, yet keep the entranceway to the left of my composition.

The front of the Cosmos Club.

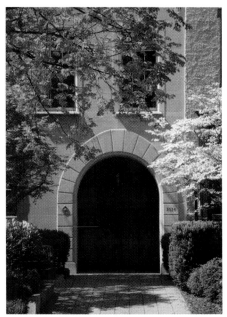

The façade of 2328 Mass Ave NW.

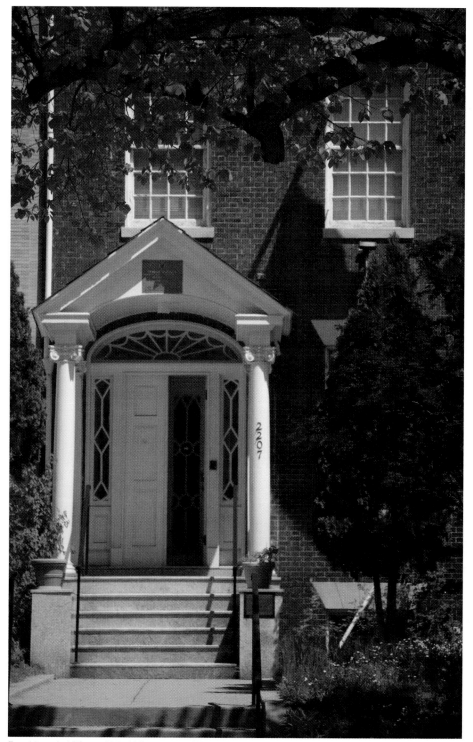

Focal length 130mm; ISO 100; aperture f/5.6; shutter speed 1/320; April 11:35 a.m.

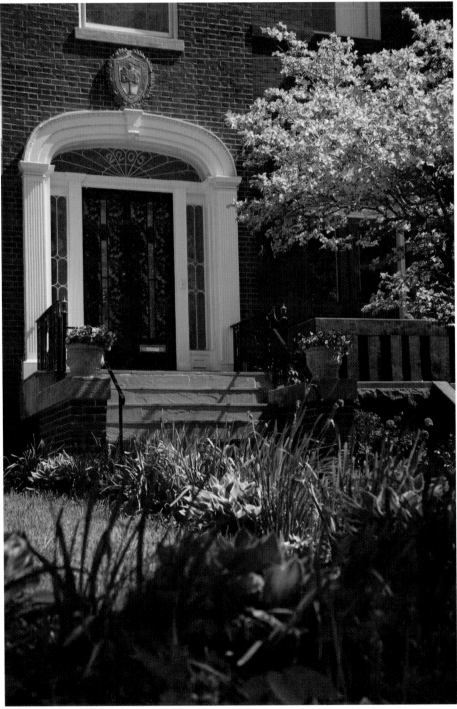

The headquarters of the National Society Daughters of the American Revolution.

The Shot

The simple theatricality of its façade makes this build-
ing an eye-catcher, especially given its location on R
Street, which is lined with dignified townhomes and
manorial structures. The architectural firm of
Hornblower and Marshall (who also designed the
National Museum of Natural History) erected this
building, which was originally an art studio, for
Edward Lind Morse, a landscape painter and youngest
son of Samuel Morse, inventor of the telegraph. The
heavy oak door, extraordinary hinges, and sturdy win-
dows all earmark this as a building constructed in the
Arts and Crafts style of the early twentieth century. I
shot this façade with my 24mm PC (perspective con-
trol) lens because the narrow sidewalk and vehicle-lined
street make it impossible to stand far enough away to
avoid converging lines. Set the lens to its zero position
and shift the front element upwards until you see the
front of the building where you want it in your frame.

The Cyprus Embassy Residence.

Focal length 24mm; ISO 100; aperture f/7.1; shutter speed 1/80; June 3:28 p.m.

Getting There

Keep your eyes peeled throughout the District. The residential districts in the northwest
suburbs, the row homes in Georgetown and south of the Capitol, and the embassies,
churches, and official buildings present an abundance of shots of a wide variety of color,
form, and personality.

When to shoot: morning, afternoon

Gates to Private Havens

Still round the corner there may wait
A new road or a secret gate,
And though I oft have passed them by,
A day will come at last when I
Shall take the hidden paths that run
West of the Moon, East of the Sun.

—J.R.R. Tolkien, *Lord of the Rings*

Around many turns in the District, you will find finely designed gates that shield the spaces that DC residents have constructed as their own private places. While hinting at the havens that lie beyond, they present elegant visual opportunities that stand in their own right.

The Shot

Taking photographs of gates and doors can result in very lyrical and poetic pictures. The images are pregnant with mystery and unexplained events. Who lives there? Who just walked through? Is it locked? Is someone leaving? Can I come in? A key to shooting this type of photo is to add, with your image-maker's bag of tricks, some romance and intrigue. My favorite "add romance here" technique is to shoot with a very wide aperture, which renders the background lush and soft, especially if the scene is bathed in diffused and dappled light. The human eye sees like this—we cannot focus on two planes at once—which is one reason why pictures shot in this style seem so intimate. The photograph becomes much more experiential, and the viewer may feel the scene first-hand, as if he were really there and not looking at a two-dimensional rendition.

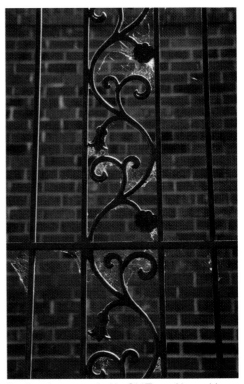

This lovely wrought-iron gate is in Old Town Alexandria, on North Fairfax Street between Princess and Queen Streets. The harsh midday sun is mellowed by the thick cover of leafy trees, and the light takes on a chiaroscuro effect, with a fine play of light and shadow dancing on the black metal of the gate.

Feather duster needed in Old Town Alexandria.

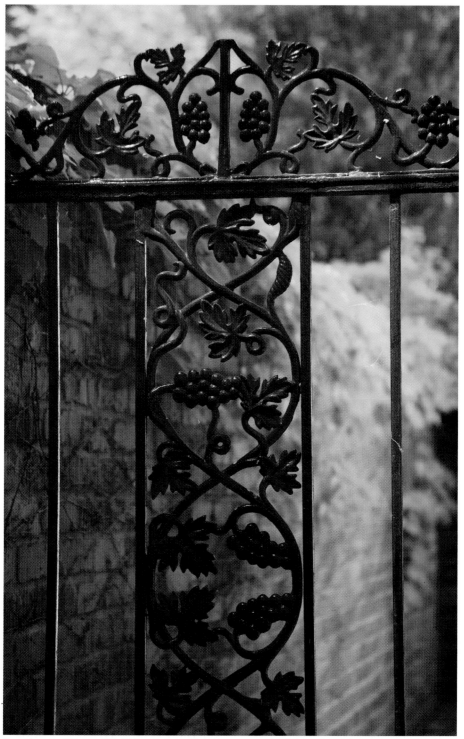

Focal length 105mm; ISO 100; aperture f/5.6; shutter speed 1/25; April 11:03 a.m.

The Shot

Surrounding the perimeter of the photograph with green-ery creates the effect here of a peephole, which, combined with the soft focus of the background and the interesting shadows on the door in the foreground, works to convey a sense of hidden activity happening out of the edge of the frame. The composition is grounded and solid and follows the adage of dividing the frame into thirds—the upper third is almost a picture unto itself, whereas the bottom two-thirds of the photograph play, literally, a supporting role, with beautiful light, texture, and color. I included the band of brickwork on the right side of the photo to tie the two pieces of the image together as one. This photograph is a perfect example of how simple but exquisite elements composed in a classic manner can make an alluring photo-graph. This gate is a side entrance to the Carlyle House Historic Park and can be found on the corner of North Lee and Cameron Streets in Old Town Alexandria.

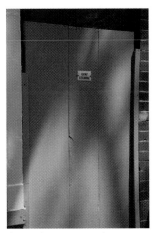

A warning on a gate in Georgetown.

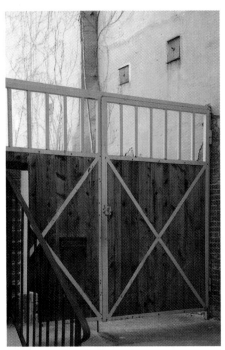

A beautiful mix of color and texture.

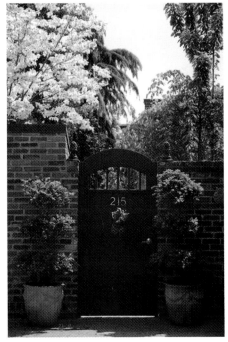

Classic Colonial gateway.

Getting There

The residential districts in the northwest suburbs with their gardens and side alleys present the greatest selection of gates, but unique and imaginative examples can be found through-out the District and Old Town Alexandria.

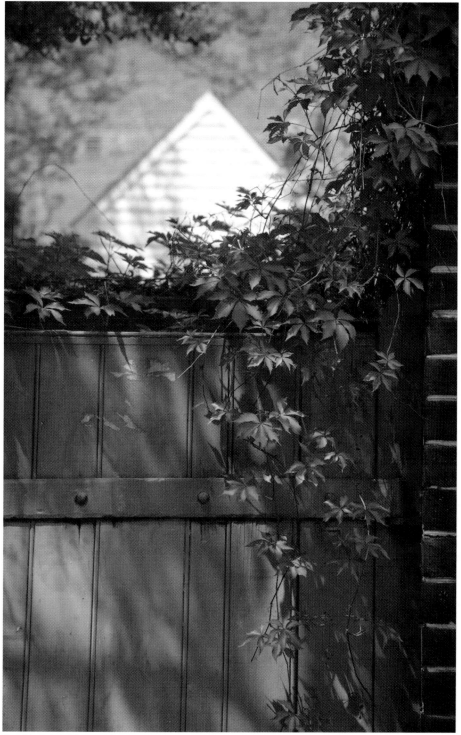

Focal length 117mm; ISO 100; aperture f/5.6; shutter speed 1/100; April 11:14 a.m.

Glen Echo Park

Start with the Chautauqua Assembly, an organization that flourished in the late nineteenth and early twentieth centuries, dedicated to the dissemination of culture to, and the entertainment of, the whole community. In 1891, locate a unit of the Assembly in Glen Echo Park to the far northwest of the city, over the state line into Maryland. In the early 1900s, convert that site of culture into an amusement park that will thrive until the 1960s and then convert the park back to a center dedicated to the practice and teaching of the arts. Overlay onto that custodians dedicated to the preservation and enhancement of the site,

and what have you got? A truly unique place that has been meticulously preserved, which provides you with opportunities to capture almost surreal shots of amusements from times past and the art deco structures that surround them.

The front view of the Glen Echo trolley car.

The Shot

Glen Echo is a wild and crazy place with heavy artistic overtones. You will feel completely at home carrying your camera and peering through the viewfinder, because the park (it is run by the National Park Service) administers a very active artist-in-residency program, and photographers, among other artistic types, abound.

The Dentzel Carousel alone will keep you occupied for hours, with its 38 horses, 2 chariots, 4 rabbits, 4 ostriches, a lion, a tiger, a giraffe, and a prancing deer. It is a veritable sensory overload. You can choose to shoot the carousel while it is spinning and try to capture part of its frenetic personality, or you can do what I did and take moody portraits of the animals. Even in the full light of day, the carousel pavilion is dim, with the dark-green roof obscuring most of the natural light. Use your tripod (which is usually not allowed on NPS property, but the rangers have a soft spot for artistic types) and try to include some of the many incandescent bulbs. They add a nice, warm glow and highlight the decorative gold-leaf details.

Art Deco shadow play.

Focal length 41mm; ISO 100; aperture f/4.5; shutter speed 1/15; May 5:14 p.m.

Focal length 60mm; ISO 100; aperture f/7.1; shutter speed 1/200; May 10:33 a.m.

The Shot

The entrance to the Crystal Pool has been beautifully restored to all its Art Deco glory and makes a perfect clean and geometric subject for picture taking. The grass berms immediately surrounding the doorway are scattered and uneven, and in order to avoid converging lines, you have to be very mindful that you and your camera are level with the architecture. I am small, and I actually stood on top of one of the hillocks to center my camera on the entrance. The day was bright and slightly overcast, which served me well here, because stark and contrasty shadows would have been very distracting. Rather than be off put by the asymmetric stone wall at the front, I used it to my advantage. The red metal railing became a strong foreground element, and the diagonal line created by both the railing and the wall pointing toward the viewer adds depth to what would otherwise be a very flat and somewhat dull picture.

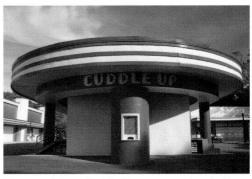

The now defunct Cuddle Up amusement park ride.

Getting There

Glen Echo Park is located at 7300 MacArthur Boulevard in Glen Echo, Maryland. It is best approached by car. From the Capital Beltway (Interstate 495), take Exit 40 on the outer loop or Exit 41 East on the inner loop. Take Clara Barton/Cabin John Parkway to the MacArthur Boulevard/Glen Echo exit. Make a left onto MacArthur Boulevard. Cross Goldsboro Road and then make a left onto Oxford Road, where you will see the parking lot. From the parking lot, follow the path across the Minnehaha Creek bridge and enter the park.

From downtown Washington, take Massachusetts Avenue to its northwest end at Goldsboro Road. Turn left and continue to MacArthur Boulevard. Turn right on MacArthur Boulevard and take an immediate left onto Oxford Road, where you will see the parking lot.

A scene near the Glen Echo playground.

When to shoot: morning, afternoon

Gravestones and Eagles

Washington holds a special place in the hearts of many Americans. Having lived a life of service to their country, military personnel find here an ideal last resting place, a chance to come home to the center of the country that was at the center of their lives. And here lives are commemorated with emblems of both country and religion. Not ostentatiously, but with discretion and taste, hidden in plain sight and waiting for you to search them out.

The extended rows of small white tomb markers are the images that many recall of the gravestones at Arlington Cemetery. There is, however, in Section One, at the very top and far end of the cemetery, an impressive selection of ornate and elaborate grave markers that generate beautiful photographs. Among these markers—and interspersed throughout the city, for that matter—perch eagles, resplendent in their role as patriotic emblems, standing watch on behalf of those who gave so much.

The Shot

In America, the appearance of gravestones and their status as craft and art form has undergone quite a transformation. What began as stones and boulders that were placed on top of the grave to, superstitiously, keep the dead from rising out of their tombs became sculptures rife with images of horror in the form of skulls, skeletons, and death angels. It was not until the Victorian era that the motifs changed from those of eternal damnation to images of everlasting peace and ornamental descriptions of the person who lay beneath. The image of the angel was used to show her role as messenger between heaven and earth, with the trumpet the instrument of choice. Here we have the winged and draped figure heralding the demise of a good captain. The late-afternoon sun brought out beautifully the cast texture of the wings and clothing, displaying also the marked contrast in the cyan tone of the sculpture and the drab gray-brown surface of the stone. The bare trees make a background that works both visually as a pattern against the sky and conceptually as a metaphor for lifelessness.

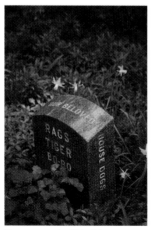

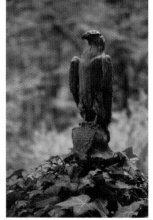

A lifelike decoration on a gravestone.

Flowers embellish this gravestone of the Post family's dogs.

A watchful eagle perched amongst English ivy.

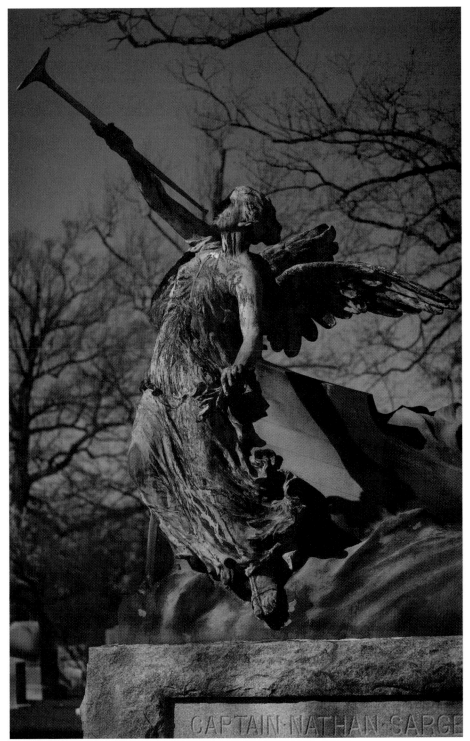

Focal length 70mm; ISO 100; aperture f/5; shutter speed 1/2500; April 3:53 p.m.

The Shot

This eagle sits atop, with his symmetric partner across the drive, a granite plinth and arch that flank the entrance to Arlington National Cemetery. From afar, they make quite a visible and dignified pair, but if you are on foot when visiting the area, they can easily be missed because of their height. At a point in history, there was not complete agreement on the choice of an eagle to represent the new nation of the United States. Benjamin Franklin felt the eagle was dishonest and lazy, because it made common practice of stealing fresh catch from the beaks of the fishing hawk. Mr. Franklin's choice for the nation's ornithic symbol was the turkey! Stone carvers would have to be quite talented to bring to a turkey the same majesty and poise that the eagle conveys....

To capture this image, stand on the cemetery side of the arch, facing northeast. The afternoon light coming from behind you highlights the carving of the feathers and musculature, and your low vantage point heroicizes the figure.

Getting There

Arlington National Cemetery is located a short distance into Arlington on the southwest bank of the Potomac River. It is reached via the Arlington Memorial Bridge, which itself is to the southwest of the Lincoln Memorial and the Mall. The Arlington National Cemetery Metro stop is regularly served by Blue Line trains.

HARD LIGHT VERSUS SOFT LIGHT

When shooting metallic objects, such as these shields and laurel wreaths at the National Cemetery, be acutely aware of your lighting situation and how the quality of the light will affect your results. These two objects are made from exactly the same material and have exactly the same finish. The only difference is that they were shot in two completely different types of the light. The first was photographed in direct sun, and the brushed quality of the gold leaf gleams with highlights and shadows that convey all the detail in a very extravagant way. The second shield, on the other hand, was photographed in open shade. The details are just as apparent as in the first image, but the lack of any direct light eradicates any specular highlights and almost makes the gold look dull and matte finished.

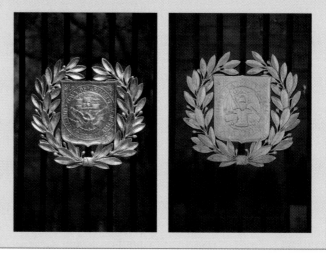

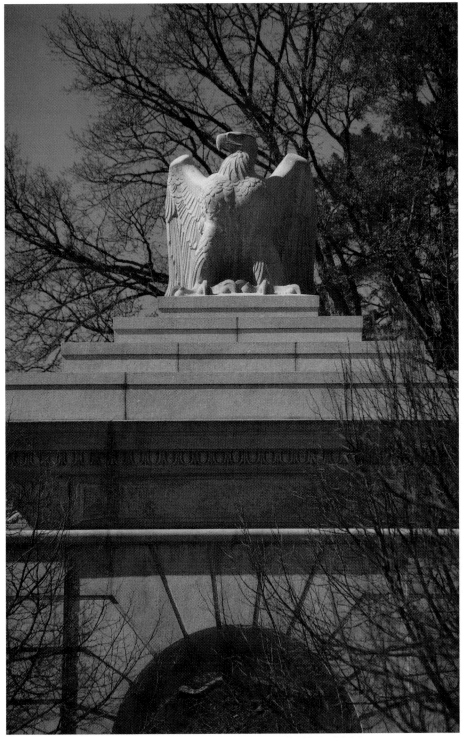

Focal length 150mm; ISO 100; aperture f/5.6; shutter speed 1/2000; April 2:24 p.m.

When to shoot: morning, afternoon

Department of Transportation

Until recently, no cabinet-level government department had relocated for more than three decades. In 2007, the U.S. Department of Transportation was, perhaps appropriately, the department to break that streak. Taking advantage of the redevelopment of the Capitol Riverfront area in Southeast DC, the DOT and 7,000 workers moved into an impressive new building located in the heart of the reenergized area.

The structure consists of the East and West Buildings, which sit on an 11-acre plot bounded by M Street, New Jersey Avenue, and 4th Street. The architecture of the buildings combines a modern feel appropriate to the rebirth of the area with a classical framework appropriate for a structure expected to stand for many decades in the ranks of major government buildings. The buildings are bordered by a Walking Museum illustrating the history and importance of transportation to the U.S. Overhead structures represent different bridge types, while a variety of exhibits combine the educational with the artistic, exemplifying the vital role that transportation plays in the national interest.

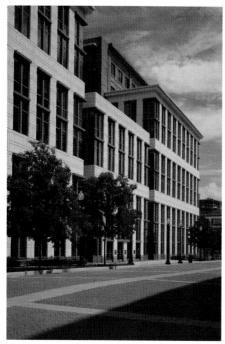

The main buildings at the DOT.

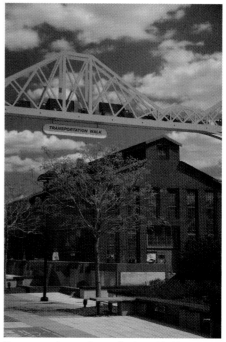

Transportation walk—a display of bridges and sculptures.

The Shot

Here we have—not really that surprisingly, as it is in a similar neighborhood—another "Charles Sheeler-esque" photograph. What is most reminiscent of his work in this image are the multiple vertical smokestacks and the heavy industrial feel. The plaza surrounding the new DOT buildings is filled with sculptures that reference a vast number of transportation modes, and this one is an ode to cross-country trucking.

I used my 50mm lens to capture the smokestacks and the authentic industrial environment, which was beautifully lit on this clear spring day. The normal lens also maintained the true verticality of the up-and-down elements in the shot—converging lines would have ruined the effect of repetition that this image displays.

Be sure to stand at the edge of the sculpture, pointing your camera down the row of stacks. This way, the sense of perspective is exaggerated, as the vertical elements reduce in size toward the horizon. Be aware of your placement of the brick stacks in the background—inclusion of these is crucial. A saturated blue sky perfectly complements the overall color scheme of browns, grays, and blues.

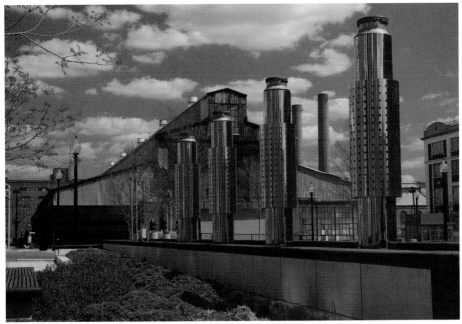

Focal length 50mm; ISO 100; aperture f/7.1; shutter speed 1/250; April 1:38 p.m.

Focal length 100mm; ISO 100; aperture f/7.1; shutter speed 1/250; April 1:28 p.m.

The Shot

Photographing art and sculptures can be very satisfying, because part of your work is already accomplished for you. In a sense, shooting art is a collaboration between the artist and you. You already have something attractive and worthy in front of your camera, and now it is your responsibility to render it into a photograph in a well-composed and appealing fashion. To that end, what could be a more perfect background for a selection of aeronautical sculptures than a blue sky with wind-tossed clouds? These sculptures are quite tall, and you will invariably have to look up at them. Find a pleasing arrangement where the wings and tails are not overlapping each other in a distracting way. I stood with the sun to my right, which cast shadows that brought out the texture and shapes of the planes. The sidewalk is light colored, as is the building that is immediately to the left of where I was standing—these two surfaces bounced light back into the scene, keeping the contrast ratio low. You can almost hear the drone of the turbine engines as the soundtrack!

Getting There

The entrance to the U.S. Department of Transportation is located at 1200 New Jersey Avenue SE. The department buildings run along the south side of M Street SE and can be readily accessed by taking the Metro to the Navy Yard Station (Green Line). Leave the station via the Navy Yard exit, and the DOT will be across M Street and to your left.

If you drive to the area, you will be able to take advantage of (paid) parking lots on M Street and New Jersey Avenue. From there, you will be able to explore all of the burgeoning Capitol Riverfront area.

A railroad-themed sculpture.

 When to shoot: morning, afternoon

International Flavor

The United States is one of the most influential countries in the world. Its national capital therefore finds itself playing a second and highly international role. At an informal level, this can be seen through the many restaurants, residents, and visitors exhibiting foreign cultures on the streets of the city, but at a more formal level, Washington demonstrates its global reach through a multitude of embassies, museums, memorials, gardens, churches, banks, organizations, and universities, each with some form of international flavor and each with a story to tell of other lands. A statue in memoriam to Sir Winston Churchill stands with one foot on British soil and one foot on U.S. soil at the edge of the grounds of the British Embassy. The Islamic Center on Massachusetts Avenue incorporates a

The flag of the European Union.

mosque and meeting place for Muslim residents and visitors. Japanese cherry trees around the Tidal Basin and the Japanese Garden at the Hillwood Estate speak gently to the ties with that country. Mahatma Gandhi's statue strides forward with quiet purpose in a small park opposite the Indian Embassy.

The Shot

The shooting conditions here were such that in order to make this photograph actually seem natural, I had to use a few tricks and techniques. Given the time of day, the sunlight, of which the foliage reflected a great amount, was quite harsh and unforgiving, causing the lush spring leaves to look light and dry. Also, the midday sky was rendered light and unappealing. Ta da! Out comes the trusty polarizing filter, an accessory you should never leave home without. With a twist of the wrist, the sky turns an azure blue, and vitality returns to the foliage.

The second problem I had to attend to was the shadow on the front of the statue from the overhead light source. My on-camera flash, set at two stops under the ambient light, brought just enough fill light into the scene to show the detail of the front side of the statue without looking artificial.

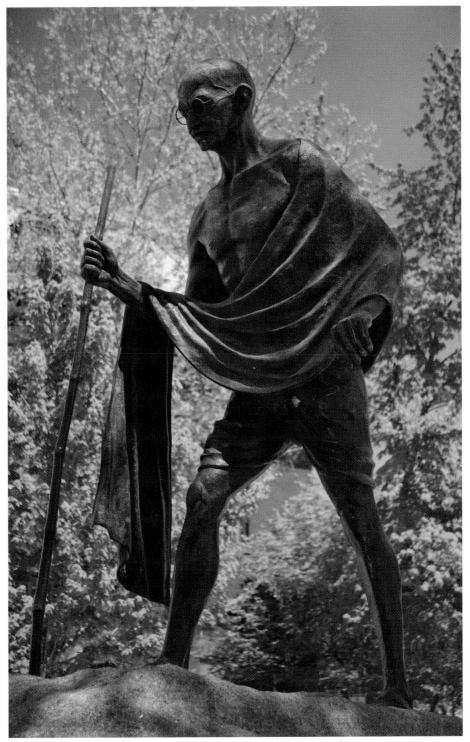

Focal length 65mm; ISO 100; aperture f/5; shutter speed 1/160; April 11:51 a.m.

The Shot

The quality of light in this photograph demonstrates the beauty and good fortune of a lightly overcast day. I was shooting at very close to noon, albeit two weeks earlier than the previous situation, but you can see how much less contrasty and more open the shadows are, even though the direction and hour are almost identical. For this reason and the fact that colors stay intense and saturated, the light of a slightly overcast day can be some of the nicest in which to photograph. Gardens, foliage, and organic surfaces benefit greatly from the slightly softened contrast, but you will also find this a preferred lighting situation for portraits and architectural shots. This Japanese garden at Hillwood is on a steep bank, and as you descend the stairs, look behind you, and you will see this tableau. The uphill view greatly enhances the composition—the horizon line is raised without having to tilt the camera, and your canvas is literally filled from edge to edge with subject matter.

The minaret of the Islamic Center.

Muslims praying streetside.

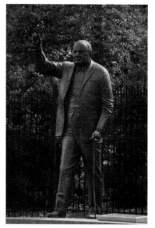
A statue of Churchill and his diplomatic stance.

Getting There

The Mahatma Gandhi Memorial is located on a triangular island along Massachusetts Avenue where it intersects with Q Street and directly across the road from the Embassy of India at 2106 Massachusetts Avenue NW.

The Islamic Center is found at 2551 Massachusetts Avenue NW.

Sir Winston Churchill's statue is sited in front of the Ambassador's residence at the British Embassy at 3100 Massachusetts Avenue NW.

The Embassy area can be accessed from the Metro station at Dupont Circle (Red Line), followed by a walk or bus ride northwest along Massachusetts Avenue.

Hillwood Estate, Museum, & Gardens is located on Linnean Avenue NW. See the Hillwood Estate section in Chapter 4 of this book for directions.

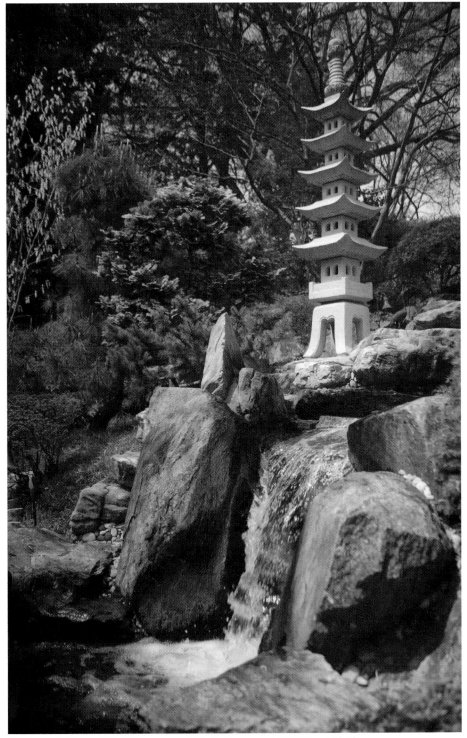

Focal length 33mm; ISO 100; aperture f/3.5; shutter speed 1/250; April 12:48 p.m.

When to shoot: morning, afternoon

Old Town Passages

The charm of Old Town Alexandria rests on the retention of its historical culture and architecture. The city, 50 years older than Washington, was formally laid out in 1749. Brick sidewalks and cobblestone streets are reminiscent of those times, as are the restored seventeenth- and eighteenth-century residences and businesses. The many passageways and nooks and crannies between the buildings, originally constructed to suit foot and horse traffic, present perhaps the most charming of features and photo opportunities.

The Shot

Passageways, tunnels, alleys, backstreets, paths—pictures with these design elements can tell stories and elicit questions, much like the doorways mentioned earlier in this chapter. The archway or opening of the passage can be thought of as a lacuna—a gap or a peephole—which is often accompanied by greenery, branches, or some other type of semitransparent barrier that adds another layer of interest and mystery to the photograph.

I was fortunate enough to walk past this opening in the brick wall at the very moment that the women were embracing. If I had arrived a couple of seconds

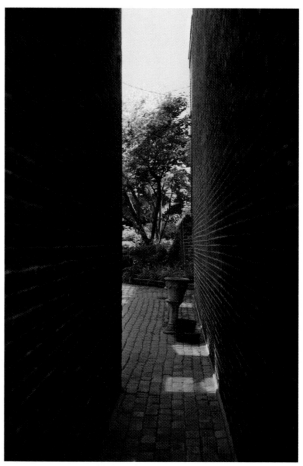

Looking down an alleyway off South Fairfax.

before or afterward, I would never have seen this intimate encounter. I like the fact that the image has many layers as your eye travels toward the centered subject—the sidewalk outside the archway, the greenery in the planters, the actual step through the arch, the brick path, the shrubbery slightly covering them, and then the women themselves. These layers make for a much more interesting image than would a straight photograph of the women hugging as they greet each other under this arch on Prince Street.

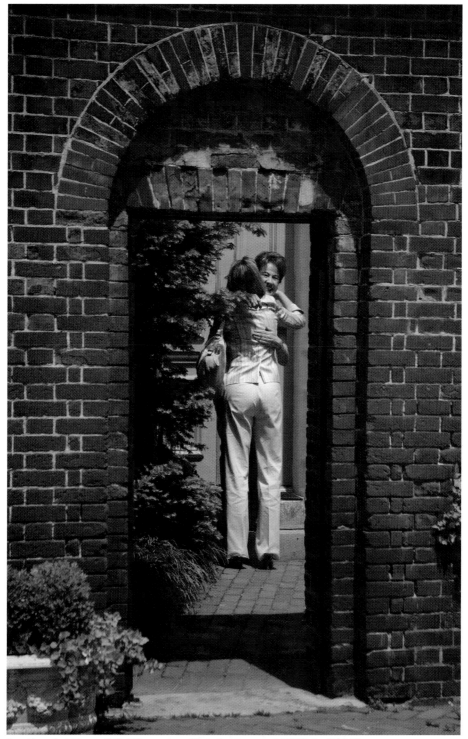

Focal length 135mm; ISO 100; aperture f/5.6; shutter speed 1/400; April 12:10 p.m.

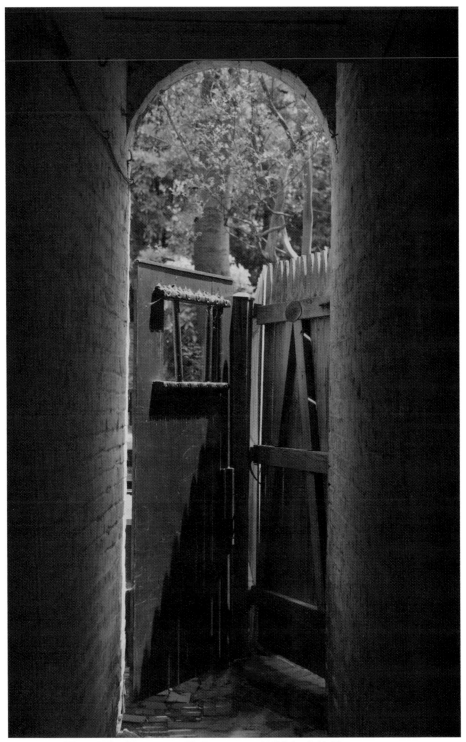

Focal length 75mm; ISO 100; aperture f/5; shutter speed 1/25; April 12:05 p.m.

The Shot

Here again we have an image that has many layers, visual metaphors, and paths down which the eye can follow. A narrow brick alleyway leads through an archway to an odd image of two doors set at an acute angle to each other. Through the framed window of one of these doors, we can see the leafy branches of trees that also veil what is beyond, further into the copse. There is history, and thus allegories and tales to be chronicled, evidenced by the moss on the cobblestones, old bricks in the wall, and quirky construction of the two gates. Keep your mind and eyes open to cinematic images such as this. Let your thoughts and vision wander. If I had not been mindful as I strolled down South Royal Street (walking north toward Prince Street), I could easily have missed this little glimpse. Explore and be adventurous—your photographs will be all the better for it.

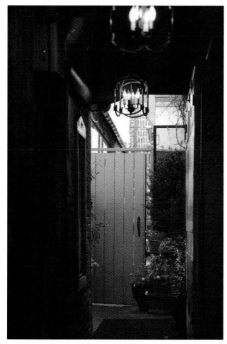

A peek behind a restaurant on Pitt Street.

Wisteria growing on an alley wall near Oronoco and N. Lee Streets.

Getting There

The Yellow or Blue Metro Line will take you from DC into Virginia and south along the Potomac to King Street Station in Alexandria. The station is located to the west end of Old Town. Walking east on King Street will take you through the town, reaching the waterfront after about one mile. To avoid the walk, take the Red or Yellow Dash bus lines that run from the Metro station along King Street to the waterfront. Old Town lies in the blocks to the north and south of King Street.

Index

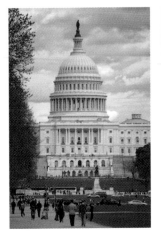
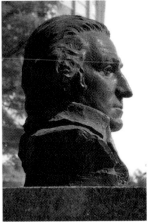
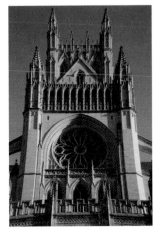

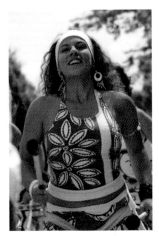

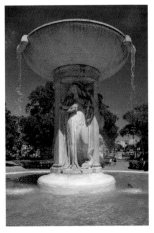

Washington, DC has a lot to offer!